VIDEOGAMEART

© 2005 Assouline Publishing
601 West 26th Street, 18th floor
New York, NY 10001, USA
Tel.: 212 989-6810 Fax: 212 647-0005
www.assouline.com

Color Separation: Studio LPT (U.S.A.)
Printed by Grafiche Milani (Italy)

Isbn: 2 84323 729 7

NIC KELMAN

VIDEOGAMEART

ASSOULINE

With apologies to Indiana

In 2004 alone, there were more 1,000 video games released. Even in a book this size, covering every game for just one single year would mean dedicating less than one third of a page to each title. Furthermore, some titles are so well known even outside the gaming community, we felt we should not dedicate precious space to materials that have already been well documented. Thus, we have attempted to paint a picture of the current state of video game art using a complex process of selection that highlights certain titles rather than others in an effort to be as broad as possible. Choices had to be made, and often they were based not on a game's popularity but on a particular innovation, vision, or artistic accomplishment. We hope our decisions will make as much sense to the reader as they did to us.

CONTENT

PREFACE

by Dr. Henry Jenkins, director, MIT Comparative Media Studies

With this book, Nic Kelman stakes out and defends the following claim: Video and computer games, as we currently understand them, constitute art. I emphasize the phrase, "as we currently understand them," because there are many more critics who have been willing to see games as a potential art form, seeing there the building blocks of something great and wonderful which we will see some day. For them, games can become art when they assume serious purposes, when they become meaningful activities, when our best artists build games, when we perfect the artificial intelligence, in short, when hell freezes over. Kelman would no doubt acknowledge that what games have offered us so far is nothing compared to what is to come, but he is still arguing that right now, on a daily basis, game designers are achieving art.

Kelman bases this claim on two core arguments: first, that video game designers are gifted craftsmen who construct compelling and visually fascinating worlds deploying skills which we would see as artful if applied in any other context; and second, that video games are constructing meaningful experiences which tap deep chords within our culture, in part because they are carrying on timeless functions previously associated with myths and legends. When he seeks analogies, it is to the great works of the Western tradition—to Homeric epics, to Arthurian romance, to Moby-Dick—and it is worth remembering in each case that these now canonical works were once the popular culture of their time. Frankly, if we really read Homer and thought about what he was describing, he offers us scenes of brutality and violence that no contemporary game

company would be willing to touch. In a few places, Kelman draws analogy to cinema—which was once known as "the toy that grew up" because it made a similar transition from an amusement parlor attraction into something which few modern readers could deny looks and acts very much like art. All of these analogies are apt and appropriate.

Sometimes, when he is feeling especially brazen, Kelman goes a bit further and argues that games represent what can easily become the most important art form of our era, one which both absorbs the most vital elements of all that has come before and pushes us toward new kinds of aesthetic experiences. At such moments, Kelman seems to be arguing for games what Wagner argued for opera.

For those who make it their duty to police the art world, these are most likely fighting words. They are frightened by the prospect that art museums and collectors might soon start paying out the excessive sums they are currently paying for piles of bricks, bottles of piss, elephant-dung-encrusted canvases, and secondhand urinals to purchase a copy of "Grand Theft Auto: Vice City" that anyone else could find marked down at the local Wal-Mart. Surely this would damage the reputation of the gatekeepers among members of the general public!

Have no fear. If video games are art, they will be a different kind of art than what has been coming out of the art schools in recent years, and at the risk of seeming like a barbarian, let me add *thank goodness*. I have argued elsewhere that video games represent the latest in a series of what mid-twentieth century cultural critic Gilbert Seldes called "lively arts," arts which occupied a space outside of the official art world, but which touched the lives of ordinary people, bringing them not simply pleasure or entertainment but also something approaching the sublime, which made them think and create and explore and experiment and, above all, play with the materials of their culture. At one time, Seldes shocked his

contemporaries by asserting that among America's greatest contributions to arts in the twentieth century would be cinema, jazz, the Broadway musical, and the comic strip. Today few would deny any of these (well, perhaps, comics) entry into the most sanctified corners of the art world. So who is to say that we will not look back at the end of the twenty-first century and ponder how anyone could have doubted the validity of Kelman's arguments here.

A few of those art critics have been prepared to defend video games as art when they are created by artists already recognized for their accomplishments in other media—so we are seeing a range of artists worldwide stage political conflicts or erotic fantasies through pretty simplistic game interfaces. As these works take their place in the Whitney Biannual, the curators are not so much conceding that video games are art as they are proclaiming that "even video games can be used to make art in the hands of a real artist." Of course, the fact that highbrow artists are starting to tap game-like interfaces speaks to the impact this medium has on our visual culture. But if games are going be thought of as art, let it be because of what Shigeru Miyamoto (Super Mario Brothers) does again and again and not because of what some pedigreed artist does once on a lark. Calling video games art matters because it helps to expand our current notion of art and not because it allows curators to colonize some new space.

For those who might reject the artistic merits of video games, it is going to take more than this book to change your minds. Nevertheless, I would urge you to suspend your disbelief, look, learn, and listen, because there is much sense in what Nic Kelman has to say here. I should confess, of course, that Nic was once my student, and so in writing this introduction, I am pursuing my two obligations as a mentor: to watch his back and take as much credit for his accomplishments as I possibly can. Any lavish praise here could easily be taken as grade inflation, so I will restrict myself to saying that he got things more or less right here and let this work speak for itself.

That said, I remain skeptical that what is most accomplished about games can be fit within the pages of a book. Is it really possible to understand the nature of dance without dancing? To make sense of the pleasures of music without listening? Then how can you imagine you understand games if you do not play them? What Kelman can tell you here are the ways that this medium looks like art and is structured like literature. Both are true, but what he can't tell you through static images and printed texts is what it feels like to move through a game space or to control a character. He spends relatively little time here on interactive design or on the ways that these games are enabling their consumers to participate in the production of new content. He tells us little about expressive movement or the role of the soundtrack in shaping how we feel about those images on the page. He tells us only a bit about artificial intelligence and the ways that it allows these characters to come alive in our minds for at least a little while. He doesn't tell you nearly enough about the expansive open-ended landscapes created by the best contemporary worlds, which give you the impression that you can go anywhere and do anything even as they channel you toward the most rewarding experiences. One must start with what can be put into a book since there are still some primitive people out there who only read books but to really grasp what he is talking about, get the kid next door to set you down in front of his Playstation and hand over his controller.

For anyone who actually knows what they are talking about, for anyone who has played even a few of the games Kelman discusses here, this case is already closed. Are games art? Sure, pass the controller. Such readers can read this book with a certain degree of nostalgia over their misbegotten youths and with a certain pleasure at being reminded of the great graphics found in their favorite games.

To be sure, some gamers and game designers still want to deny that video games can be art because of the low (or lofty, depending on your perspective) reputation art has in contemporary culture. How

can something this engaging possibly be discussed alongside the usual forced march through the local art museum? Does anyone want their favorite recreation to be taken over by stuffy art historians, pompous society matrons, and mumbling docents? Gamers and game designers should think long and hard before taking on the burden of art, if only because it may decrease sales and frighten the children. This says more about what some historians have called the sacredization of art across the late-nineteenth and twentieth centuries than it does about the merits of this particular medium.

Perhaps most of all, these gamers and game designers fear that calling games "art" will somehow make game designers responsible. If we are being honest, we take great pleasure in the fact that games are reckless and irresponsible, do not respect borders and boundaries, are not afraid to risk bad taste, go for intense emotional responses, and yank us out of the realm of ordinary experience. Nobody wants to see a still living and emerging art stuck full of pins and dunked in formaldehyde.

Yet what would happen if calling games "art" gave greater expressive freedom to our most gifted game designers, allowing them to explore new spaces, empowering them to experiment even more with their medium, providing them with the kinds of critics who recognize and reward innovation, creating better educated and informed consumers who demand more from the games they play? Can thinking about games as an art result in, to use a technical term, more kickass games?

Being a member of the professoriate, I would also hope that calling video games "art" will force gamers (myself included) to re-evaluate our stereotypes about the art world and go back to earlier works with a fresh perspective. From our early-twenty-first century perspective, we can see the great artists of the past as groping toward some of the things that our best game designers accomplish almost effortlessly. Take Leo Tolstoy, for example. He spent almost a hundred pages at the end of *War and Peace* re-imagining how the

Battle of Borodino would have come out if you tweaked certain variables. What if we read this oft-skimmed passage as a design document for a simulation game? Given how much effort Tolstoy spent trying to produced a detailed re-creation of the battle, wouldn't he have wanted a medium which could easily restage the battle again and again with different outcomes? Or take Rembrandt, who demonstrated his technical mastery by capturing the texture of rust, fur, and leather, and the qualities of reflected light. Wouldn't he have been interested in the new kinds of immersiveness enabled by contemporary video games? Or think Bosch, whose paintings must be scanned slowly to take in all of the surreal details, the fascinating environments, the complex activities. Can you not imagine that he would have made killer side-scrollers, where each new level is more engaging and eye-catching than the last? Or what about the German Expressionist filmmakers who built massive studios so they could totally control every visual element. Wouldn't they have used state-of-the-art computer modeling to create the worlds of their imagination from scratch? Or what about the surrealists, who wanted to introduce an element of randomness into their art and who saw games as a device to free their imaginations. Wouldn't they have relished the chance to turn over the joystick to the player? And we can go on.

The power of a book like the one you are now holding in your hands is that it both may help art school grads to appreciate the aesthetic accomplishments that are all around them and may help gamers to discover that traditional art may be much more interesting than their teachers ever told them. What Kelman says here is sure to be contested by art critics and gamers alike. That's part of the fun, especially if such discussions allow us to sharpen our analytic tools and come up with aesthetic categories which are appropriate to this emerging and mutating art form.

Let the games begin.

INTRODUCTION

Imagine if, to date, nothing had ever been written about film. No analysis of set design, no discussion on Russian theories of editing or the significance of color in French cinema, not a word about how our perception of Sherlock Holmes was altered for all time by Basil Rathbone's nose. Were this the case, it would be hard, if not impossible, to know where to begin talking about such a vast and differentiated medium. And yet this is almost precisely the situation we face today with video games.

In the past few years, consumers have spent more on video games worldwide than they have on films. By the end of next year, the game industry will eclipse even the music industry in gross revenues, and by 2008 it will be making more than both music and film combined. Even if we take these numbers as only the roughest of guides, they tell us something important: video games are now the de facto dominant art form in the world.

In spite of this, there has been almost nothing written about the medium. In the last few years, a small handful of universities have created tiny departments of video game studies, there have been one or two issues of journals that focus on thinking about the cultural impact and significance of game content, and a variety of art

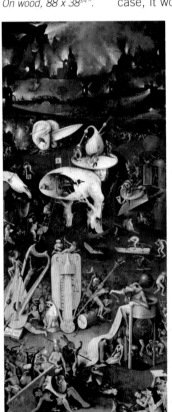

Hieronymus Bosch
The Garden of Earthly Delights. *Right-side-wing of the triptych:* Hell. *On wood, 88 x 38³/₄".*

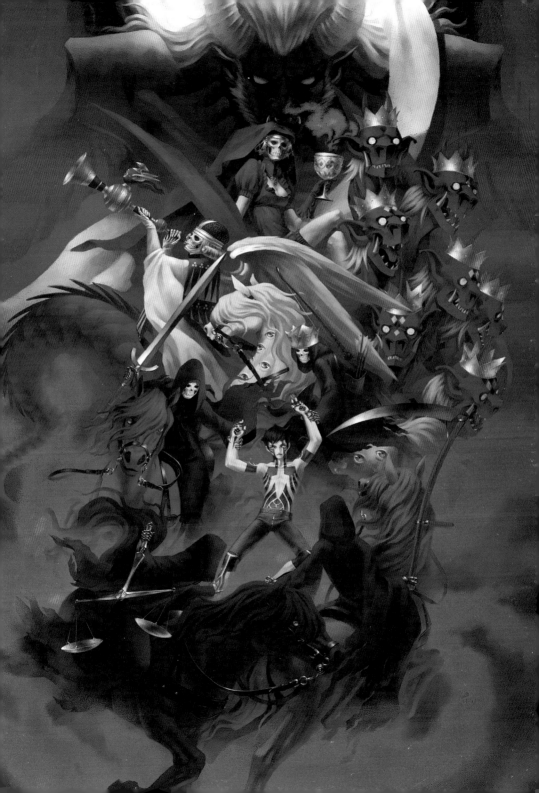

collections have been published on the work of an individual game or game series. But this is all. For an industry employing literally tens of thousands of artists, designers, writers, and musicians all over the world, videogaming seems incredibly underrepresented when we consider the enormous film theory or music sections at our local bookstores.

Although perhaps this underrepresentation is not surprising when we consider the history of the industry and its relatively recent meteoric rise to the world's most popular form of media. Video games are called "games" for a reason. At the very least, the medium began and developed for some time without artistic pretensions. Unlike film, which started by imitating photography (and thereby painting) and theater, pioneer video games were nothing more than a few

monochromatic boxes or lines. The first games, like "Tennis for Two," (a 1958 laboratory experiment created by a Manhattan Project scientist), "Spacewar!" (the first arcade game, 1971), and "Pong"(1975), used symbols for people, balls, or even spaceships and aliens; these symbols were so simple, the games could be considered art only by the most abstract minimalist. They were revolutionary because of their interactivity; they were an invention that could *respond* to its user, because they could offer tests of skill that previously had always required another human being. This element of interactivity, the truly

distinctive component of video games that sets them apart from other forms, is also, as we shall see, at the heart of many of the artistic and narrative choices games make today. It is true that very early on, even within the medium's limitations, design icons like "Pac-Man" (the first video game protagonist, created in 1980) or "Space Invaders" emerged to become permanent parts of our worldwide cultural heritage, but the origins of games, their excuse and their inspiration, still lay with gaming, not art. They still depended on their interactivity to hold people's interest to subject matters that were visually and narratively more simplistic than a children's book. Thus, it is perhaps unremarkable that, at their outset, video games were considered little more than entertainment, little more than a novelty, and unworthy of serious contemplation from a cultural or artistic perspective.

Recently, however, as part of their ascendancy to the top of the competition for our entertainment dollar, games have crossed the technological threshold necessary for them to make the move from brilliant design to burgeoning Tenth Lively Art (perhaps the liveliest of all). As the medium most closely tied to technological advancement for its execution— more so, even, than film—the boundaries of its limitations have exploded outward exponentially, exactly in sync with advances in electronic engineering. As computer processing speeds and storage capacities increase, more environments, more people, more creatures, more detail, can be displayed

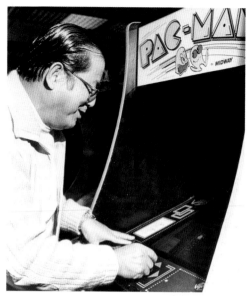

Above:
Masaya Nakamura, father of the popular video arcade game, takes a turn at Pac-Man. *He is happy about the global success of his creation, but "a little concerned about the way some young people play so much."*

Opposite page:
Author David Sudnow plays a table top Pac-Man game.

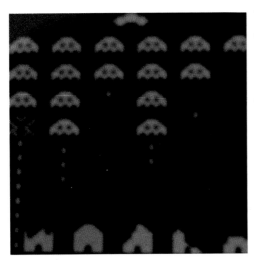

Space Invaders.
Developer: Taito.

than ever before, and longer stories can be told. In addition, as programmers understand better and better how to manipulate the power of the computer, more imaginative interactions can be created among all of these components of games. Today the scope of video games extends to representing entire three-dimensional universes on a single DVD, from cars, to pets, to clothing, to the social dynamics of group relationships. Thanks to progress in technology, it is now more or less true that if we can dream it, it can be made a gaming reality. And in this extension of scope, art has happened in two distinct ways.

The first, most obvious way is in the components of games that correspond more or less to traditional media. For example, set virtually free of storage restrictions in the past five years, the writing, music, and set design of games have all progressed by leaps and bounds. Today game developers may employ dozens of writers who, for a single title, compose twenty-to-fifty-hour scripts involving sometimes hundreds of characters. Game development also now includes teams of artists and designers, as well as experts in various fields such as architecture or military engineering, who all work together to ensure that the "fantastic" experience of a game is as "real" as possible. One need only compare, for example, the writing of the "Chronicles of Riddick" game with the *Chronicles of Riddick* film to see that games may have eclipsed movies not just in terms of how much money they make, but also in terms of the quality of their more traditional elements, like writing.

In addition, beyond these elements of game production—clearly related to already-established art forms—there are also artistic elements that are unique to games but could still, conceivably, be seen as extensions of traditional forms. For example, there are entire teams whose job is to create characters—and not simply the way they look, but the way their faces express emotion, how they move, how they react. Another example of such an element might be designing levels for games: what do areas in the game look like, and how do they work as places in which the game might be played? Elements of game design such as these have also come into their own thanks to faster and faster processing speeds and more and more storage, but they, too, might still be considered offshoots of other established art forms, such as illustration or sculpture.

The second and perhaps more interesting way in which games have recently made the leap from entertainment to art is in terms of the overall experience of the game. Just as we can talk about the various artistic elements that make up a film—the cinematography, the screenwriting, and so on—but also talk about whole films as works of art, in recent years the same has slowly begun to be true for games. And because games are the world's first truly interactive art form, it is on this topic that there is plenty to be discussed, debated, and analyzed for the very first time.

As mentioned above, games are set apart from all other media by their reactivity; they constantly change and shift in response to

From the Myst series.
Developer: Cyan.
One of the best-recognized game environments of all time, the original "Myst" set new standards for the quality of computer generated environments and also for the ways in which topology and gameplay interact. It created photo-realistic fantasy worlds and showed a glimpse of the direction game art and design would take before the end of the last century.

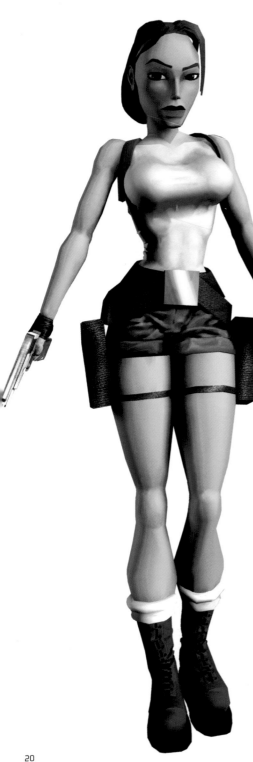

input. They are an active experience requiring at least one participant, not a viewer, reader, or listener who remains passive, but a player. The implications of this distinction are both far-reaching and profound. The difference, for example, between the experience of *reading* about a protagonist in a narrative and *being* a protagonist in a narrative is far from trivial. It has complex implications for the way character identification and plot threads function that have yet to be explored and understood. The same is true for the difference between the function of settings in games and that of settings in traditional narratives. In games, the setting is something that one constantly interacts with, not simply a backdrop, as it often is in traditional storytelling.

But beyond the differences that interactivity creates between elements of video games and those same elements of traditional arts, if we look at specific games as a whole and attempt to determine if they are works of art rather than simply works of entertainment, we quickly realize interactivity also makes this distinction not immediately apparent or intuitive. For instance, one of the best recent examples of a game

that demands to be taken seriously as a work of art is "Katamari Damacy." Here, players roll a small, "sticky" ball around a messy room or town in an attempt to pick things up and make their ball as big as possible within a time limit. This game has extremely limited narrative elements and is quite simple, if brilliant, in its concept and gameplay. It might, in fact, be seen initially to bear closer resemblance to a toy than a work of art. But spending more than twenty minutes with the Katamari (the name of the sticky ball) will convince all but the most hardened skeptic that its interactivity synthesizes the sum of its beautiful parts—its spectacular design and music, for example—into an artistic whole unlike anything found in other media. Another excellent example of a game that, as a whole, might be considered art, is "Rez." On its surface, "Rez" appears to be little more than a three-dimensional version of "Space Invaders." But again, through its interactivity, it transcends that oversimplification as the brilliant graphic design, music, and pace all constantly mutate in response to the player's actions.

Furthermore, as we better understand the

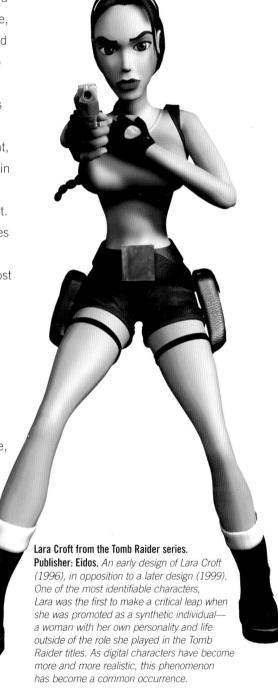

Lara Croft from the Tomb Raider series.
Publisher: Eidos. *An early design of Lara Croft (1996), in opposition to a later design (1999). One of the most identifiable characters, Lara was the first to make a critical leap when she was promoted as a synthetic individual— a woman with her own personality and life outside of the role she played in the Tomb Raider titles. As digital characters have become more and more realistic, this phenomenon has become a common occurrence.*

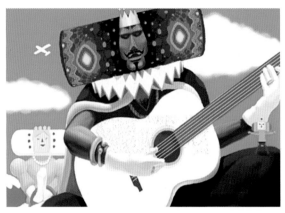

The Royal Family from Katamari Damacy. Publisher: Namco.
The "Spirit of Bulkiness" game became a worldwide pop-culture phenomenon after starting as a student animation project. Here we see the King of the Cosmos, his wife, and the Prince (the protagonist of the game) sharing a musical moment. Showing diverse design influences from 1960s psychedelic art to 2000s Kubrick collectibles, "Katamari Damacy" synthesizes music, design, concept, and gameplay into an experience that transcends the term "game," and creates for most "players" the kind of visceral impressions we most often associate with traditional art forms.

effects of interactivity on our experience of art, it will be interesting to see what we might then learn about traditional, passive art forms by comparison with games. What do the differences between the new and unique interactive medium of video games and more traditional mediums reveal about the nature of art itself? What might they tell us about why artistic endeavor and experience is so compelling, so essential to our daily lives? For example, let us assume there is a direct link between the popularity of games and their ability, granted by interactivity, to immerse us as never before in alternate realities. The ability to do this effectively is also an essential part of certain traditional narrative media, notably fiction and film, so what then does the success of games imply about the relative importance of immersion (and perhaps escapism) as a component of art in general? By asking questions like this one, the serious analysis of games could reveal interesting new ways of understanding both traditional forms and art as a whole.

However, given the volume of material, where do we begin?

I believe the answer can only be: somewhere. Yes, it is true that there is already an unfathomable amount of work to be analyzed, that games are perhaps unique in human history because, as an entirely original form of art, they have grown to their current proportions and significance in a mere twenty-five years. But in much the same way that a good game provides a tutorial level at its outset so new players can learn its rules, mythos, and objectives,

this book will attempt to cover a little bit of everything in the hope of generating further discussion about what must eventually come to be seen as *the* artistic medium of the new millennium.

Starting by touching on character and some of the issues it raises for both the protagonist and the antagonist, we will then take a look at how environment in games acts both similarly and differently than environment in other, usually narrative, experiences; move on to touch on the inanimate in games and its uses (for example, physical items like keys or swords as plot drivers); and finally look at several diverse topics deserving of attention but falling into their own unique categories, such as the influence of animation on game design.

If art is all we can dream, games are the ultimate fulfillment of that potential, the ultimate departure from reality into spaces of our own creation. And if art is a journey into the human mind and soul, games take us further on that journey than most of us had ever imagined possible. I would like to believe this book is also the beginning of a journey, a journey others will decide to continue.

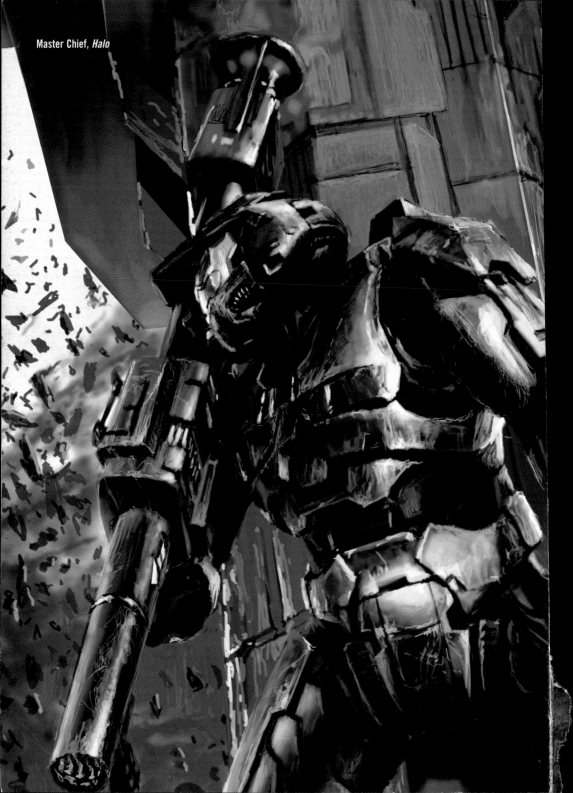

Master Chief, *Halo*

level 1

level 1
PROTAGONISTS

On the spectrum of abstract to concrete art forms, video games might be seen as the most concrete. They demonstrate a remarkable variety of ideas in an even more remarkable variety of universes, but because they must always be interactive, they must always have as their focus some perceivable, concrete entity. You cannot create a video game about an idea or a feeling as you could a poem, a piece of music, or an abstract painting. Whether it is a person, a car, or a worm, the player must always have some kind of distinct and visible object to move through a given physical environment. Even in the most abstract games—for example, puzzle titles like "Tetris" or "Bejeweled"—the player is still maneuvering objects through a physical space (and is frequently even aided by a persona that gives physical form on the screen to the player's role as manipulator). Thus, if we restrict the term "protagonist" to its most simple definition as a physical entity at the center of some kind of action, all games must have a protagonist. Although this entity may sometimes be a team of individuals, it does not substantially change the fundamental precept of the nature of video games.

At first, this necessity for an entity that is the focus of the game may seem a serious restriction. But the same interactivity that always requires a protagonist to be present is also responsible for allowing games to have a broader range of subject matter than traditional films or prose. This is because interactivity also sets games free from needing a

Preceding pages:
Master Chief from the Halo. Publisher: Microsoft Game Studios.
Perhaps the most famous "faceless" hero of all time.

Opposite page:
Munch from Munch's Oddysee. Developer: Oddworld Inhabitants.
Not what many people might picture when they imagine a video game hero, Munch both epitomizes the ideal of the underdog and illustrates the breadth of imagination and realization in today's games.

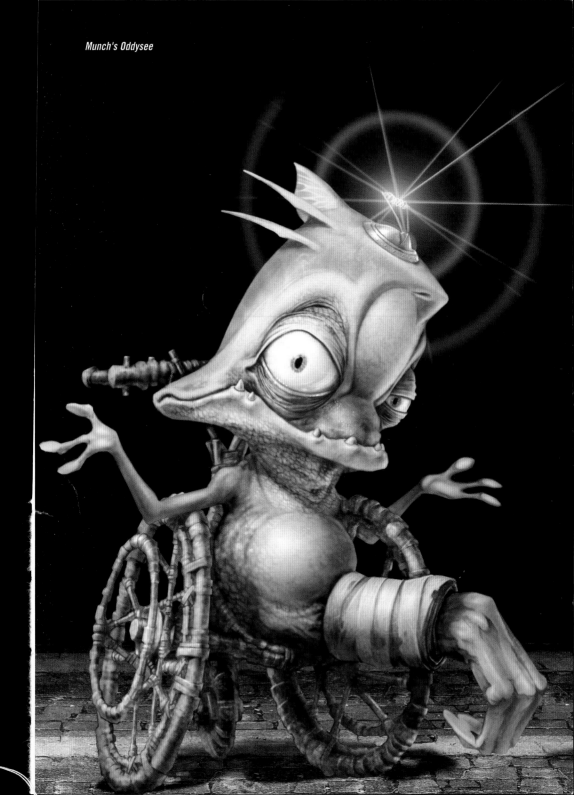

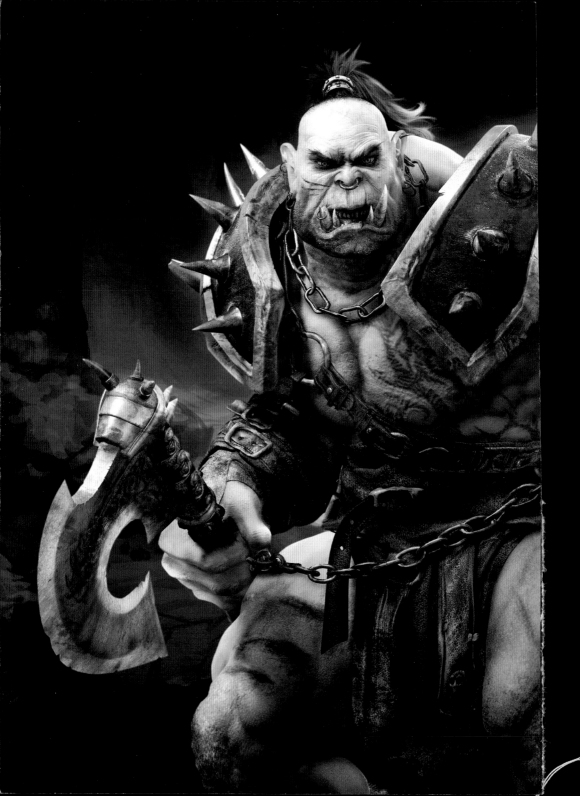

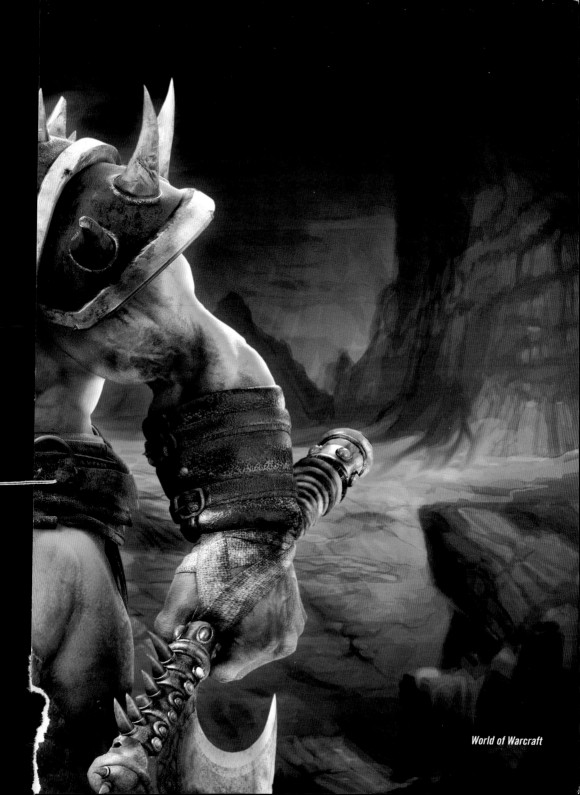

World of Warcraft

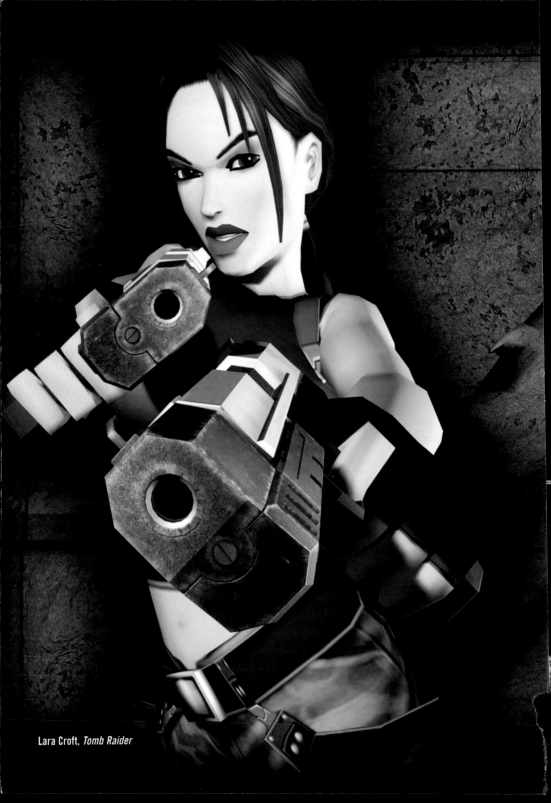

Lara Croft, *Tomb Raider*

narrative to maintain the interest of a player. With the exception of experimental (and still mainly marginal) works, passive media forms must use the artistic "trick" of moving a protagonist through a plot to maintain interest. In games, this necessity is absent, its function filled by interactivity.

In video games, however, the case is almost the opposite. Narrative is, in fact, a latecomer to the form, since early games did not have the technological support that allowed them to convey anything like a complex story structure. Before the capacity was developed in the early 1990s to store large amounts of dialogue and animation, as well as to save a player's progress partway through a game, narrative was almost absent from games played on home video game consoles. Some PC, or even Commodore 64 titles, like the entirely text-based "Zork," exhibited more complex stories, but at the expense of graphics, and some early console titles like "Adventure" did attempt simple story lines, but these stories were really little more than directives such as "Now go kill the dragon."

At best, games of the early 1980s contained a backstory that was little more than an explanation for the situations in which the player found the protagonist: The princess has been kidnapped by a giant barrel-throwing ape and you must rescue her by climbing these ramps ("Donkey Kong"). Aliens have invaded the Earth and you must fight them off in an experimental spaceship while also rescuing survivors ("Defender"). But more often than not, games contained no narrative at all—many early games were simple sports simulations or science fiction variants of such simulations— and yet they still held the attention of the player for hours on end. Why? Because that player was directly controlling some discrete entity (or "protagonist") and had been given specific tasks to achieve with it. No matter how simple those tasks

Preceding pages:
An orc from World of Warcraft. Developer: Blizzard Entertainment.
Customization of everything from hairstyles to weapons enhances the identification a player feels with a character in a game. The question of racial identity is central to most role-playing games, where the player often chooses his race before making other choices; specific races are usually better suited for specific jobs, their suitability often telegraphed by their design. Orcs, for example, make excellent warriors.

Opposite page:
Lara Croft from the Tomb Raider series. Publisher: Eidos.
One of the earliest characters identifiable by non-gamers, the roster of video game protagonists that mainstream audiences now recognize grows every year.

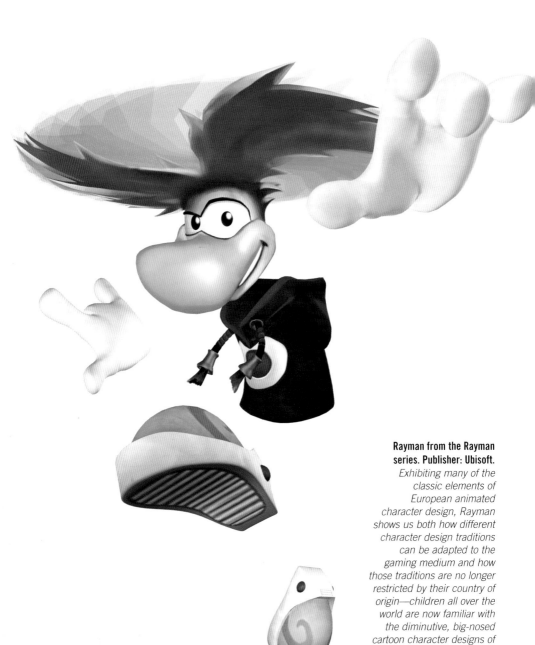

Rayman from the Rayman series. Publisher: Ubisoft.
Exhibiting many of the classic elements of European animated character design, Rayman shows us both how different character design traditions can be adapted to the gaming medium and how those traditions are no longer restricted by their country of origin—children all over the world are now familiar with the diminutive, big-nosed cartoon character designs of France just as they are with the long-limbed, big-eyed, spiky-haired anime character designs of Japan.

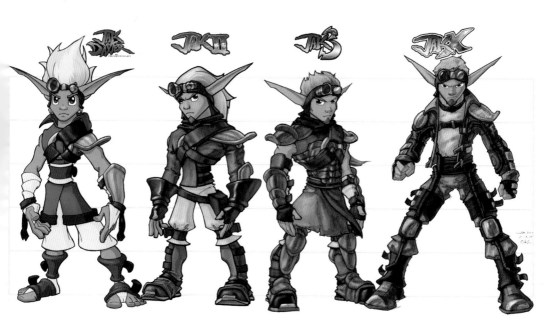

might have been—even just winning the race or killing all the alien invaders—their interactivity held the player's attention in the presence of a protagonist but the absence of a narrative. In fact, the power of interactivity to hold our attention in the absence of narrative continues to be demonstrated even today by massively multiplayer games like "Everquest" and "Dark Age of Camelot." These games have been among the most addictive of all time ("Everquest" is nicknamed "Evercrack" by gamers), yet are almost completely devoid of narrative experience. They have backstory and histories associated with their universes, but the player does not move his character through a narrative. Instead, he simply interacts—with the environment, with creatures, and of course, with other players who are online at the same time—but this is enough to make these games overwhelmingly compelling.

In fact, given the way interactivity sets games free from the need to have a narrative, it is interesting that narrative

Above:
Jak from the Jak and Daxter series. Developer: Naughty Dog. Publisher: Sony Computer Entertainment America. *This progression of the character design for Jak nicely demonstrates the way that characters are continually evolving to keep their appeal current. Jak's original design is more oriented toward a younger audience; but his second iteration is somewhat darker and more mature, and later designs illustrate further developments in the series story line.*

Following pages:
A Valkyn from Dark Age of Camelot. Developer: Mythic Entertainment.

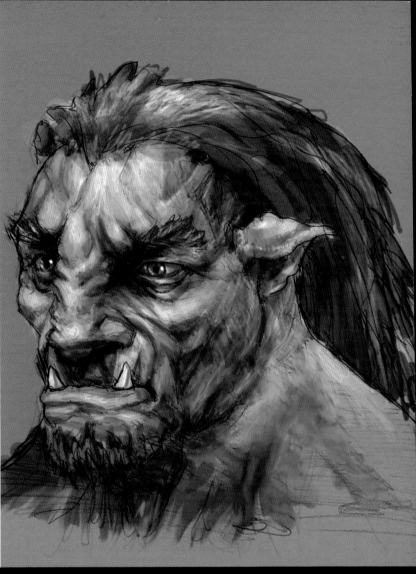

What decisions did you make regarding racial distinctions?

"Our racial choices were pretty easy to make—we had the background of each realm, so we looked at the mythology of each to come up with people and creatures that inhabit the legends. So, for example, we ended up with the Saracen in Albion—from the legend of Palomides, the Saracen knight. There are many more races than these, of course, but they give you an idea of the path we took to identify each of them."

What direction is video game art and design taking with regard to character design?

"Sometimes I think that art production and technical capability is moving along faster than design. It's amazing how much more lifelike a stylized character can look than a hyperrealistic one, and hopefully soon we'll see a trend toward more personality and less realism. That's my personal taste, of course."

MATT FIROR, VICE-PRESIDENT OF DEVELOPMENT AT MYTHIC ENTERTAINMENT

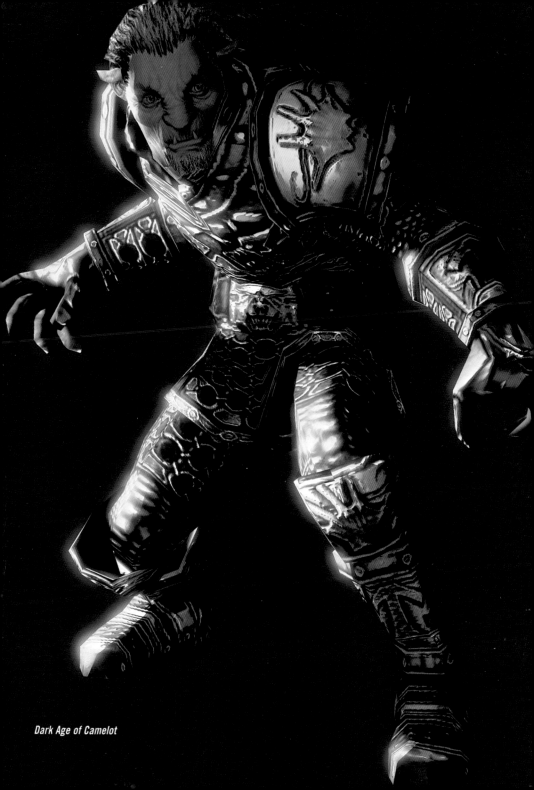

Dark Age of Camelot

has become as universal to games as it is today (almost all non-simulation titles now have attached narratives, no matter how simplistic). This may point to some fundamental human need to experience a story, even when we would be compelled without one. Furthermore, by the very nature of a game's format, they are particularly well suited to inventing and conveying not just any narrative, but specifically mythological narratives. They take us as participants far beyond where we can go as viewers or listeners or readers because they allow us to no longer merely *wish* we could be a mythical hero, but to actually *be* him or her, to control his or her every move, every action, every decision. This distinction is demonstrated perhaps most clearly by the intense attachment players form to their characters in massively multiplayer games, but also by the fact that all gamers, not just those in multiplayer games, describe the

actions of a game character using "I" and not "he" (as in
"then I killed the dragon," not "then he killed the dragon").
Some would say this focus of games is a result of their being
aimed, originally, at an audience of teenage boys. However,
this statement really reverses cause and effect. Because
children's imaginations are so active, when games were in
their infancy, it was children who first recognized the
potential in what were little more than collections of dots,
colors, and sounds—the potential to become the perfect
expression of the urges that drive our fascination with
mythology. Because games always require an entity at the
center of their action who/that must overcome a series of
increasingly difficult tasks, and at the same time, because
they also allow us, through interactivity, to become that entity
(rather than simply observing him or her), video games are
the ultimate realization of the fundamental human need for

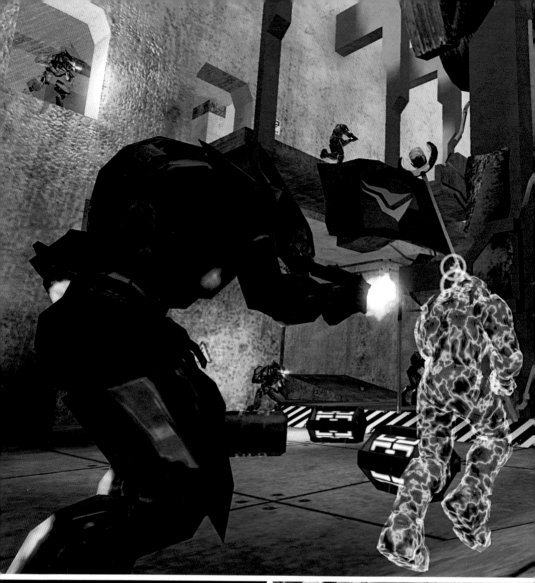

A multiplayer arena and atmospheric character studies from Halo 2. Publisher: Microsoft Game Studios.

Designing the multiplayer component of a game where players can compete head-to-head in a first-person-shooter format is an art unto itself, and some successful titles are published as exclusively multiplayer games using this format. Players have a choice of characters that usually stem from the single-player, more narrative version of the game. Atmospheric studies can be used by design teams to ensure that a protagonist always conveys a spirit similar to that of the atmospheric images, no matter what environment or situation he is in.

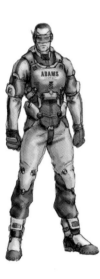
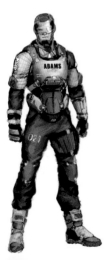
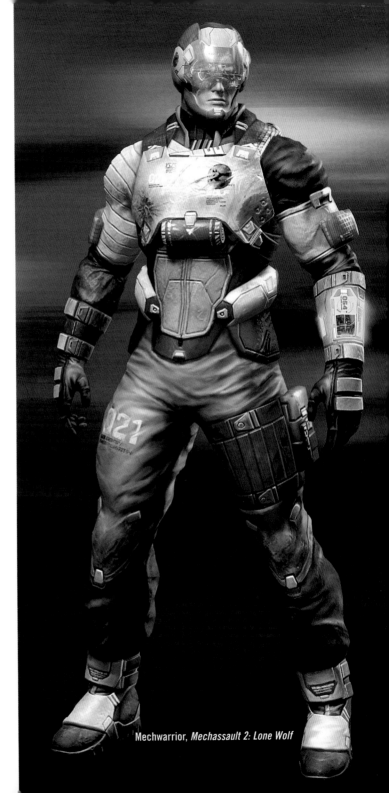

Mechwarrior, *Mechassault 2: Lone Wolf*

mythologies. This reasoning is supported by the fact that the audience for games has grown older with the medium, the average age of a gamer today being 28 and rising. It seems perfectly reasonable to assume, in fact, that the people who grew up with games will continue to play them as they continue to age, in much the same way that *The Odyssey, Le Morte d'Arthur, The Tale of Genji,* and *The Lord of the Rings* have something to offer readers and viewers of all ages.

Whether it's an investment banker pretending to be Shaquille O'Neal in "NBA Live" or a New York City real estate tycoon in "Tycoon City," a teenager pretending to be a genetically modified space marine in "Halo," or a little girl pretending to be a imaginary creature that can inhale the powers of those around her in a "Kirby" title, once we recognize that games, at their heart, are an expression of our desire for the presence of myth in our daily lives, other points become clear. It means, in turn, that certain conventions are more important and more central to their narrative component than others, and that they result in some of the commonalities shared across games and genres. With the "hero of a thousand faces" almost always at the center of video games, in much the same way he is in opera or Hollywood action movies, we see familiar recurring themes: the triumphant underdog, the common man caught up in (and important to) events on a global scale, the outsider proving he is not so much odd as he is special, the unavoidable prophecy fulfilled, hard work rewarded, and so on. However, because these archetypes have been so well categorized and their presence in games is so apparent, we will not dwell on demonstrating their presence, but rather look at some new archetypes that, while still related to common mythological types, have come into their own in video games.

Opposite page:
The Mechwarrior from the Mechassault series. Developer: Day 1 Studios.
Another famous "faceless hero." Of particular interest here are the concept sketches that show how the character was always conceived as faceless.

Following pages:
Jericho Cross from Darkwatch. Developer: High Moon Studios.
"Jericho evolution: this set of drawings show the evolution of the game concept through the visual evolution of our main protagonist, Jericho. Darkwatch started out as more of a cartoonlike adventure and a caricature of the Old West genre. It gradually evolved into the Gothic Vampire Western you see now."
HIGH MOON STUDIOS

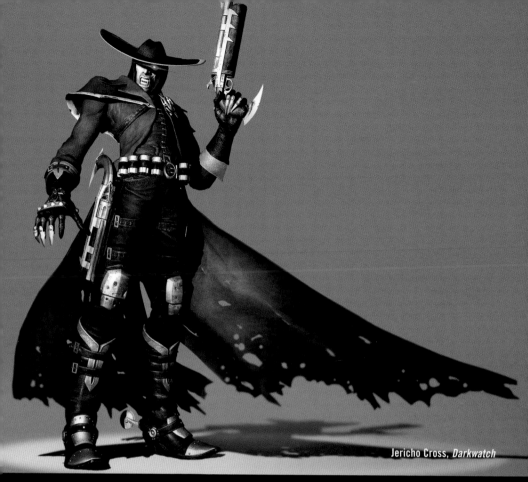

Jericho Cross, *Darkwatch*

"Disgusted by the atrocities he witnessed in the Civil War, Jericho deserted his regiment and drifted out west. In 1876, Jericho's attempt to rob a Darkwatch train landed him in the middle of a millennia-old war between the undead and the Darkwatch. Even a little bit of backstory is instrumental in shaping the visual development of a character. Just like a character actor constructs the psyche of the character he wishes to portray, a concept artist can use backstory and character development to make specific choices to visually communicate that type of character."

HIGH MOON STUDIOS

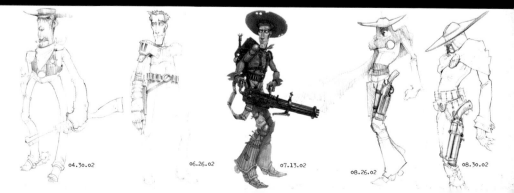

04.30.02 06.26.02 07.13.02 08.26.02 08.30.02

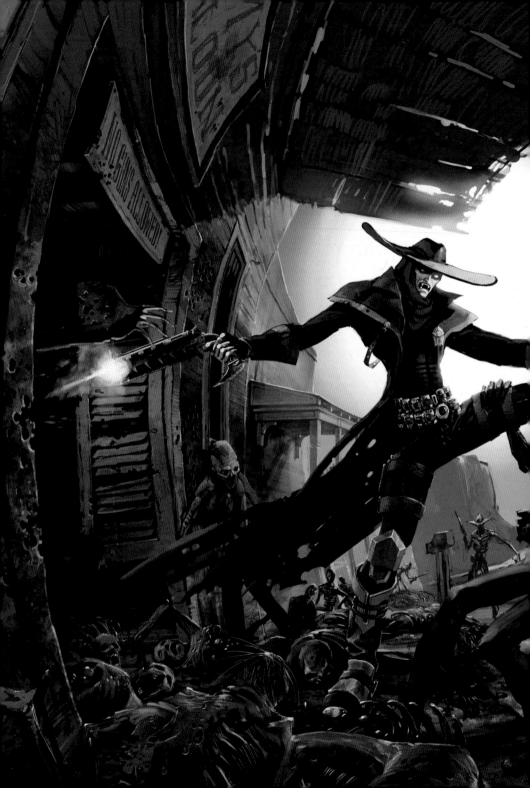

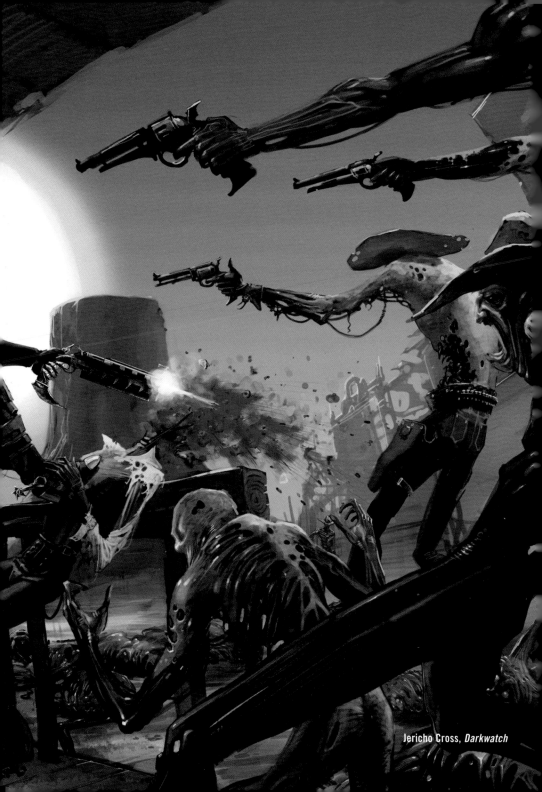

Jericho Cross, *Darkwatch*

The first of these is the hero without a face. From "Ninja Gaiden," "Doom," "Halo," and "Soul Reaver" to racing and real-time strategy games, many games either hide the face of the protagonist behind a mask or, by the nature of the gameplay, prevent that face from being seen. Such protagonists are a good place to begin our discussion because they relate so clearly to the player's unconscious feeling that he is the protagonist. With the protagonist's face hidden or having no form at all, the player is free to map his own persona into the game like the listener or reader of classical or medieval sagas might, but in a much more powerful and intimate fashion. Related to this category—and even more prevalent, in fact—is the generic human protagonist. Characters with few strong, defining features and almost forgettable faces can be found in many games, the best-known example being, perhaps, The Guy from "Grand Theft Auto 3," but also in many survival horror games like the Silent Hill or Resident Evil series. The generic character design, the forgettable face (almost always a Caucasian male with dark hair and eyes), relates to the concept in traditional mythology of an ordinary man or woman caught up in global events. Many of these generic looking characters also have nothing special about their skills, talents, or backgrounds. They do not simply *look* ordinary, they *are* ordinary (unlike other game heroes). This enhances the identification the player feels with the character, because the character's success in the game then depends almost entirely on the player's own ability to make him or her succeed. What is more, by both looking like and behaving like an "everyman," every man (or woman) can imagine he or she is the character much more easily. Most recently, characters like Carl Johnson in "GTA San Andreas" have even allowed an enormous degree of customization in

Opposite page:
Hattori Hanzou from Kessen 3. Publisher: Koei.
Hanzou is a legendary ninja of seventeenth century Japan. We see here how such historical figures are modernized for their participation in the newest medium to chronicle their exploits.

Following pages:
Mio and Mayu Amakura from Fatal Frame II: Crimson Butterfly. Publisher: Tecmo.
The twins epitomize the virginal videogame protagonist while also intensifying the emotional experience of this survival horror title because of their vulnerability.

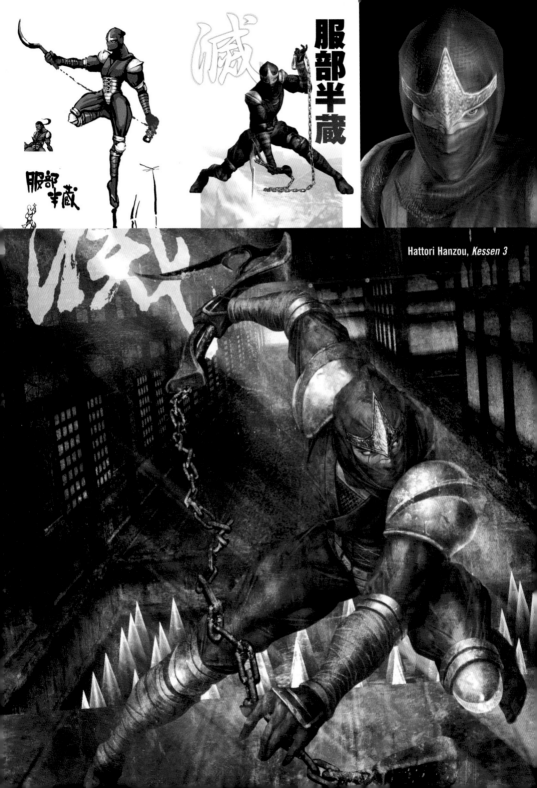

服部半蔵

滅

Hattori Hanzou, *Kessen 3*

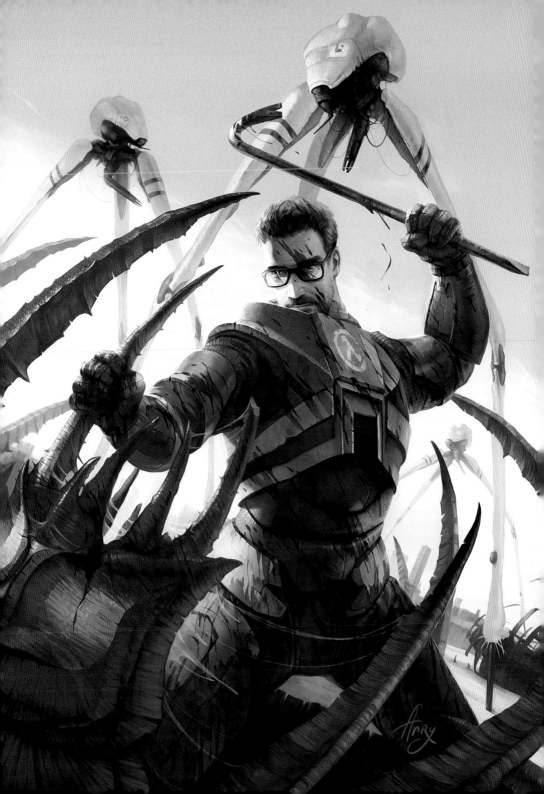

the game with regard to the character's physical appearance. By allowing the player to change his character's physique, clothes, car, hairstyle, tattoos, and other physical attributes, the player feels an even greater sense of "ownership." In such cases, the game hero very much becomes an unconscious expression of the player's inner self. It is not surprising, then, that the "hero without a face" frequently makes annual lists of favorites, like the characters from the Grand Theft Auto series, ninjas from a wide range of titles, Raziel from the Soul Reaver series, or Master Chief from the Halo series.

A slight variation on this type is the common man who discovers, through the course of the game, that he is, in fact, special in some way. This is a more extreme version of the archetype decsribed above since it makes explicit the underlying concept that any individual might have a messiah inside him or her waiting to be revealed. In this respect, this more obvious form of everyman-as-hero shares a closer relationship to traditional themes of prophecy, since it also reveals more clearly the hand of fate at work in everyday lives. If the protagonist begins the game appearing to be just another member of his or her species, but is then shown to, in fact, have previously unrealized powers, it is clear he or she has been chosen by some higher force for a special task. The development of the hero's inner self, in such cases, is more and more frequently demonstrated and modeled by changes in the hero's exterior form

John Vattic from Second Sight. Publisher: Codemasters. *Another excellent example of the "everyman" protagonist, John Vattic is a normal MIT brain and cognitive scientist who wakes up in a strange facility and discovers he has been blessed with psychic powers. The quest for identity is a common theme with such characters.*

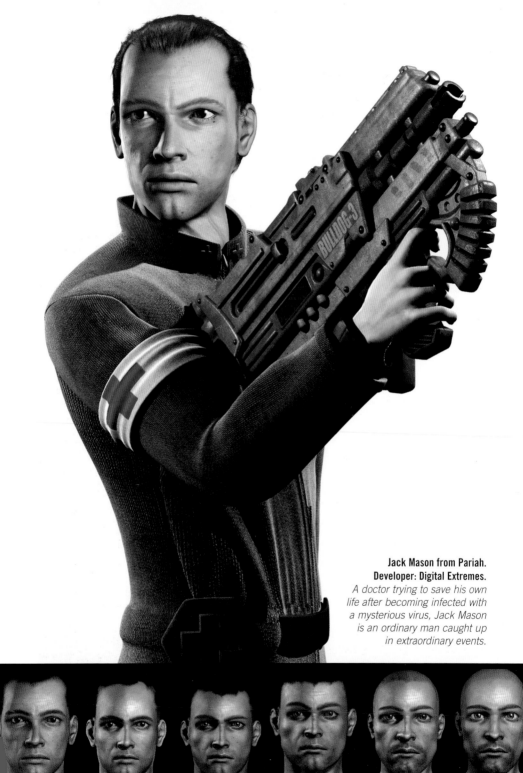

**Jack Mason from Pariah.
Developer: Digital Extremes.**
*A doctor trying to save his own
life after becoming infected with
a mysterious virus, Jack Mason
is an ordinary man caught up
in extraordinary events.*

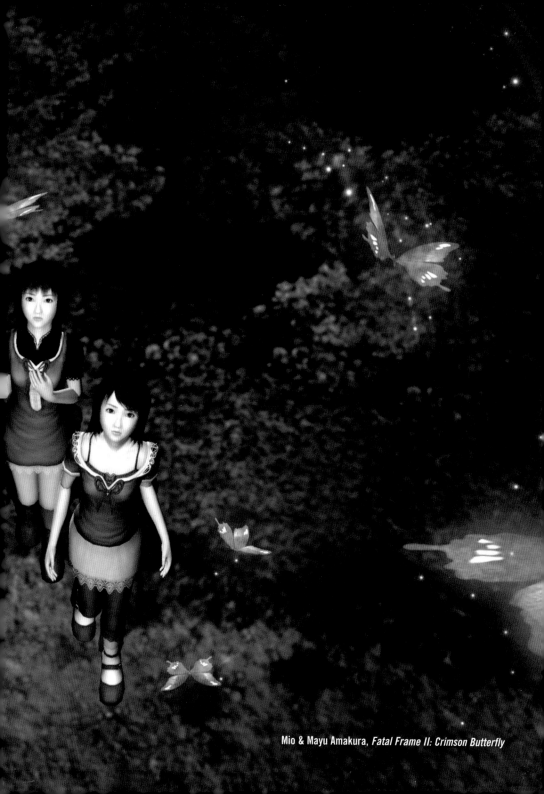

Mio & Mayu Amakura, *Fatal Frame II: Crimson Butterfly*

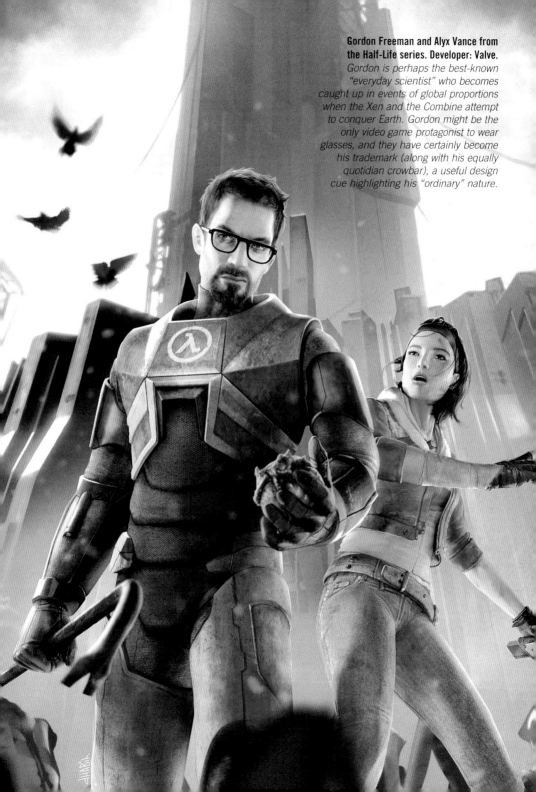

Gordon Freeman and Alyx Vance from the Half-Life series. Developer: Valve.
Gordon is perhaps the best-known "everyday scientist" who becomes caught up in events of global proportions when the Xen and the Combine attempt to conquer Earth. Gordon might be the only video game protagonist to wear glasses, and they have certainly become his trademark (along with his equally quotidian crowbar), a useful design cue highlighting his "ordinary" nature.

through the course of the game. Such indications of the character's increasing abilities began in games by allowing the main character to acquire more and more impressive-looking costumes, armor, or weapons, and such acquisitions are still important drivers in generating continuing interest in a game as it progresses. But again, as technology allowed more and more detail to be included in a character, as well as changes to that character's appearance through the course of the game, developers have done an outstanding job of altering the main character's appearance to indicate not just that character's growing power, but his or her moral choices as well. In the successful titles "Fable" or "Knights of the Old Republic," for example, the protagonists begin the game looking completely ordinary but may grow horns or acquire glowing eyes if they make evil choices on their path to power, or white hair and an angelic glow if they make good choices. Characters that follow this more explicit, traditional mythological model of "everyman-turned-messiah" (versus the "everyman") are common enough within role-playing games to be almost their own subgenre (as demonstrated by the main characters from all the Final Fantasy titles), but they are also frequently seen across genres, like the stars of the earlier Oddworld platforming titles or Kratos from the action-adventure title "God of War."

The everyman protagonist takes on some of his or her most interesting dimensions, however, in the video game version of the legend (as distinct

Kate Walker from the Syberia series. Developer: Microids. *Walker is one of the earliest "everywoman" characters in video games. A character rendering of this quality might be the result of many detailed sketches and paintings that are then sculpted by hand into a 3-D bust. The bust is then scanned to digitize its dimensions, and computer graphics artists will design the texture and color of the skin, eyes, hair, etc. to make the character as lifelike as possible.*

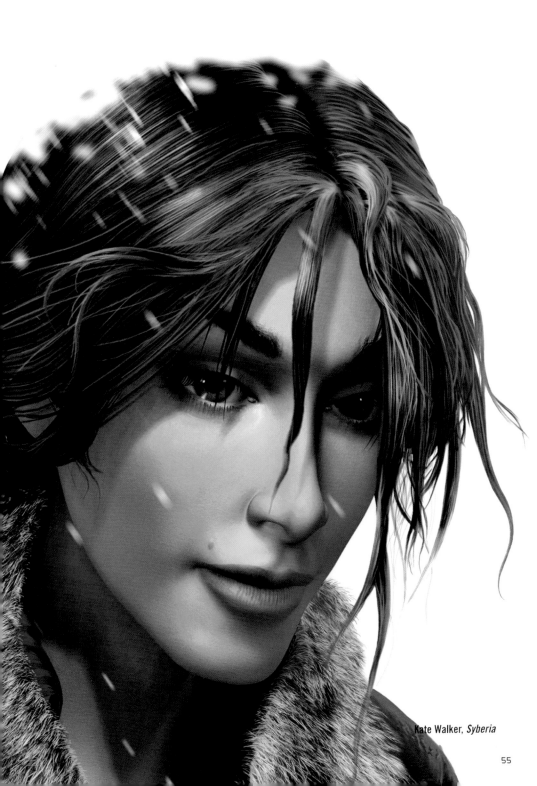

Kate Walker, *Syberia*

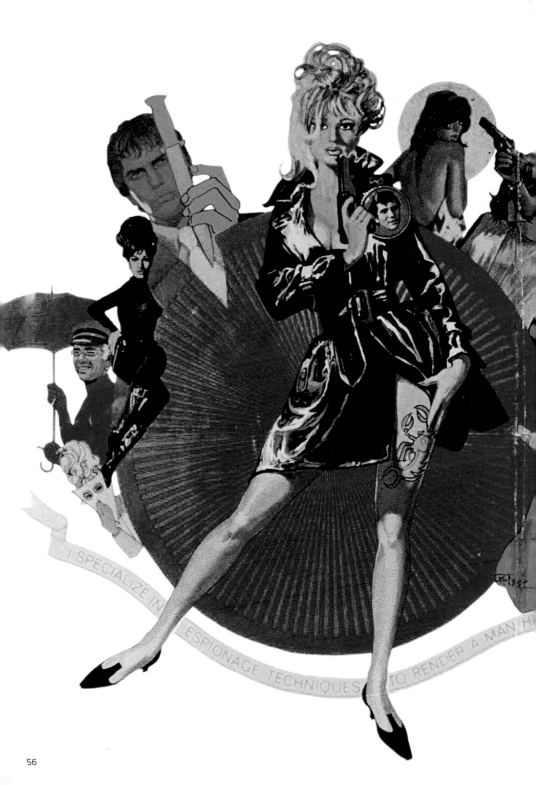

I SPECIALIZE IN ESPIONAGE TECHNIQUES TO RENDER A MAN H

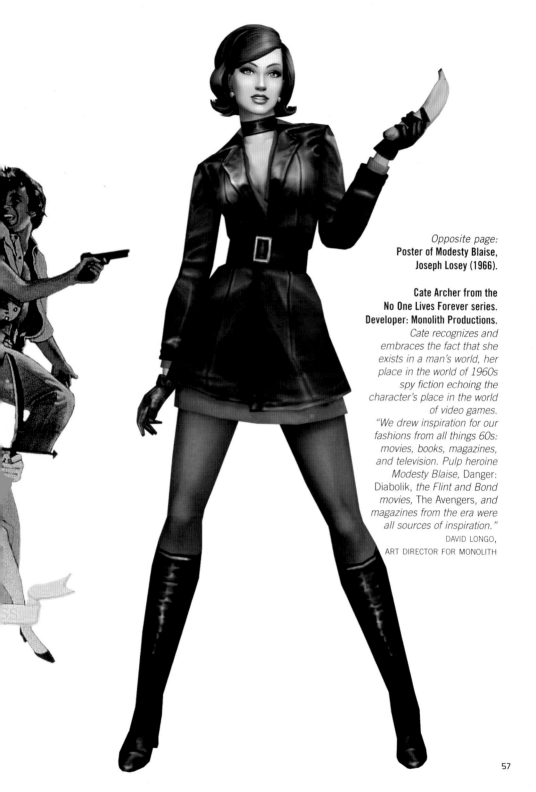

**Cate Archer from the
No One Lives Forever series.
Developer: Monolith Productions.**
*Cate recognizes and
embraces the fact that she
exists in a man's world, her
place in the world of 1960s
spy fiction echoing the
character's place in the world
of video games.*
"We drew inspiration for our
fashions from all things 60s:
movies, books, magazines,
and television. Pulp heroine
Modesty Blaise, Danger:
Diabolik, *the Flint and Bond
movies,* The Avengers, *and
magazines from the era were
all sources of inspiration.*"
DAVID LONGO,
ART DIRECTOR FOR MONOLITH

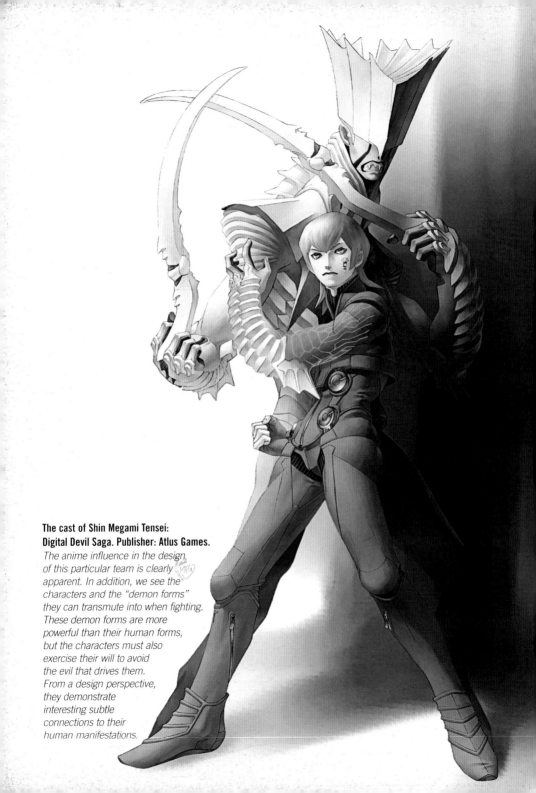

The cast of Shin Megami Tensei: Digital Devil Saga. Publisher: Atlus Games.

The anime influence in the design of this particular team is clearly apparent. In addition, we see the characters and the "demon forms" they can transmute into when fighting. These demon forms are more powerful than their human forms, but the characters must also exercise their will to avoid the evil that drives them. From a design perspective, they demonstrate interesting subtle connections to their human manifestations.

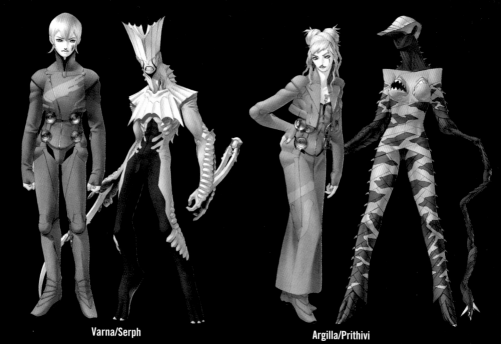

Varna/Serph

Argilla/Prithivi

"You'll understand this once you play the game, but the demon forms are the main characters' true natures and represent their fates. So I wanted to show that this is a game where you change into a demon to fight. Since the demon transformation in the game is similar to downloading a program, this picture of Serph (left) shows the "rewriting of his program code.""

KAZUMA KANEKO, LEAD DESIGNER

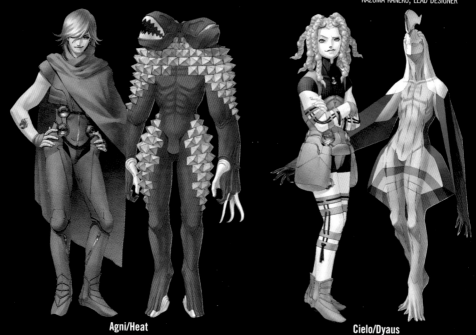

Agni/Heat

Cielo/Dyaus

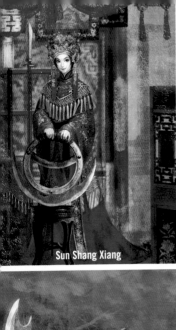

Sun Shang Xiang

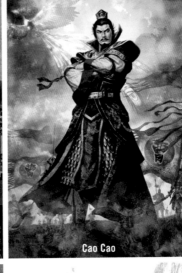

Cao Cao

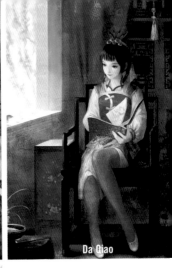

Da Qiao

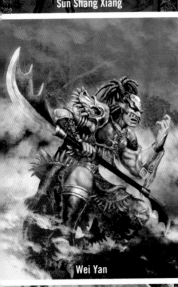

Wei Yan

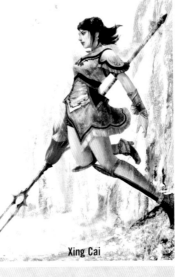

Xing Cai

Zuo Ci

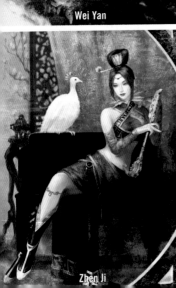

Zhen Ji

Yuan Shao

Jiang Wei

from myth, because historical people or events are the focus of legend). Here, the player actually controls real people who have been mapped into digital form. Typically, in sports simulations where the talents and skills of real athletes are emulated by the game, the player is actually allowed to become another living person who has, for whatever reason, been deemed to have the requisite legendary status. While it is true that many myths are understood to have been based on real people and, since the advent of mass media, we are used to reading about the exploits of legendary figures (whether warriors in the nineteenth century or sports heroes today), it is through games that legend, like myth, achieves its apotheosis. In games, once again because they are interactive, we are allowed to actually inhabit the skin of legendary figures, to take on their talents and abilities and use them as if they were our own, and this ability allows games to become the ultimate manifestation of our need and desire for hero worship. Taken to its furthest extreme, players are even allowed to become a legendary version of themselves in the most sold game of all time, "The Sims." In these cases, the design of such characters is deemed to be a success based on how "realistic" the player feels the imitation of reality to be—does his pitcher throws exactly like Pedro Martinez? Does his Sim act like a real banker? And designers make choices in creating this illusion of reality. When a face cannot be modeled exactly, due to the limitations of technology, some features, such as the person's eyes, are obviously chosen as more important and requiring more detail at the expense of other, less important, features. And even when a face or a motion can be modeled almost exactly—as is becoming the norm today—designers still "tweak" their imitations so they seem even more real than reality, exaggerating certain signature motions of famous players and subduing others.

Opposite page:
Cao Cao and others from the Dynasty Warriors series. Publisher: Koei.
Based on the ancient Chinese legends of the Warring States period, this popular series is a Peking Opera brought to life in the gaming medium. Like the operas themselves, the series features a broad ensemble of familiar legendary characters, as well as acrobatic gameplay reminiscent of the older and more established form. Again, games like these make much more apparent the connection between this new medium and classical myth and legend.

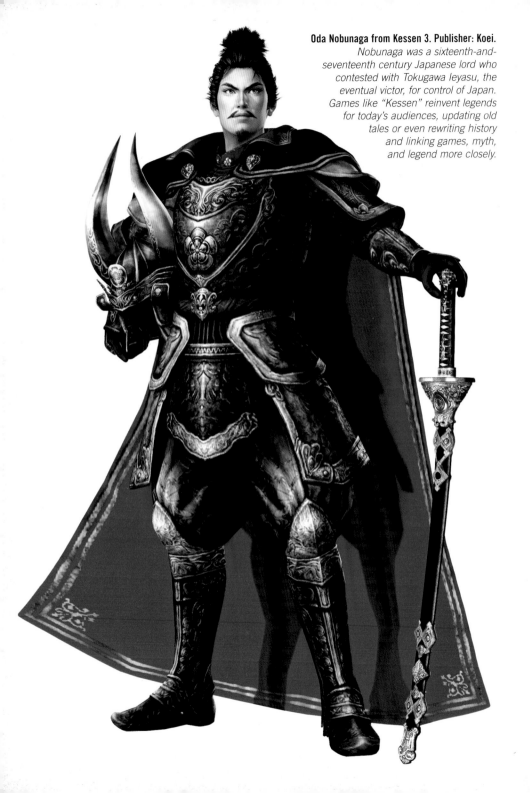

Oda Nobunaga from Kessen 3. Publisher: Koei.
Nobunaga was a sixteenth-and-seventeenth century Japanese lord who contested with Tokugawa Ieyasu, the eventual victor, for control of Japan. Games like "Kessen" reinvent legends for today's audiences, updating old tales or even rewriting history and linking games, myth, and legend more closely.

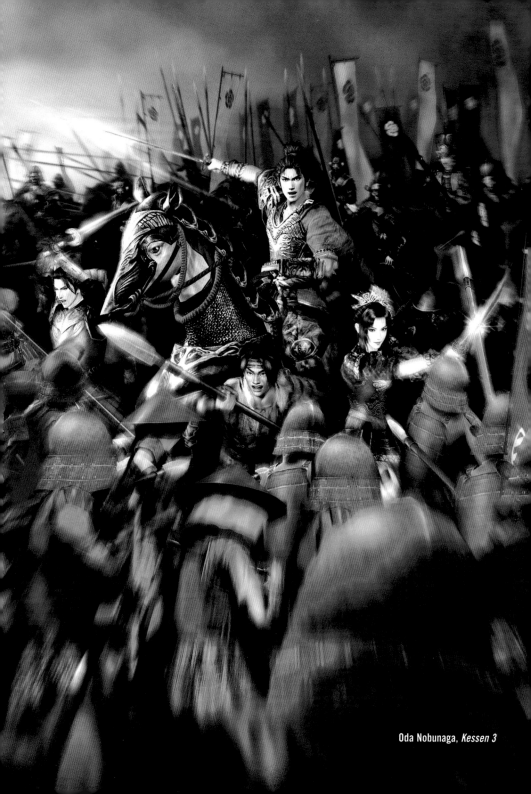

Oda Nobunaga, *Kessen 3*

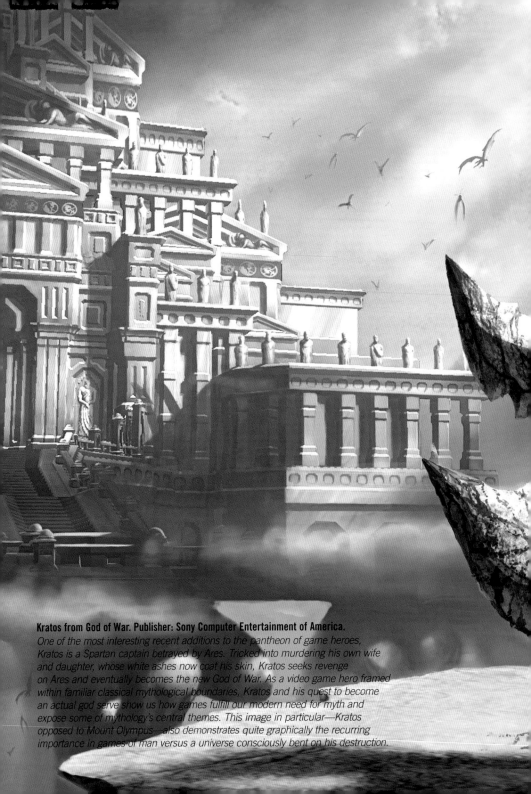

Kratos from God of War. Publisher: Sony Computer Entertainment of America.
One of the most interesting recent additions to the pantheon of game heroes,
Kratos is a Spartan captain betrayed by Ares. Tricked into murdering his own wife
and daughter, whose white ashes now coat his skin, Kratos seeks revenge
on Ares and eventually becomes the new God of War. As a video game hero framed
within familiar classical mythological boundaries, Kratos and his quest to become
an actual god serve show us how games fulfill our modern need for myth and
expose some of mythology's central themes. This image in particular—Kratos
opposed to Mount Olympus—also demonstrates quite graphically the recurring
importance in games of man versus a universe consciously bent on his destruction.

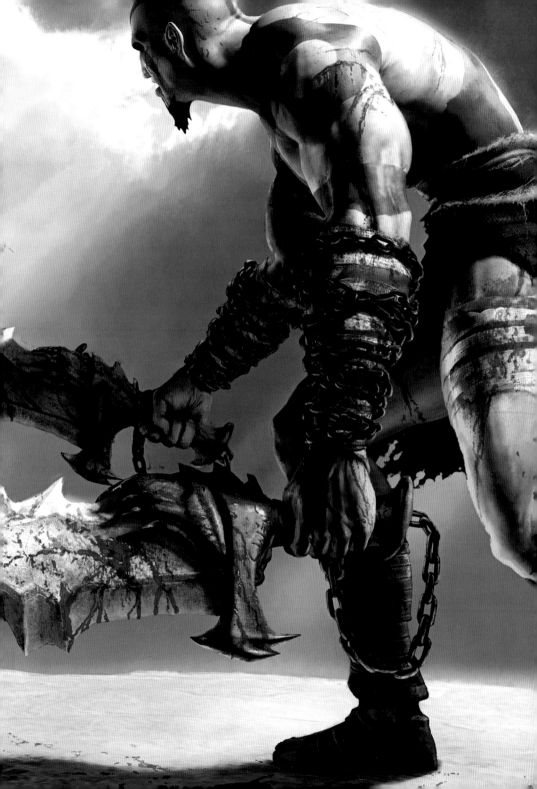

Abe, *Oddworld*

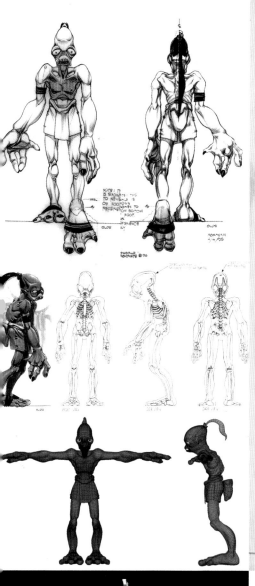

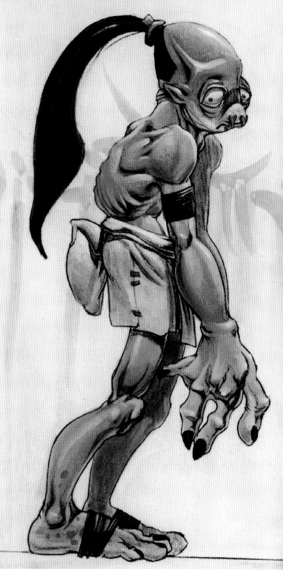

Abe from the Oddworld series.
Developer: Oddworld Inhabitants.

Perhaps the best example of "odd" proving to be, in fact, "special." These development images of Abe show the remarkable amount of background work that goes into making an imaginary creature like Abe seem to be a living, breathing individual from a plausible, if alien, species. Abe—and other characters in the Oddworld series—are based not simply on sketches of different poses, but also on studies of how his skeleton and musculature might function, computer blocking studies that allow animators to refine his motion, and so on.

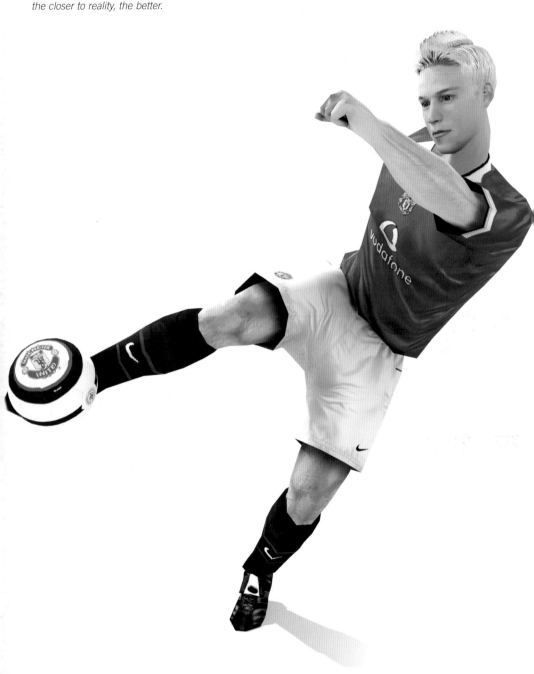

Henry, Pires, Viera, Campbell, and Smith—Arsenal Players from the Club Football series. Publisher: Codemasters.

For true sports simulations (as opposed to more interpretative games like "Tony Hawk's Underground"), the closer to reality, the better.

As may be expected, then, given the way games naturally lend themselves to the mythic form and the way the mythic form in turn lends itself so strongly to everyman protagonists, it is hardly surprising that perhaps the largest number of game protagonists fall into this category. It is surprising, however, that what may be the next largest category of archetypical protagonists in games has almost no analogy in classical myth and legend: evil acting as good. When we look at the myths created before 1950, heroes might have had personal flaws, but they tended to be inherently good people performing good deeds. In modern myths such as Clint Eastwood Westerns, we begin to see characters of questionable moral character performing good deeds for the purpose of narrative. This type of character is taken to its most extreme in the video game. Here, this common protagonist includes the likes of demons, vampires, drug dealers, or hit men drawn into narratives that require them to act in ways that go against their ancestry or backstory, and who, thereby, become the hero of the game. Such protagonists are not even antiheros in the traditional sense, as they usually possess all the common traits of heroes—courage, intelligence, skill, etc.

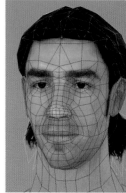

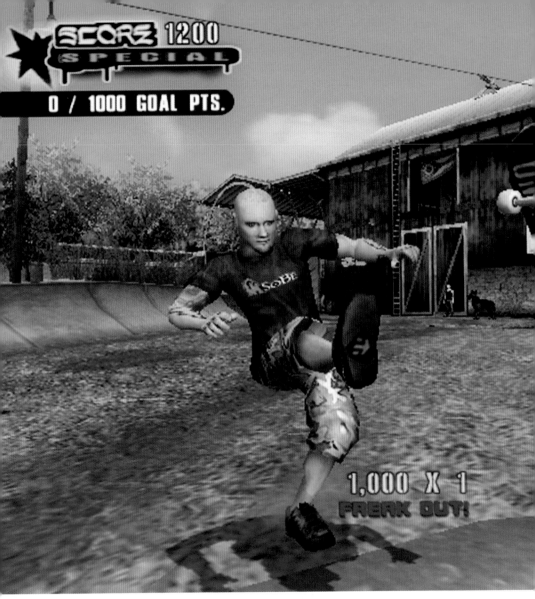

SCORE 1200
SPECIAL

0 / 1000 GOAL PTS.

1,000 X 1
FREAK OUT!

Mike Vallely, Tony Hawk, and Benjamin Franklin from Tony Hawk's Underground 2.
Publisher: Activision.
Games like the THUG series allow a reinvention and reinterpretation
of legendary figures, creating the kinds of postmodern juxtapositions
we have come to expect from art today and, in this case, also making
a political statement about the relevance of the Founding Fathers
and what might be the most American of sports. Indeed, Franklin's
association with the skating subculture brings it from the periphery
of American culture to its center, while skating's association
with Franklin emphasizes the aspects of his character that many
skaters might consider admirable.

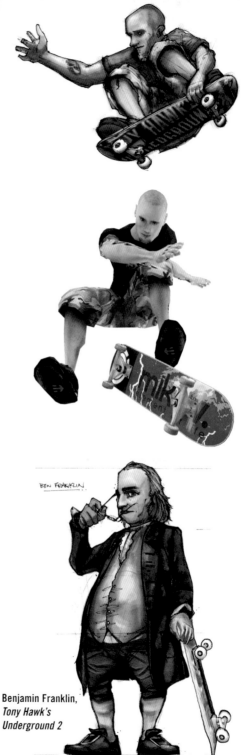

Mike Vallely,
Tony Hawk's Underground 2

Ben Franklin

Tony Hawk,
Tony Hawk's Underground 2

Benjamin Franklin,
*Tony Hawk's
Underground 2*

Clint Eastwood in For a Few Dollars More, Sergio Leone (1965).

Instead, they are simply of evil heritage or nature but still acting for good: still "heroes" in the true sense of the word. Nor are they taking part in some kind of redemption narrative, since they are most often still serving their own ends rather than seeking some kind of forgiveness for their previous actions.

Such characters often draw upon specific design tropes inherited from their country of origin. For example, these characters originating in Japan, where white is the color of death, often have white hair and pale skin, while characters like this designed in America frequently have overshadowed eyes and downward tilting heads like so many Hollywood villains. Some of the most intriguing design choices for these characters are universal—for example, the trench coat, with its "Goth" associations, makes a frequent appearance as the garment of choice. Such characters are usually human, as if only humans were capable of making the choices between good and evil necessary for this character's function. The

idea that we are so compelled by characters who have exchanged their "black hats" for "white" ones is fascinating in terms of understanding modern culture. It has often been remarked that the advent of modern media has destroyed the idea of the hero, that we are no longer capable of seeing only the good in public figures because everything about their lives is recorded and revealed. Perhaps this new mythic archetype in games is a reflection of this, in that players might believe the hero to be that much more realistic if he or she begins the game with a troubled, or even evil, past. Or perhaps it is simply that these characters allow us to play out our darker fantasies while still operating within moral or ethical norms. If this is the case, it might explain why such characters are not common in traditional mythology since, even before Christianity, myths supported specific ethical codes that required black and white perceptions of good and evil. The possibility that we sometimes simply want to play out our darkest fantasies is supported, in fact, by the growing

The Stranger from Oddworld: Stranger's Wrath. Developer: Oddworld Inhabitants.
The Man With No Name takes on a whole new persona…and species.

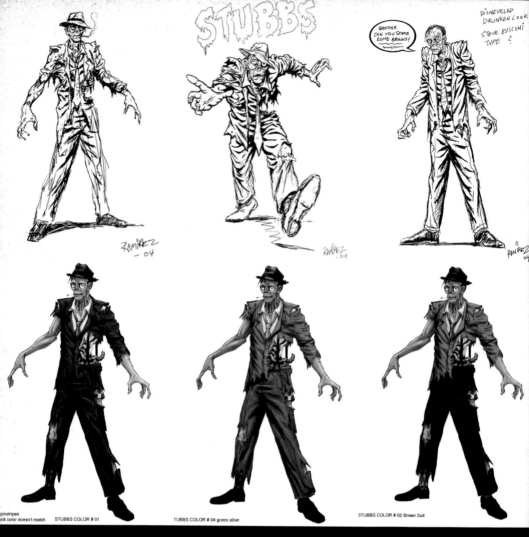

STUBBS

BROTHER CAN YOU SPARE SOME BRAINS!

DISHEVELED DRUNKEN LOOK STEVE BUSCEMI TYPE?

RAMIREZ -04

RAMIREZ -04

RAMIREZ 04

t pinstripes
sock color doesn't match STUBBS COLOR # 01

TUBBS COLOR # 04 green olive

STUBBS COLOR # 02 Brown Suit

**Stubbs from Stubbs the Zombie.
Developer: Wide Load Games.**
*Stubbs offers a nice study
in a main character's
conceptual development,
highlighting many of the
concerns that arise—from
such major issues as the
character's playability to
more subtle issues like
what color scheme best
suits his character.*

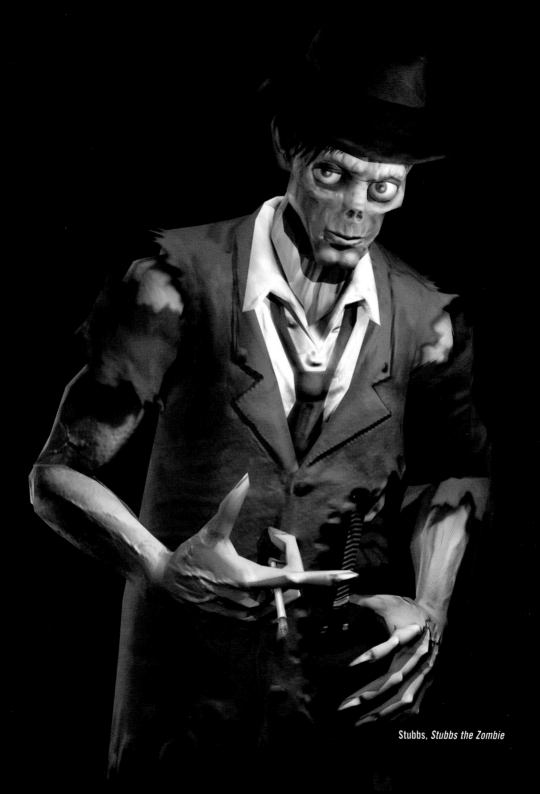

Stubbs, *Stubbs the Zombie*

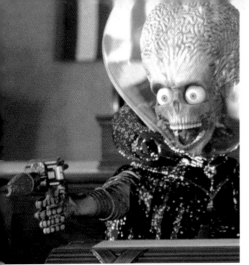

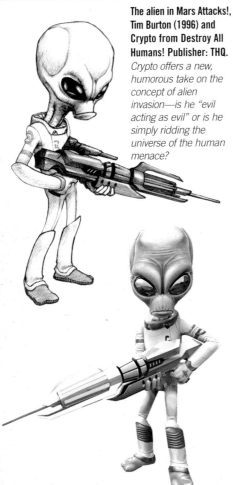

The alien in Mars Attacks!, Tim Burton (1996) and Crypto from Destroy All Humans! Publisher: THQ.
Crypto offers a new, humorous take on the concept of alien invasion—is he "evil acting as evil" or is he simply ridding the universe of the human menace?

trend in games for the dark "hero" to no longer pursue what would typically be seen as morally acceptable goals. In the past few years, we have seen several games where the player is no longer a criminal turned vigilante, like Mark Hammond in "The Getaway," or a half-demon turned demon-slayer like Dante in "Devil May Cry," but simply an evil character pursuing evil goals like Tommy Vercetti in "GTA Vice City." What is particularly interesting is the power these characters have beyond their game universes. There are many uninteresting game protagonists that have become famous because they were at the center of a great game, but with this evil-as-good archetype, the reverse is often true: an interesting character has become well-known in spite of being at the heart of a mediocre, or even poor, game. As games continue to develop, this archetype will be a critical one to watch, since it is almost unique to the game medium. It may also reveal a great deal about the nature of what makes a protagonist appealing, not just in games but in all narratives forms, as well as some of the different purposes myth serves today versus in antiquity.

Another archetype we might not expect to be quite so popular is the American soldier. Whether portrayed in

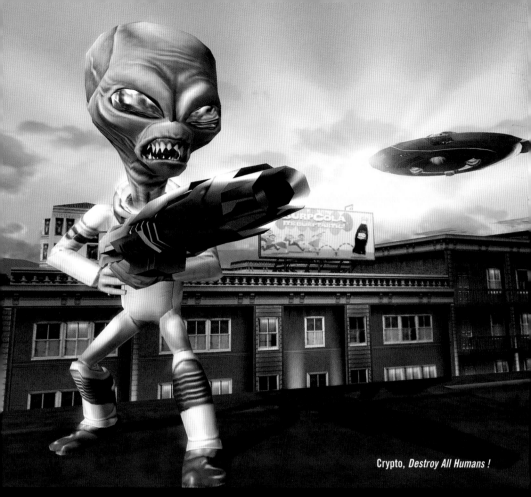

Crypto, *Destroy All Humans !*

What specific 1950s resources did you draw upon for the design of the game?
"*Old sci-fi movies, Norman Rockwell paintings, Hitchcock films, and anything else we could get our hands on that gave us insight into 1950s Americana. Our approach was to make all of Crypto's weapons, vehicles, and gadgets feel like they were consistent with the Furon universe then set this into our recreation of 1950s America. We did reference the 1950s sci-fi movies for Crypto's weapons, but we needed to add contemporary elements to bring about the final look of their design.*"

What were some concepts for the look of the main character that were discarded?
"*We steered away from the 'guy in a costume' type of alien, which was the staple of B-movies of the 1950s and started with a more modern depiction, more akin to* Communion *and* Mars Attacks! *There were only few slight variations of his design, but Crypto has remained virtually the same from the beginning. We did have a version of Crypto with an extremely large mouth, but it didn't seem garner much support and it was dropped.*"

Evil, Good, and Neutral cow gods from Black and White 2. Developer: Lionhead Studios.

The innovative Black and White series takes the mythological basis of many games to its logical conclusion by allowing gamers to actually play the role of a god with an earthly animal avatar that can enforce their will. Again, the player's choice of avatar allows them to best express themselves as well—will they choose the lighthearted cow or the more serious wolf or lion avatars?

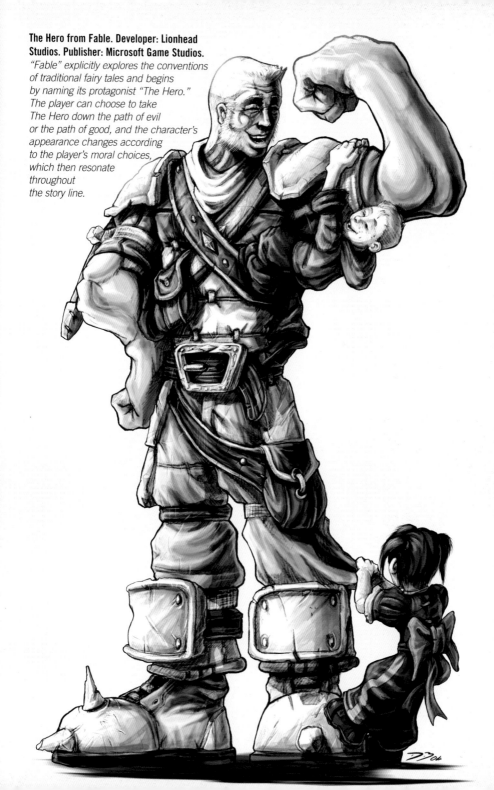

The Hero from Fable. Developer: Lionhead Studios. Publisher: Microsoft Game Studios.

"Fable" explicitly explores the conventions of traditional fairy tales and begins by naming its protagonist "The Hero." The player can choose to take The Hero down the path of evil or the path of good, and the character's appearance changes according to the player's moral choices, which then resonate throughout the story line.

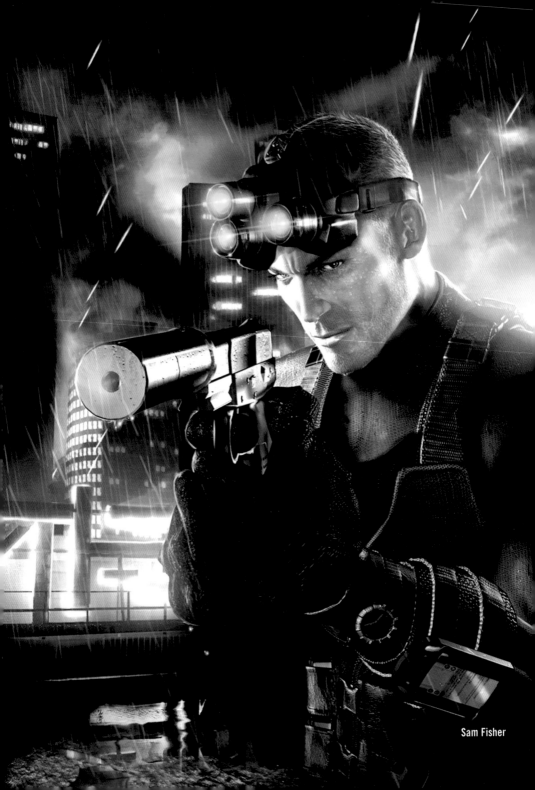

Sam Fisher

games developed in Asia, Europe, or the United States, this archetype continues, even in today's political climate, to be as popular—if not more so—as it was following World War II. While it is true there are some very popular titles like "Kessen" or "Age of Empires" that focus on warfare based in different cultures like shogunate Japan or ancient Rome, these titles are usually strategy games featuring entire armies and are almost always period-based. When it comes to focusing on a single individual taking part in modern warfare, the American soldier is, by far, the most popular. Not that he does not take on an interesting variety of forms—from the romanticized Japanese interpretations such as Solid and Liquid Snake in the Metal Gear Solid titles (based on Kurt Russell's Snake Plissken character in *Escape from New York*), to the "hyper-realistic" versions we see in games developed in the U.S. (like the various Tom Clancy titles), to the realistic version found in "Operation Flashpoint" (which is developed in the U.K. but is used to train actual U.S. soldiers), to the science-fictionalized vision of the future soldier we see depicted in "Halo's" Master Chief. There has even been a recent explosion of World War II titles that depict the American G.I. conquering the Axis in a variety of WWII theaters. What has proved particularly interesting about this frequently depicted type is that, anti-intuitively, the most compromised, the most human, personality is most often portrayed in games developed in the United States (such as the Tom Clancy games). The idea that countries openly opposed to U.S. foreign policy on both a governmental and a societal level are not just comfortable with, but are attracted to, the idea of mythologizing the American solider as the omnipresent deliverer of justice is a fascinating one. In this case, it might be the very fact that games are not taken seriously as a form of expression that allows this charged political statement to express itself free from criticism.

Sam Fisher, the ideal of the revisionist American soldier, in a game published by Ubisoft.

**The Commando Squad from the Commandos series.
Publisher: Eidos.**

*The Commandos offer an excellent example
of a team protagonist. The Commando himself is
still the central character, but each member of
the team offers something different to the
gameplay, and it is only as a group that they can
succeed. In addition, each character has his
own backstory, nationality, and so on—from the
Irish Commando, to the British Sapper, to the
French Spy, to the Australian Diver, to the
American Driver.*

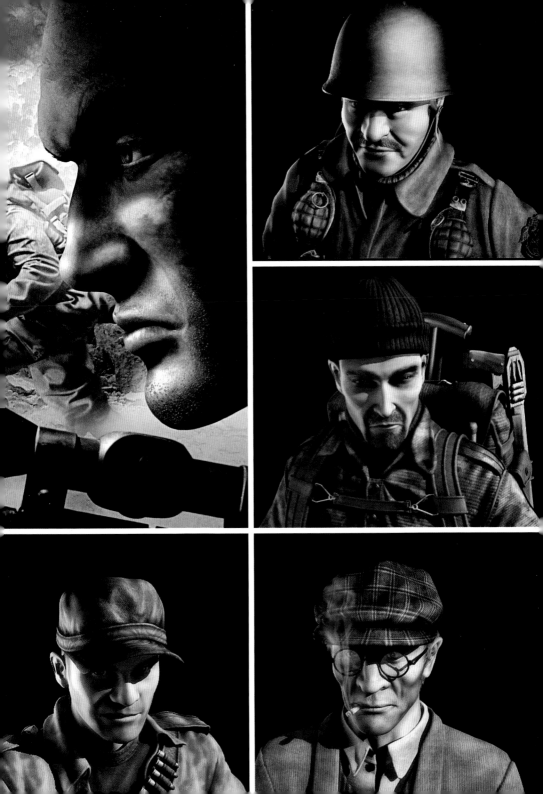

This possibility is certainly the case with a fourth important archetype: the fetishized female as protagonist. The best-known character within this archetypical class is, of course, "Tomb Raider's" Lara Croft, but she was not the first of this type, nor is she, by any means, the only example. This woman of "ideal" physique is most common, interestingly enough, in head-to-head fighting games. In this genre, certain titles, such as "DOA," have in fact become famous for their sexy characters and have done calendars and even spin-off beach volleyball games using only the female characters from the original title. But this archetype is certainly apparent across the board in other titles, and there are few games that do not include a fetishized female form, even if only in a supporting role. In some ways, this archetype is the least interesting from a cultural perspective because it almost certainly does owe its origins to its appeal to the pubescent sexuality of teenage boys. The design influence of the modern comic book superheroine, in turn derived from the pinup girl of the 1940s and 1950s, is equally obvious and is perhaps most clearly demonstrated by the fact that many of these characters end up in their own comic books or calendars. But there are some interesting points to consider when we look more closely. First, almost all of these characters fit into either the virgin or the dominatrix character archetype. Unlike with film noir or many other "masculine fantasy" genres, the sexually aggressive femme fatale that we would expect to be most appealing to adolescent males is rarely present in games. Instead, fetishized female characters are either innocents blessed with impressive powers (like Yuna in "Final Fantasy X" and Ling Xiaoyu in "Tekken") or unapproachable, domineering, hardened adventurers

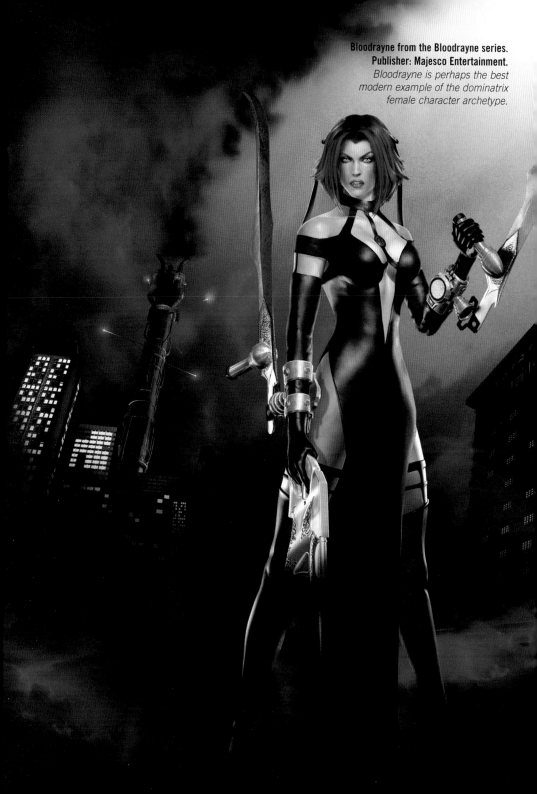

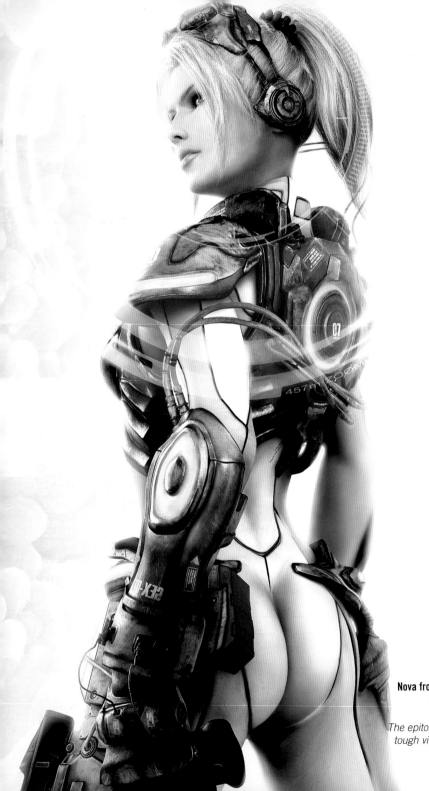

**Nova from Starcraft: Ghost.
Developer: Blizzard
Entertainment.**
*The epitome of the modern
tough videogame heroine.*

like Lulu and Nina Williams in the same titles respectively. The visual symbols of their status are always clear. Schoolgirl skirts, elaborate kimonos, simple white lace, and fresh, friendly faces, often with short hair, are just some of the common design elements of the innocent archetype, while tight leather or metal buckles, straps, arched eyebrows, and long nails and hair tell the player a female character is a force to be reckoned with. Such a drastic division into two such essentially asexual types for female protagonists may have occurred because, as we have seen, identification with a game's protagonist is so close, so intimate, the idea of a female protagonist who is overtly sexual in behavior, not just in appearance, might create some difficulties for male players. If this is the case, however, it must then make us wonder how much of the fascination with this archetype is based on players consciously fantasizing about them, and how much is based on players unconsciously fantasizing about *being* them. As time progresses, this archetype may prove very interesting. Will we learn more from games about the unconscious connection between fantasizing about manipulating the opposite sex and wanting to *be* the opposite sex? As far-fetched as this sounds, one only need look at the enormous number of men who anonymously choose to play female characters instead of male ones in Massively Multiplayer Online games to realize there is something deeper going on with the fetishized female than simply appealing visually to teenage boys. With more than 85 percent of female characters in such games registered to men, and these games simultaneously providing the most clear-cut example of our desire to *become* the characters in games, we are forced to look more closely at the fetishized female

KOS-MOS from Xenosaga II. Publisher: Namco.
An android designed specifically to fight an invading alien menace, KOS-MOS also embodies many of the elements of the tough female protagonist.

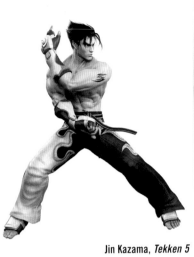

Jin Kazama, *Tekken 5*

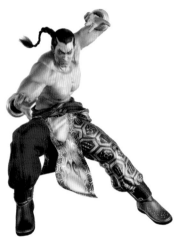

Feng Wei, *Tekken 5*

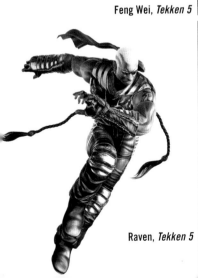

Raven, *Tekken 5*

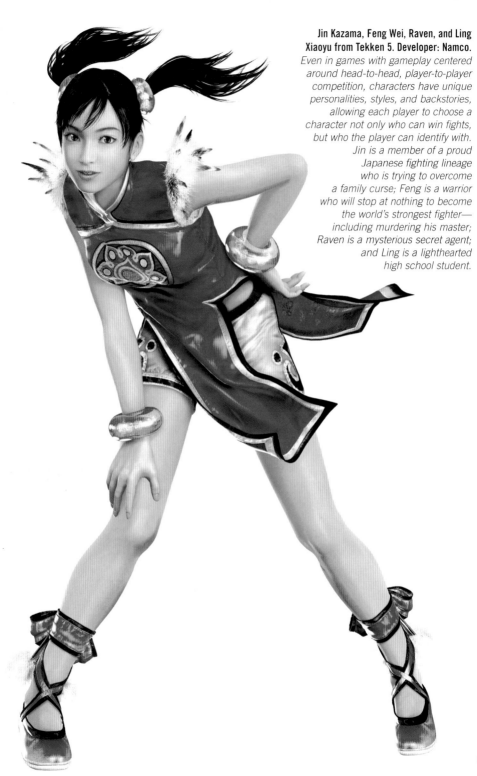

Jin Kazama, Feng Wei, Raven, and Ling Xiaoyu from Tekken 5. Developer: Namco.
Even in games with gameplay centered around head-to-head, player-to-player competition, characters have unique personalities, styles, and backstories, allowing each player to choose a character not only who can win fights, but who the player can identify with. Jin is a member of a proud Japanese fighting lineage who is trying to overcome a family curse; Feng is a warrior who will stop at nothing to become the world's strongest fighter— including murdering his master; Raven is a mysterious secret agent; and Ling is a lighthearted high school student.

Ryu & Ken, *Streetfighter*

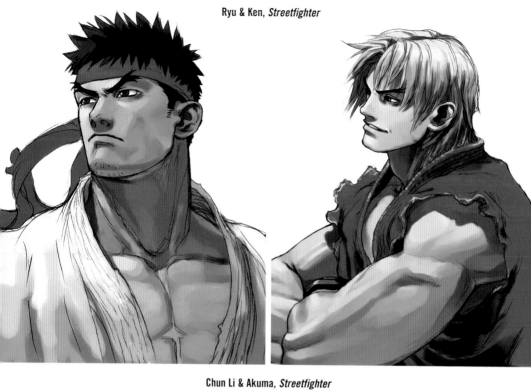

Chun Li & Akuma, *Streetfighter*

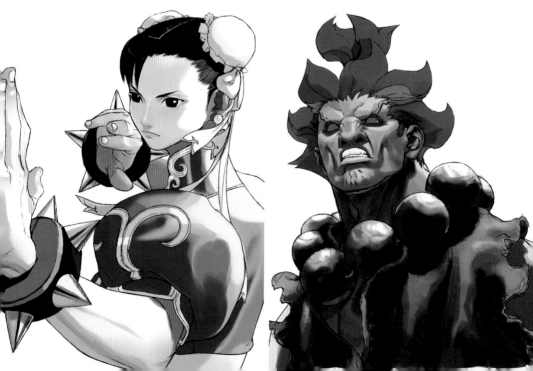

than we might otherwise—perhaps even re-examining her historical place in comics as well. In many ways, then, this archetype, which appears on the surface to be one of the most obvious in its origins, may prove to be one of the most complex and least understood archetypes in gaming.

The archetypes discussed above constitute the vast majority of all protagonists in games, but there are, of course, many other fascinating types that could be further explored. For example, the protagonist as a team of complementary individuals deserves some attention. In this case, the principal focus of the story is shared between characters who can only achieve their ultimate goals through cooperation. Games like the "Final Fantasy," "Xenosaga," "Dragonquest," and other popular series are typically structured so that the individuals each possess specific talents or skills that will be required at specific times but none of which, independently, would be sufficient to complete the tasks set before them. In addition, the narrative of such games is usually built around learning about each character's backstory, while interpersonal relationships also often evolve within the group during the course of the game. This "team protagonist" is interesting because it emphasizes the individual as part of a greater whole. Thus, in some ways, the "team protagonist" is the least Western and least mythologically formulaic, because without the rest of the group, the individual is incapable of achieving anything at all. Interestingly enough, these ensemble-based games were made

The cast from the Streetfighter series. Publisher: Capcom.
Even such well-established characters as those from "Streetfighter" undergo a continual process of evolution to ensure that their design does not become dated. Here we see some of the series' familiar characters in their recent renditions, which show more up-to-date hairstyles, physiques, and other details that do not echo the game's 1980s origins.

Following pages:
Sasha Nein, Coach Morceau Oleander, Raz, and Milla Vodello from Psychonauts. Publisher: Majesco Entertainment.

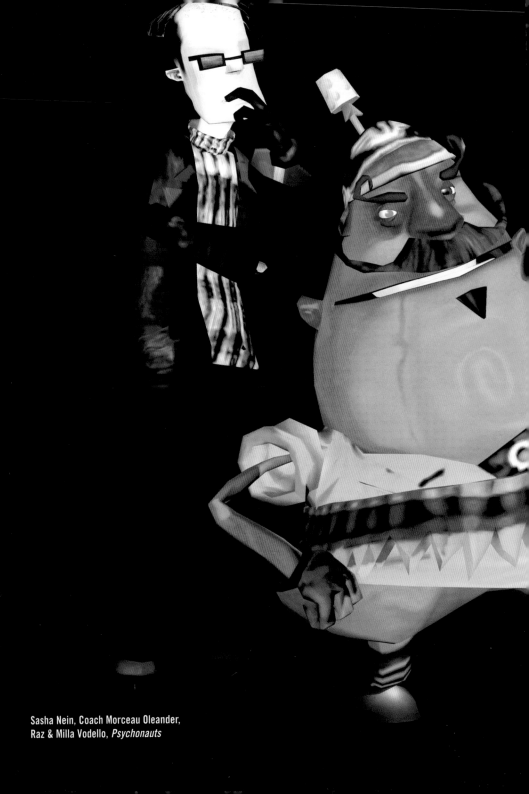

Sasha Nein, Coach Morceau Oleander,
Raz & Milla Vodello, *Psychonauts*

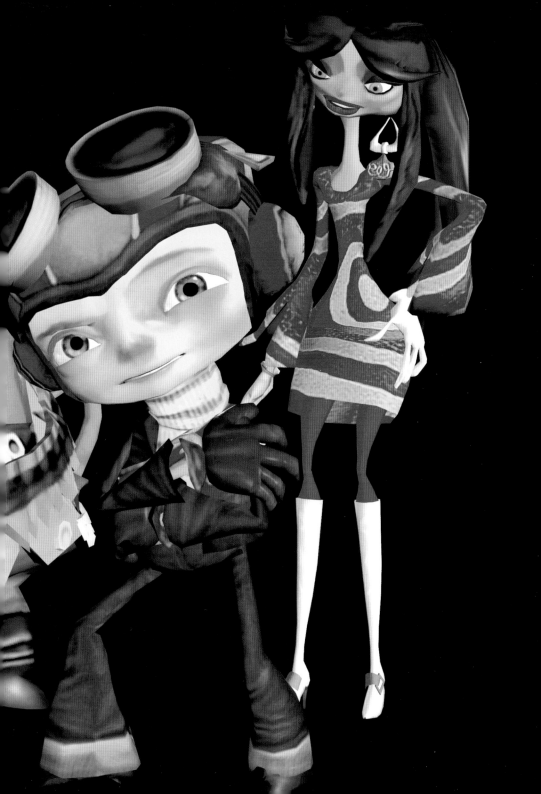

popular by Asian developers like SquareEnix, and it is in Asia, where the audience can relate them to popular folktales of heroic teams, that they continue to be even more popular than they have become in the West.

With the number of game genres growing every day, often with their own archetypical protagonists as their focus, it also seems reasonable to assume there will be no shortage of new personifications in need of classification and analysis, each with its own lessons to teach us about mythology and art. But beyond the simple introduction every year of new mythological archetypes, the affinity of the game format for central protagonists has worked in conjunction with its global appeal to produce many other interesting cultural by-products. For example, a cross-fertilization of mythologies via games has occurred on a massive scale in the past ten to twenty years. Almost all game development takes place in Japan or the United States, but games are distributed all over the world, and gamers everywhere are becoming as familiar with Japanese and American mythology as they may have been with their own—perhaps even more familiar. Ask an Australian or French gamer today what a Japanese demon slayer looks like and you will receive a fairly accurate answer. The same holds true for his or her Japanese counterpart regarding American sports stars.

Having said all this, while the suitability of the game format for creating mythic archetypes may be the primary unconscious force at work in the creation of game protagonists, there are, of course,

Below:
Ratchet and Clank from the Ratchet and Clank series. Developer: Insomniac. Publisher: Sony Computer Entertainment America.

Opposite page:
Various characters from Lego Star Wars. Publisher: Eidos.
Perhaps the ultimate postmodern game, "Lego Star Wars" mixes a toy, a film, and a role-playing video game into one single property.

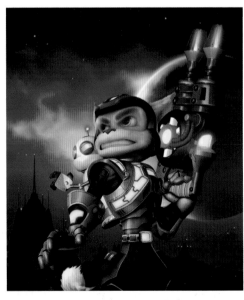

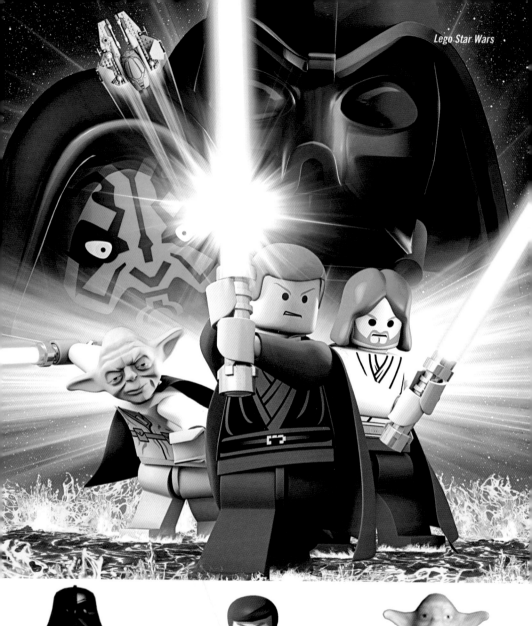

Lego Star Wars

Some of the worms from Worms 4. Publisher: Codemasters.
Again, a game that mixes pop culture references into its own design.

many conscious and more practical motivations. To begin with, all game protagonists must meet certain requirements of playability. This may mean they have, for example, greater physical than mental prowess (it is easier to create a game about outrunning opponents than outthinking them) or have external characteristics dictated by the fashion standards of the decade. However, much like the more common classical mythological archetypes, these factors are somewhat more obvious, and thus of somewhat less immediate importance.

In fact, as mentioned in the introduction to this work, so little has been written about the medium that many questions still need to be asked about game protagonists. For example, a close analysis of which characters have failed and which have succeeded, as well as an exploration of the possible reasons behind those successes and failures, would be highly worthwhile and sometimes surprising. A "worm in a

spacesuit" is an accurate description of one game protagonist from the 1990s, but from this description alone, one would not necessarily assume that Earthworm Jim was among the most popular characters of that decade. Instead, many humorous and original elements of his design and execution—like his brilliantly executed expressions or his ability to swing from his own body—brought him to life in a way that transcended his simple description and allowed him and his game to become pop culture icons. Pursuing further examples like this and reaching a better understanding of what makes a successful game character may give us insight into what makes certain fictional characters compelling in general. Another interesting topic, in this case worthy of further speculation if not analysis, would be how the game protagonist might change as technological outsourcing pushes more and more elements of game development

The Prince from Katamari Damacy. Publisher: Namco.
The elegant and simple design of this character evokes modern electronica album-cover art. Creating a truly unique and original look for this title, it defines its own graphic style rather than attempting to imitate reality or previously established forms.

outside the G7 nations. What might a game derived from the mythology of India or Eastern Europe or Africa look like, and what would the persona of the protagonist be?

It should be clear by now that the characters at the heart of today's video games deserve to be taken seriously as important contributions to global art, narrative, and culture. Their genesis and execution is too complex and too considered, their reach and impact too great, for them to be taken otherwise. It is time we accorded the game protagonist his or her place as the natural ancestor and logical inheritor of the traditions founded by mythologies' earliest epics. Just as written fiction began with legend and moved into myth but eventually turned to imitations of reality, it is not inconceivable that we will see this development in games. What such a game might look like—a common man dealing with common problems rather than those of mythic proportions—is hard to say at this point, although "GTA San Andreas" and a handful of other titles offer some clues. But even though games continue to emphasize the mythic narratives for which they may be best suited, it can not be said they are any less about the central struggles of humanity than more traditional media. As such, we should begin to look more closely and consider more seriously their new archetypes. Because as mythic mirrors born from our unconscious, video games may teach us more about ourselves—about what we value, who we are, and what we desire—than we may care to realize.

Gitaroo-Man from Gitaroo-Man. Publisher: Koei.
Gitaroo-Man is a legendary intergalactic superhero embodied in a nerdy highschool student and who can fight evil aliens with the power of his Gitaroo. These images show how developers translate many of the design elements present in Japanese science fiction and horror films, anime, and children's cartoons into the game medium.

Gitaroo-Man, *Gitaroo-Man*

THE EVOLUTION OF NARRATIVE

The addition of narrative to video games is one clear way in which the latter reveal something fundamental about art that we might not have suspected otherwise: the desire for narrative, for story, is so strong, we like to see narratives even when we would be compelled without them. The earliest games demonstrated quite clearly that they could command a wide audience without any kind of attached narrative, and there are a large number of games today—even outside the sports and sim titles—that do not have strong narratives and are still highly successful. Yet narratives have become an important part of games (as evidenced by the large numbers of screenwriters and fiction writers starting to become involved in game development).

In some ways, this inclusion of narrative in games can be seen as analogous to the addition of narrative to music. Music began as an abstract medium, compelling without an attached narrative, but was still driven to evolve into new forms that included storytelling components such the first epic songs, the lay of the Middle Ages, or the relatively recent opera. The evolution of narrative in video games mirrors this quite closely, and game narratives continue to grow more complex as time passes. Because games are a visual medium and always have some kind of discrete protagonist, we tend to compare them with films rather than music, but if we compare the narratives and characters in games with their equivalents in narrative musical forms, we gain a

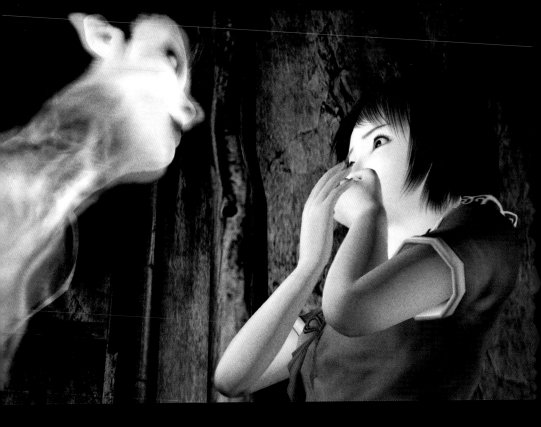

Above:
From Fatal Frame II: Crimson Butterfly. Publisher: Tecmo.

Opposite page:
From Alone in the Dark: The New Nightmare. Developer: Darkworks.
The Alone in the Dark series has always been known for its strong story lines reminiscent of Edgar Allen Poe or H. P. Lovecraft, and provides an excellent example of the potential of translating traditional narrative genres to the game medium.

clearer understanding of the way those characters and narratives function. Just as we do not expect original, realistic narratives in opera, but rather archetypes and tropes that are carried by the music, in games we should, perhaps, have similar expectations for narratives at this early stage in the medium's development. In fact, the real weight of our interest has been held for so long by the interactive experience games offer, it is not surprising that many game narratives still tend to be quite simple. Even as this book is going to press, this is changing, and some recent military and secret-agent simulation titles like the Tom Clancy ones have stories more complex and more carefully plotted than most books from the same genre. But even in these cases, game narratives still share the focus of their equivalents in music: they are principally concerned with myth and legend.

However, games do differ from music in one important way. There is nothing about music that suggests it is particularly suited to telling stories of epic archetypes. It is possible to imagine the operatic equivalent, for example, of an independent film. That is to say, we can imagine an opera that attempts to imitate reality in all of its most everyday aspects. But the same cannot be said to be true for games; their interactivity, their necessity for a central protagonist who must constantly overcome obstacles and enemies in an environment designed to challenge him or her, means that they are, indeed, well suited to the mythological form. A case might even be made that games are better suited to telling mythic tales of epic proportion than any other medium to date because of the inherent nature of their form.

As game audiences grow older, it will be interesting to see if a demand arises for more mature stories just as it has for more mature themes. Will we see the game equivalent of a realist novel or film at some point in the future? Given the innovative nature of the industry, this certainly seems possible, but for now, as we look at the content of games, and specifically their art and design, it is important to remember what themes they explore most frequently, how well suited the medium is to those themes, and why.

Darkwatch

level 1

level 2

level 3

level 4

level 5

level 2
ENVIRONMENTS

In much the same way that the very nature of video games creates a predilection for certain character archetypes, the same holds true for their environments. There may be multitudes of looks and designs, many different time periods and degrees of reality represented in games, but ultimately the game environment almost always serves not just as a backdrop or setting for events, but as an obstacle that must be overcome for events to progress.

It is true, certainly, that games frequently have antagonists, but it is the interaction of protagonist and antagonist with their environment that creates a compelling game. Narrative structure has often been described as a protagonist moving through an increasingly difficult series of obstacles in order to achieve some ultimate goal. In video games, it is the environment that frequently provides this increasingly difficult series of obstacles. This underlying structure was often so overt in the early history of games that it evolved into the concept of "levels," which were implicitly assumed to grow more and more difficult as they followed one another. Interestingly enough, as games have evolved, the idea of the explicit "level" has almost become a negative concept. In much the same way that certain early mystery plots might be deemed too predictable today, games have developed a remarkable array of methods for disguising what must always be a core component of their structure. Often however, these are simply facades,

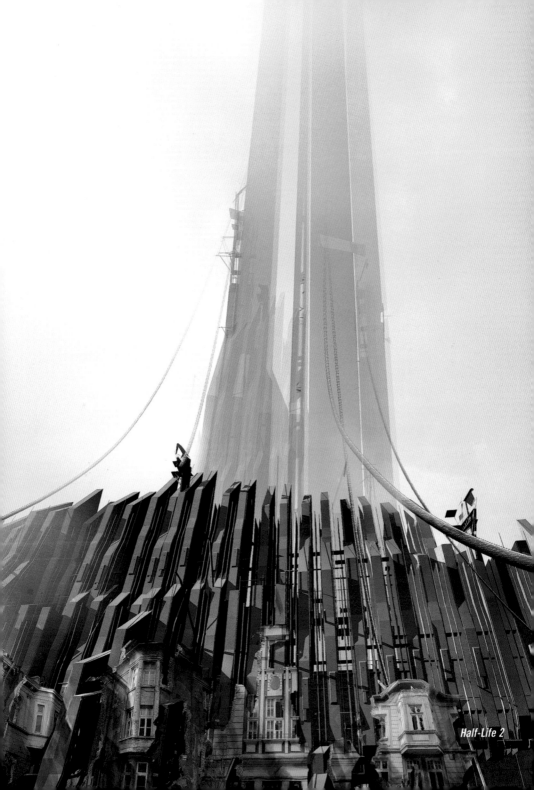

Half-Life 2

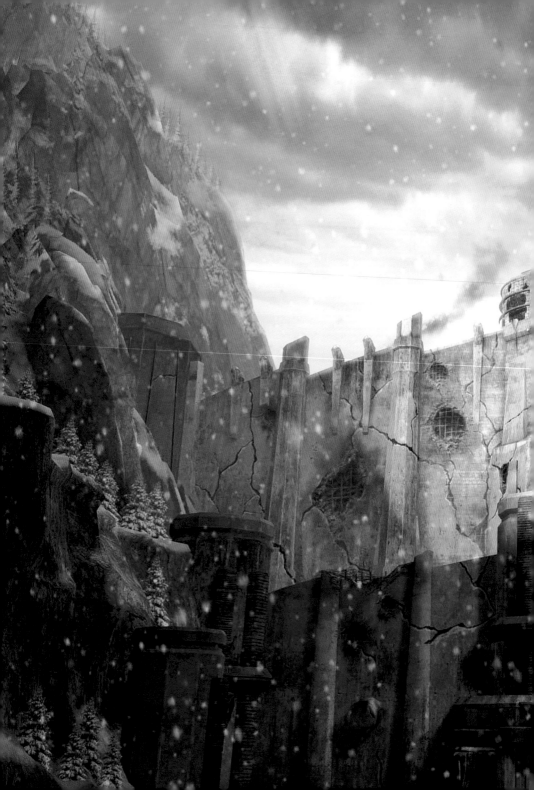

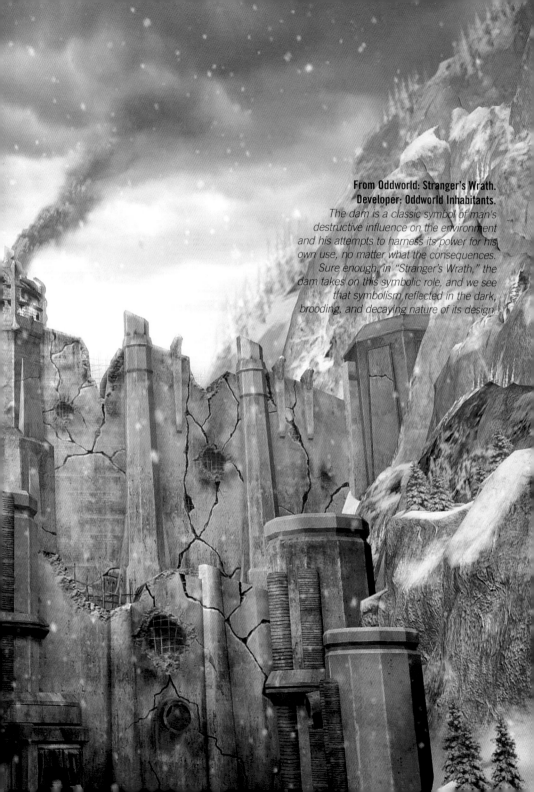

From Oddworld: Stranger's Wrath.
Developer: Oddworld Inhabitants.
*The dam is a classic symbol of man's
destructive influence on the environment
and his attempts to harness its power for his
own use, no matter what the consequences.
Sure enough, in "Stranger's Wrath," the
dam takes on this symbolic role, and we see
that symbolism reflected in the dark,
brooding, and decaying nature of its design.*

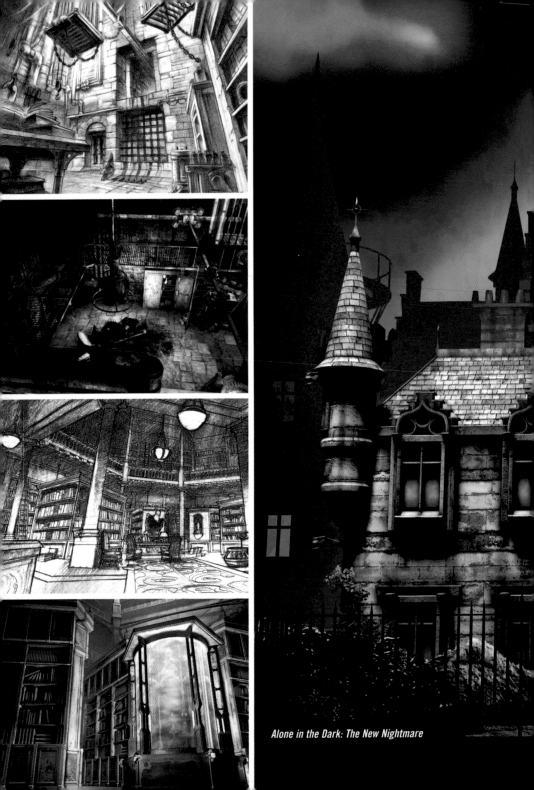

Alone in the Dark: The New Nightmare

Preceding pages:
From Alone in the Dark:
The New Nightmare.
Developer: Darkworks.
Many classic horror environments allow new designs to draw upon established tropes for added effect. The attention to detail, with regard to the textures of the materials, the dramatic lighting effects, and other elements that create more than realism, convey a specific mood.

because the concept of progression is still inherent in these games; as the game progresses, the protagonist becomes better and better at what he or she does and must face more and more difficult challenges. Thus, the environment and the challenges it provides must grow increasingly difficult.

When we look at the spectacular environments of today's games, which involve complex narratives and cinema-quality production design, they can easily be confused with the more basic, sometimes more passive role

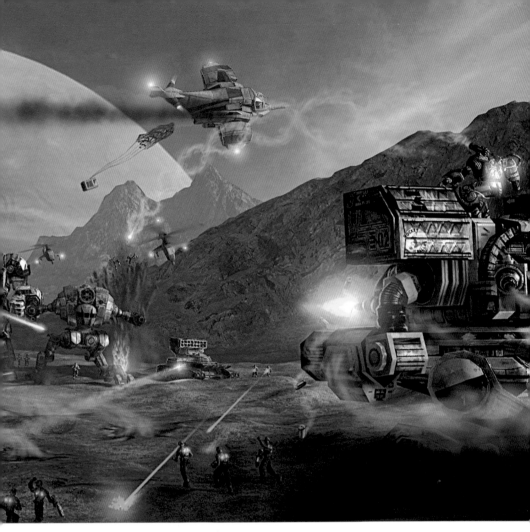

From Mechassault 2:
Lone Wolf.
Developer: Day 1 Studios.

that environments play in books or films or theater.

Yes, a setting can be important in many ways in traditional

forms—it can provide symbolism or even impetus for the

story—but it is rarely an active component throughout the

entire course of the work. Instead, in video games, the

"shape" of the game, its progression, is determined by the

space in which it is played. In "Pac-Man," for example,

there is a protagonist (Pac-Man himself), there are

antagonists (Inky, Blinky, Pinky, and Clyde), and there is a

goal (collect all the dots). But the game itself is created by

From the Red Faction series.
Developer: Volition.
Here we see a variety of science-fiction design traditions executed beautifully: for example, the environments' inhuman scale and their unwelcoming feel that seems to have grown organically from function, rather than any consideration for the people who must occupy them.

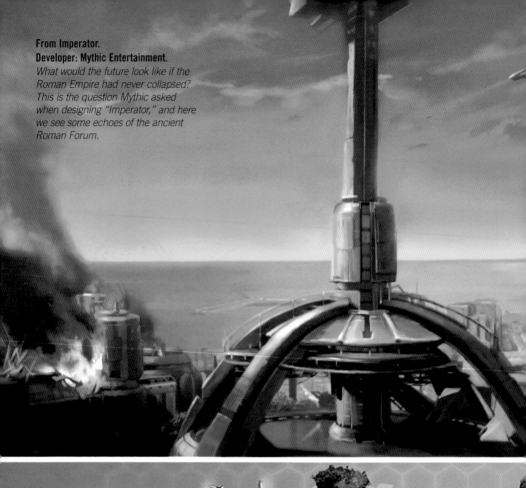

From Imperator.
Developer: Mythic Entertainment.
What would the future look like if the Roman Empire had never collapsed? This is the question Mythic asked when designing "Imperator," and here we see some echoes of the ancient Roman Forum.

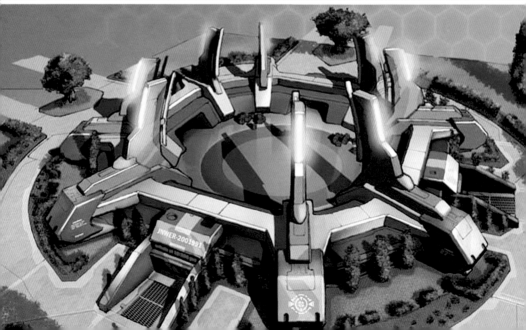

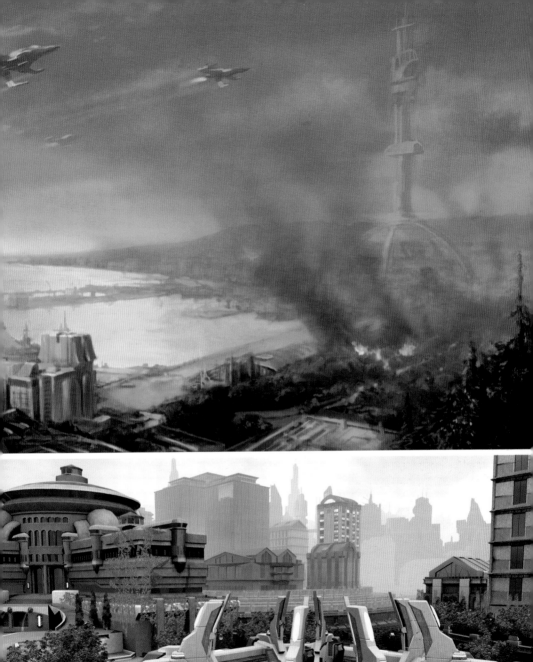

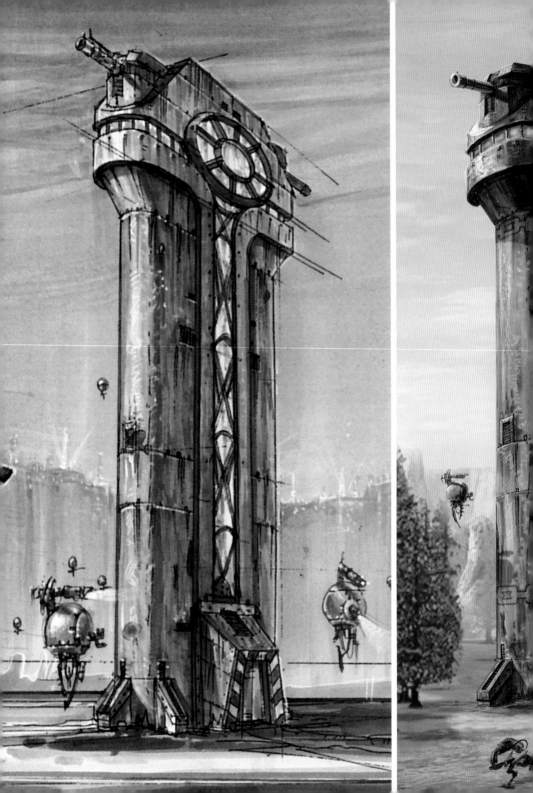

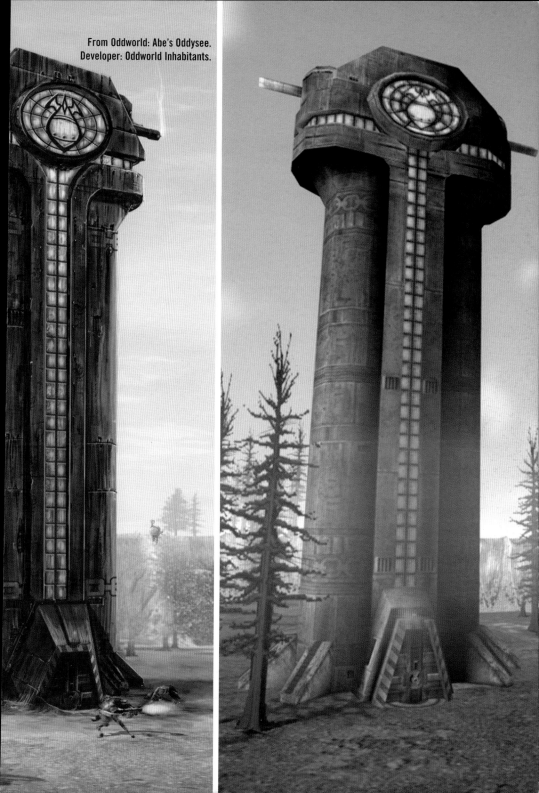

From Oddworld: Abe's Oddysee.
Developer: Oddworld Inhabitants.

"Oddworld has always viewed its content as art, regardless of the medium, and aspired for it to have the same level of social/political criticism by which more classical forms of art are regarded. To that end, its artists and designers give a 'cracked mirror' reflection of our own society and culture. The characters and environments have a firm footing in reality, with lifelike skeletal structures and familiar textures, but each has its own underlying story and its own special place within the context of the game and the story. The hope is that in the final product, something about the artist's insight manifests itself in the work and, as a result, helps to inform or question the beliefs of the viewers."

ODDWORLD INHABITANTS

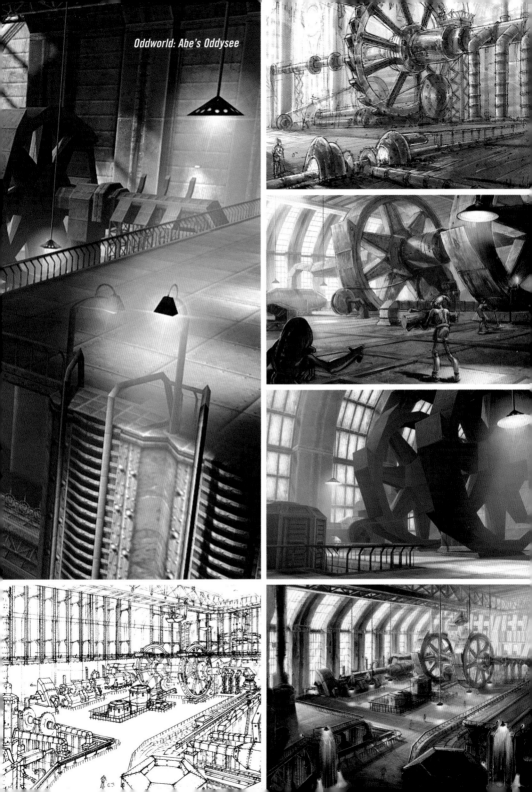

Oddworld: Abe's Oddysee

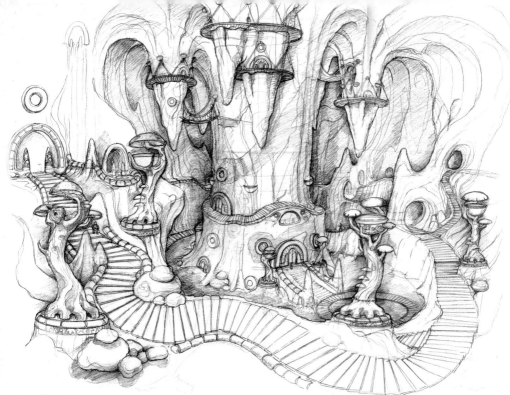

Preceding pages:
From Oddworld: Abe's Oddysee. Developer: Oddworld Inhabitants.

Above and opposite:
Dark Age of Camelot. Developer: Mythic Entertainment.
This underground cavern is part of a civilization with its own culture, history, and artistic and architectural traditions.

Following pages:
From Jak 3. Developer: Naughty Dog. Publisher: Sony Computer Entertainment of America.
This archeological dig, which has revealed a technologically advanced relic from the past, allows the environment to convey a sense of cultural history and of myths within myths.

In much the same way that the very nature of video games creates a predilection for certain character archetypes, the same holds true for their environments. There may be multitudes of looks and designs, many different time periods and degrees of reality represented in games, but ultimately the game environment almost always serves not just as a backdrop or setting for events, but as an obstacle that must be overcome for events to progress.

It is true, certainly, that games frequently have antagonists, but it is the interaction of protagonist and antagonist with their environment that creates a compelling game. Narrative structure has often been described as a protagonist moving through an increasingly difficult series of obstacles in order to achieve some ultimate goal. In video games, it is the environment that frequently provides this increasingly difficult series of obstacles. This underlying

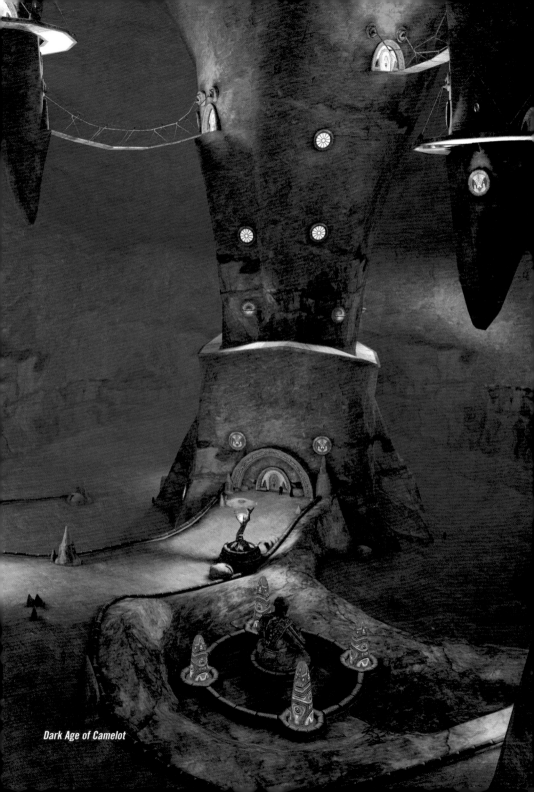

Dark Age of Camelot

Jak III

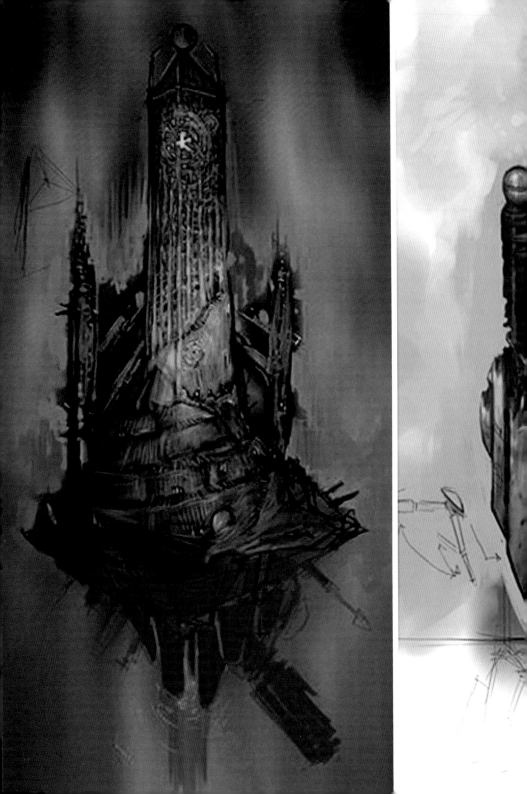

From the Summoner series.
Developer: Volition.

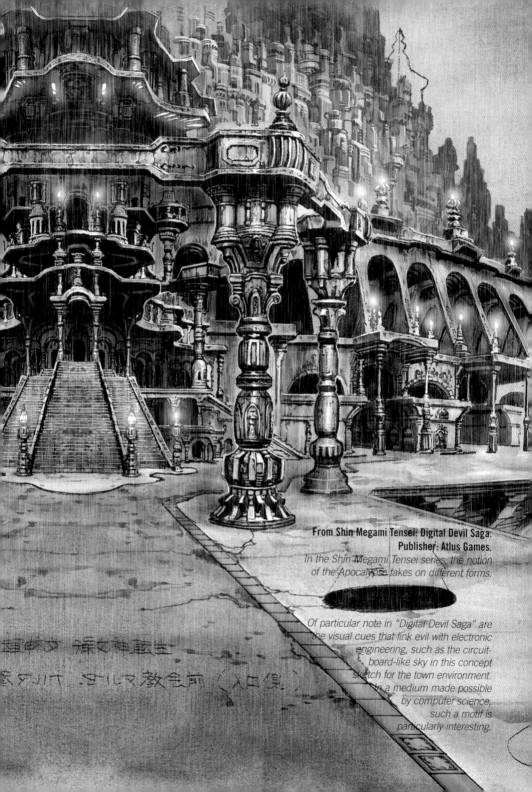

From Shin Megami Tensei: Digital Devil Saga:
Publisher: Atlus Games.
In the Shin Megami Tensei series, the notion
of the Apocalypse takes on different forms.

Of particular note in "Digital Devil Saga" are
the visual cues that link evil with electronic
engineering, such as the circuit-
board-like sky in this concept
sketch for the town environment.
In a medium made possible
by computer science,
such a motif is
particularly interesting.

But first and foremost, they must fulfill their role as active participants in games. Naturally, the best environments disguise this functionality, making the player feel as if the attempt to make them challenging is not arbitrary. This becomes more and more true today as even the most complex platforming games often involve extensive narratives, which then interact with the design of the environments in interesting ways. An excellent example of such a circumstance is provided by the Jak series, in which a simple quest to restore environmental stability to a remote village evolves into a epic tale spanning futuristic cities, desert wastelands, lush forests, and ancient ruins to provide the environmental variety necessary to keep the gameplay compelling and original. In games today, the setting must be everything it is in traditional narratives, but must also provide interesting opportunities for challenging navigation and exploration that does not seem forced. The opportunities an environment could provide for interesting gameplay may even work in reverse to determine the course of the narrative; the potential of an environment to be an active participant in gameplay may often

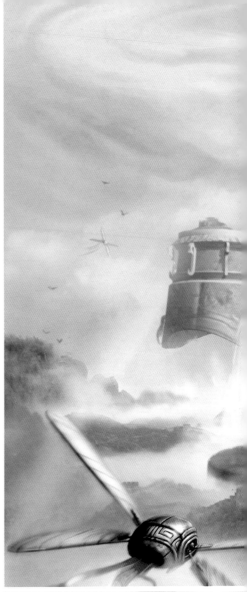

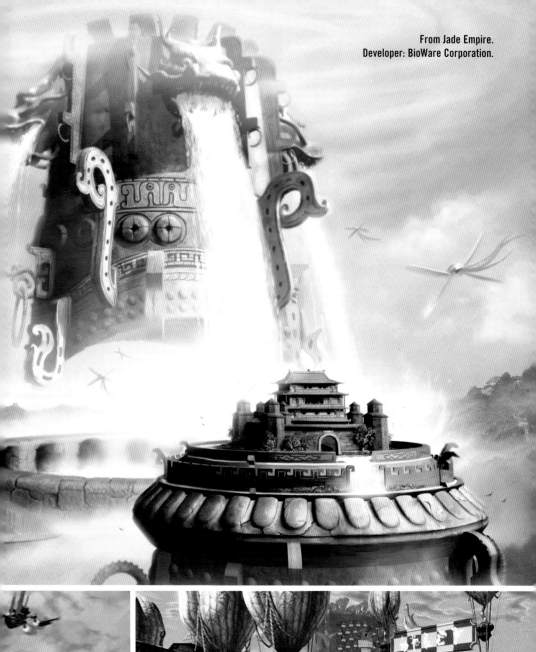

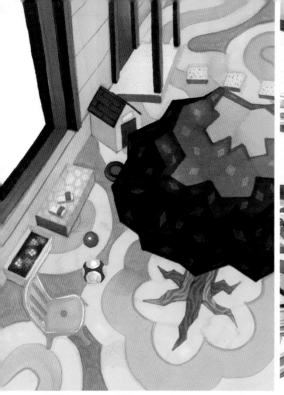

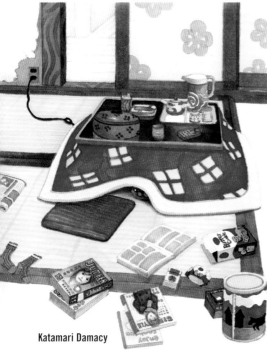

Katamari Damacy

determine the flow of the game's narrative, and not the other way around.

In meeting this condition, designers and writers have come up with a remarkable variety of settings that operate within this parameter but do not appear to be restricted by it. In fact, this condition seems not so much to be a restriction as an exercise in imagination. Yes, games have more than their fair share of tombs, temples, fortresses, and enemy bases. "Traditional" adventure environments like those in Tomb Raider, Neverwinter Nights, or James Bond titles call to mind classic adventure stories and draw upon such sources for their inspiration and appeal. But games also have their share of more original environments, like carefully constructed archipelagoes, post-apocalyptic cityscapes, Mount Olympuses, and coral reefs. Games like "Zelda the Windwaker," "Shin Megami Tensei," "God of War," and "Ecco the Dolphin" take such less common environments and turn them into places of challenge and exploration. Some, like "Katamari Damacy," have even managed to make adventurous and interactive territory out of literally nothing more than a messy floor. If anything, game designers have proven not that there are only a limited number of environments suitable as gamespaces but rather that anything can become a gamespace if looked at from the right perspective. In fact, a game's environment often proves to be its most creative element, since only certain specific genres require that the environment bear any resemblance to a real-world counterpart.

From Katamari Damacy. Publisher: Namco.
Studies like these show how carefully designers must construct and reinvent even the most commonplace and familiar environments so they work as successful gamespaces...and in this case, become the game itself.

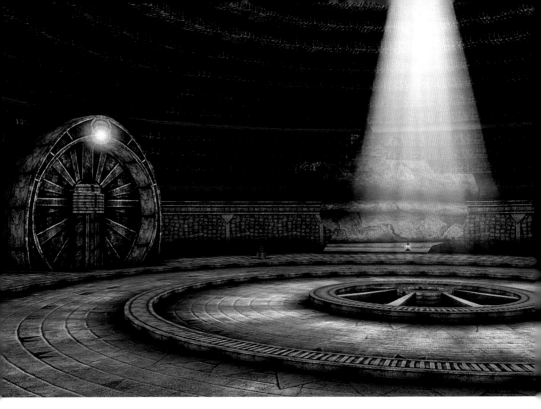

From the Myst series.
Developer: Cyan.

Thus they become, perhaps, the most diverse, the most creative element of video games, even though there are still archetypical game environments, just as there are archetypical characters.

The most prevalent of these archetypes is most likely the fantastic environment. This is a space that, by definition, must bear as little resemblance as possible to the reality we know in order for it to be convincing and successful. In addition, because the rules of reality need not apply, the potential for the environment to restrict or influence the narrative is automatically reduced; as long as the environment functions within the laws of reality as defined by the game itself, suspension of disbelief is maintained. Thus, it is in these environments that we see some of the most spectacular visions brought to life in a range of subcategories.

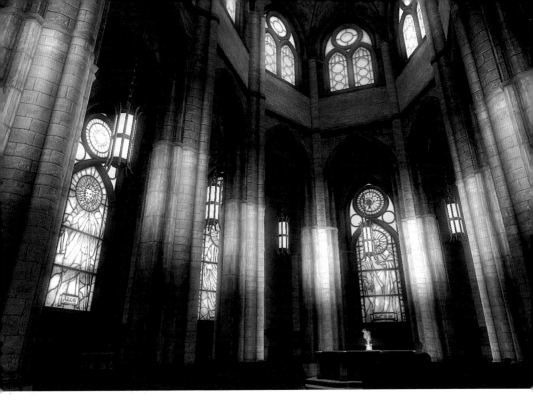

In titles like "Halo" or "Metroid Prime," between the wonders of advanced technology, irregular laws of physics, and flora, fauna, and geography, we see worlds or structures that in their beauty and spectacle go beyond many of the most brilliantly imagined science-fiction worlds found in traditional media. Unrealistic architecture, gigantic spaceships, or even giant robots offer the opportunity to demonstrate stunning designs that are only truly successful if they seem to resemble nothing on earth.

The next most common fantasy environment is the medieval fantasy world such as that found in games like the Elder Scrolls or Baldur's Gate series. Here, technology may be absent and unable to offer justifications for environments that defy the laws of physics, but the presence of magic provides a more than acceptable substitute, with the powers of the supernatural raising stone

From Elder Scrolls IV: Oblivion. Developer: Bethesda Softworks.
Reality and romance mixed together for the right blend of immersion and fantasy are key to role-playing games. Creating worlds that seem at once both real and imaginary is one of the major challenges faced in the design of games like this one.

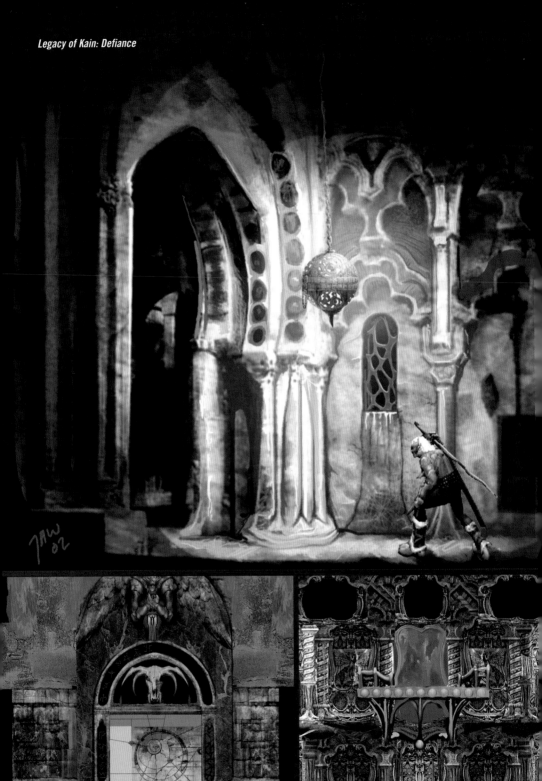

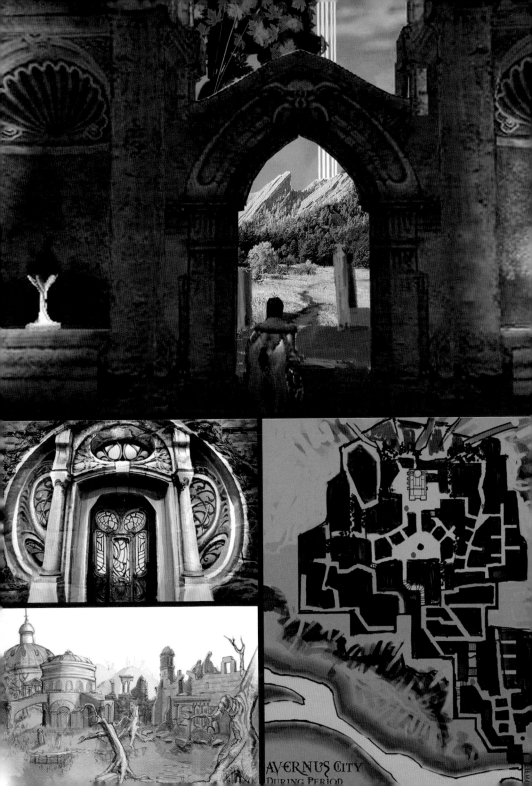

AVERNUS CITY
DURING PERIOD

"Above these apparent hieroglyphics was a figure of evident pictorial intent, though its impressionistic execution forbade a very clear idea of its nature. It seemed to be a sort of monster, or symbol representing a monster, of a form which only a diseased fancy could conceive. If I say that my somewhat extravagant imagination yielded simultaneous pictures of an octopus, a dragon, and a human caricature, I shall not be unfaithful to the spirit of the thing. A pulpy, tentacled head surmounted a grotesque and scaly body with rudimentary wings; but it was the general outline of the whole which made it most shockingly frightful. Behind the figure was a vague suggestions of a Cyclopean architectural background."

H. P. Lovecraft,
The Call of Cthulhu, 1926

structures to the heights of the tallest steel skyscrapers. In these worlds, too, the geography, flora, and fauna, free of the restrictions of our world, often provide spectacular backdrops that can serve as obstacles to the characters in the game without seeming forced. Petrified skeletons of dragons, wizard towers that reach into the clouds, entire towns that float in the air—in these kinds of environments, too, we find examples of designs that are quite original even if inspired by fairty tales, classical mythology, and medieval art and architecture.

Also in the fantasy category we find the environment of the alternate dimension, with hell as the forerunner in terms of repeated occurrence. In Dantesque fashion, hell is frequently divided into levels for the purposes of games and, just like the other environments in this subcategory, because it does not need to justify any kind of physical basis for its existence, it often seems more like the stuff of dreams or nightmares than anything resembling a world we might consciously imagine. Sometimes such environments draw upon traditional materials for their inspiration, as in the way "Devil May Cry" demonstrates some relationship to Bosch, but more often than not they are completely original in their visions.

The last subclass of the fantastic environment we often see are worlds without justification. That is to say, there is no rationale or explanation for the kind of world it is, nor does the player expect one. Most frequently, such environments are designed in games for younger players, and their animated origins and influences are markedly apparent. Games like "Klonoa," "Kirby," or even "Sonic the Hedgehog" feature such worlds, and they are often among the most varied and beautiful (even within this category of the fantastic) because no rules need apply at all—the

Preceding pages:
From Legacy of Kain: Defiance. Publisher: Eidos. *Few games have created such vivid and compelling alternative cultures complete with their own art and architecture as the Soul Reaver series. Such attention to detail in the environments completes the illusion of inhabiting a different universe.*

Opposite page:
From The Call of Cthulhu. Developer: Bethesda Softworks.

Following pages:
From Shin Megami Tensei: Nocturne. Developer: Atlus Games and Terminal Reality. *In these visions of hell, the Devil's throne room imitates an American robber baron's study (where the Devil himself appears as a wealthy old industrialist and the study is but a stage set), and once more, we see the protagonist lost in the daunting scale of his surroundings.*

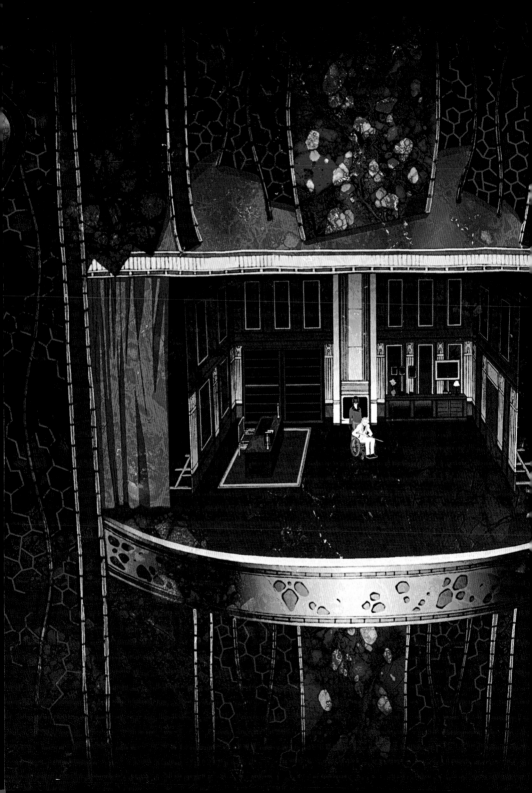

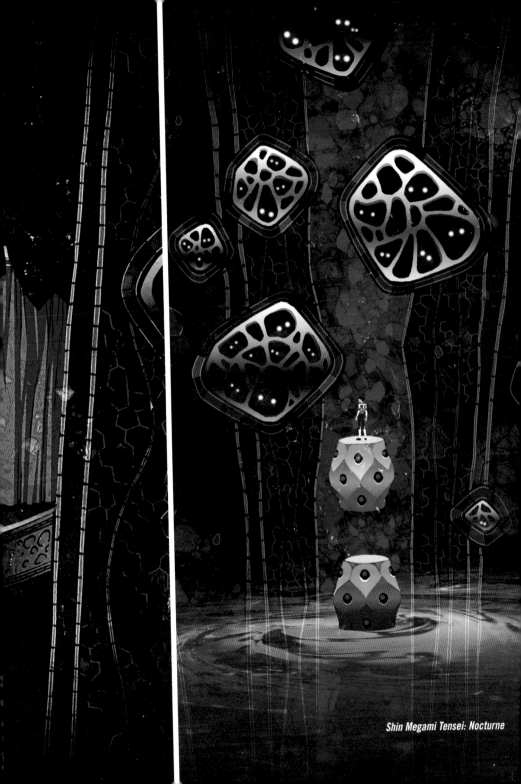

Shin Megami Tensei: Nocturne

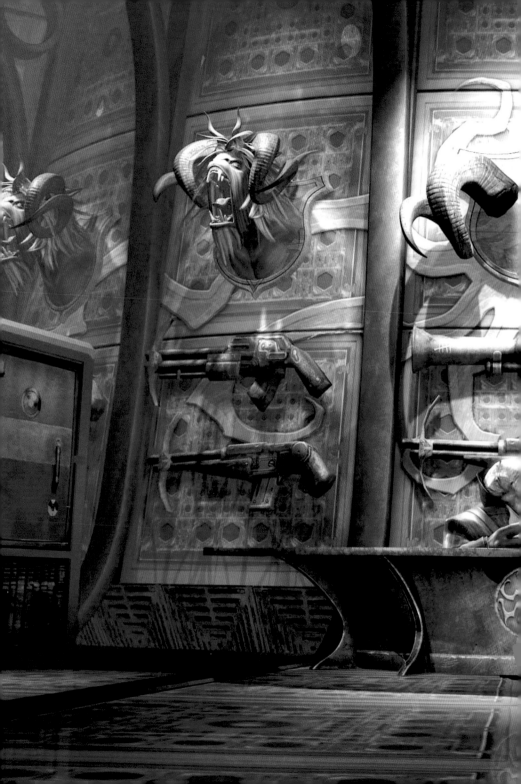

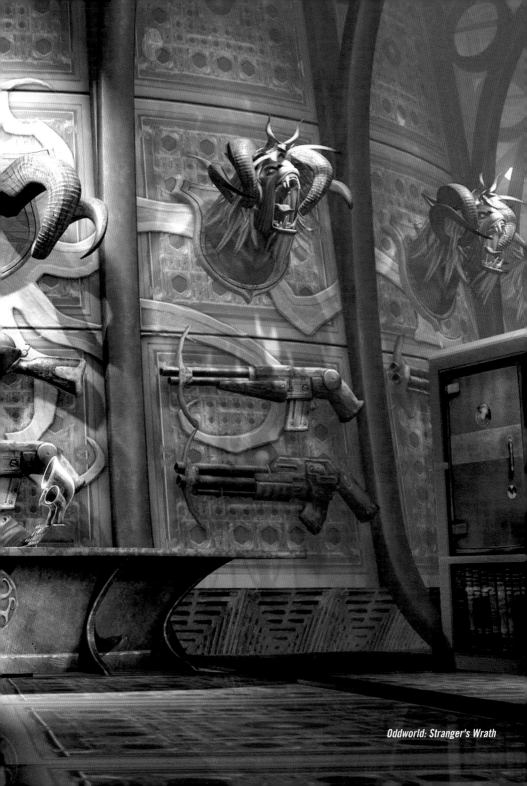

Oddworld: Stranger's Wrath

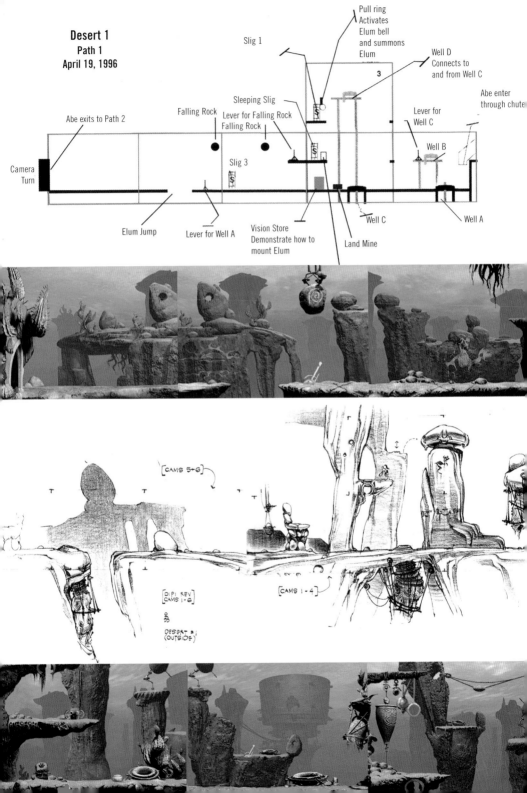

Desert 1
Path 1
April 19, 1996

Abe exits to Path 2

Camera Turn

Falling Rock

Slig 1

Pull ring
Activates
Elum bell
and summons
Elum

3

Well D
Connects to
and from Well C

Abe enter
through chute

Sleeping Slig
Lever for Falling Rock
Falling Rock

Lever for
Well C

Slig 3

Well B

Elum Jump

Lever for Well A

Vision Store
Demonstrate how to
mount Elum

Land Mine

Well C

Well A

[CAMS 5+6]

[DIPI REV
CAMS 1-6]

[CAMS 1-4]

DESERT 1
(OUTSIDE)

player's suspension of disbelief can almost never be violated no matter how strange the world appears.

One theme we cannot help but notice running through all the subcategories in this group is their epic scale—monoliths, megaliths, mountains, and towers reach for the sky or spread across backgrounds generating parallax. In many ways, these environments often reflect the mythic stature of the characters that move through them, and yet the bones of long-dead giants or the ruins of enormous alien fortresses abound, suggesting that these worlds operated on even larger scales in the past and hinting in some ways that even as these games are our modern mythologies, they also must contain myths and legends of their own.

At the opposite end of the spectrum to the many kinds of fantastic environments, we find hyperrealistic environments. Military simulation games, sports games, racing games, and others feature places that quite often could be visited in real life. In these cases, such as in the WWII title "Brothers in Arms," designers frequently visit the locations in question, returning to their computers with photographs and sketches that are then translated into digital equivalents. These spaces are fascinating in two ways. First, we must consider the ability of their designers to adapt real world environments to the active requirements of the game environment. This adaptation is less evident in sports or racing games, where the space being modeled was also designed in the real world to provide challenges for participants. In these cases, the closer the modeling is to reality, the more successful the space is typically considered to be. But in other types of games, such as military simulations or even certain crime titles, the area being modeled must be changed in such a way that it

Preceding pages:
From Oddworld: Stranger's Wrath. Developer: Oddworld Inhabitants.
Few games take on capitalism's exploitation of physical labor and the environmental consequences of industrialism as well as the Oddworld series. Here we see the video game "boss" interpreted as a corporate CEO in his lair.

Opposite page:
From Oddworld: Abe's Oddysee. Developer: Oddworld Inhabitants.
These concept sketches from a traditional "side-scroller," along with the final executions of the levels themselves clearly illustrate the ways in which terrain must both seem natural and offer gameplay challenges.

Following pages:
From Oddworld: Abe's Oddysee Developer: Oddworld Inhabitants.

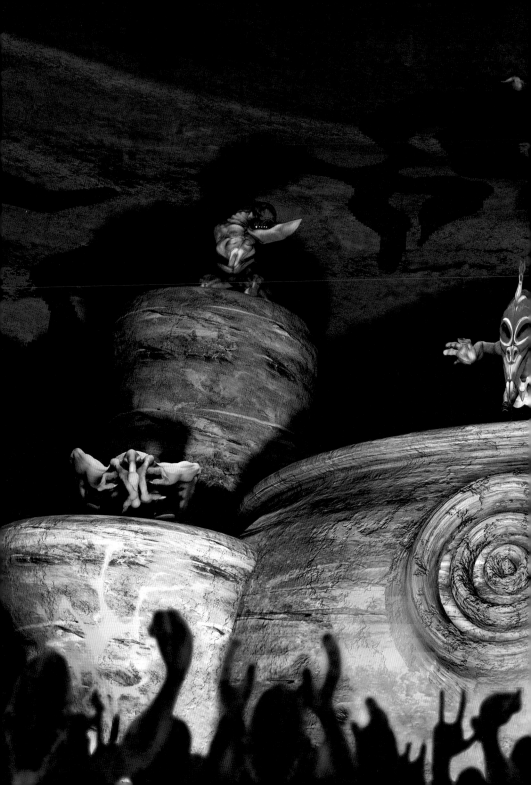

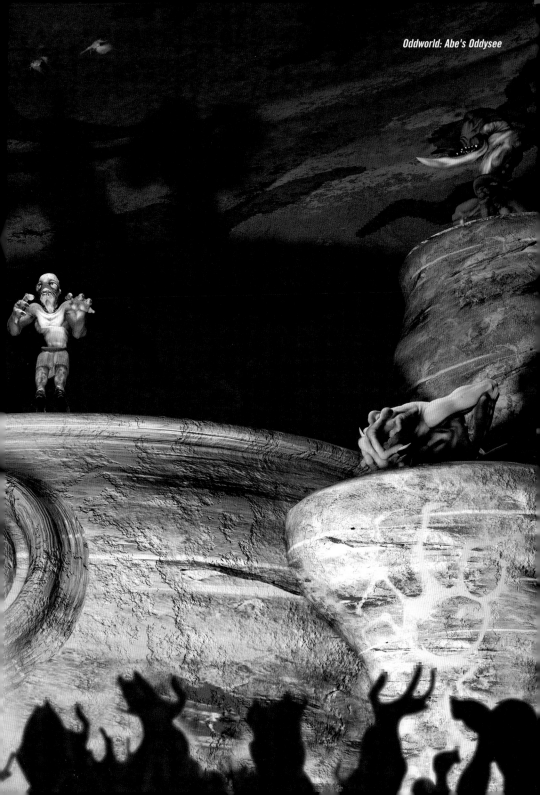

From Oddworld: Munch's Oddysee.
Developer: Oddworld Inhabitants.
Again, the concept of advertising and mass-marketing as evil is apparent in many of the Oddworld designs. Here we see vending machines that are used in the game to sell the protagonists items they can use to enhance their powers but that are also clearly bad for the consumer's long-term health.

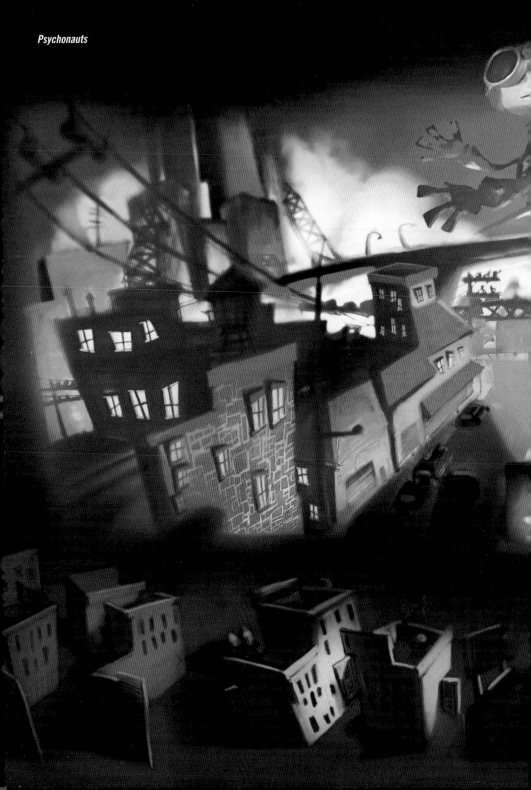

dangling beds

4

huge pile of debris

PETTEN 9/01

ASYLUM COURTYARD

ends at boards start

FLOOR

STAIR TOWER

OUTER WALL OF CAGE

3

b

2

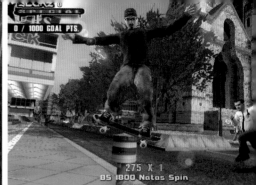

275 X 1
BS 1800 Natas Spin

Tony Hawk's Underground 2

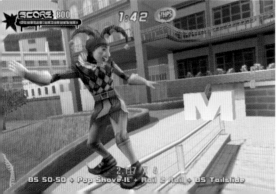

800 · 1:42 · THPS

2,17 X 4
BS 50-50 + Pop Shove-It + Rail 2 Rail + BS Tailslide

SCORE 0
25 / 1000 GOAL PTS.

1,630 X 3
Spine Transfer + Backflip + Indy

provides the requisite challenges to the player, but does not violate their sense that they are in a space that really exists. This challenge is often met and conquered with remarkable imagination, as in the "The Getaway," which models modern London accurately enough to visit real places using real directions, but still alters the scale and fine details of the city to make it appropriate for gameplay. The second interesting point worth examining for such spaces is that designers often find ways to improve upon the reality they are imitating, making the world over not the way that it is or was, but the way it might have been if the sun was shining just so or the mountains were slightly farther south.

In many ways, this practice is not that different from the cinematic version of history—"based on a true story" becomes "based on a real place"—and there are many real-world places that gamers believe they have become familiar with by visiting them through a game. An excellent example of this is given by "GTA San Andreas," which provides all the sights, sounds, and flavor of California and Nevada without actually modeling a single real building or place.

The metaphysical and philosophical implications of these improvements are as far-reaching as the implications of our fascination with the video game protagonist. They could suggest, for example, that there is some kind of standard to which we constantly compare reality and that video games, as alternate realities, are capable of manifesting for us. In addition, all such "real" spaces, not just those that have been "improved," tend to heighten the player's immersion in a game and thereby improve the experience of the game as a whole. For example, much was made of the precise scale modeling of Manhattan that was achieved in the "Spiderman 2" game, and the fact that the player could

Preceding pages:
From Psychonauts. Publisher: Majesco Entertainment.
Proving that almost anywhere can be the setting for a game, "Psychonauts" brilliantly takes place inside people's minds.

Opposite page:
From Tony Hawk's Underground 2. Publisher: Activison.
This composite version of New Orleans shows both how real-world environments are reinvented to provide the necessary challenges for a video game and also the artistry involved in capturing the essence of a real location in a compressed form. In games like this, the notion of "level" becomes less linear and more free-form. Players can explore any part of the level at any time, and it is unclear at what point the level is "completed" —if ever.

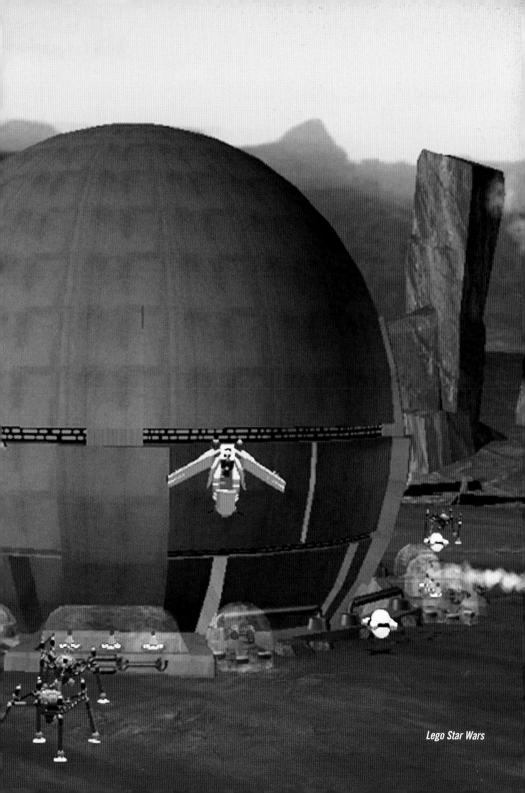

Lego Star Wars

Preceding pages:
From Lego Star Wars.
Publisher: Eidos.
Reinventing the look and feel of familiar environments (even imaginary ones like those from the Star Wars films) so that they work as a gamespace can be quite challenging. Using individual Lego bricks to create the environments would have been a very simple way to create a Lego version of Star Wars, but it would not have been practical from a technical standpoint. Instead, designers used many of the design hallmarks of Lego, such as plastic textures rather than metal ones, and monochromatic lines that appear to have been pressed on rather than painted.

now take on the role of a superhero in a real place was a large part of the game's success.

Between these two extremes of fantasy and reality, we find other common environmental archetypes that are neither completely fantastic nor hyperrealistic. In attempting to set a game in a fictionalized version of our own world, designers have often dwelt on cityscapes as game settings. For a variety of reasons, cityscapes are somewhat easier to reproduce convincingly with the technology currently at the disposable of game developers since they generally involve flat surfaces—unlike rocks, trees, water, or other components of natural environments. Consequently, we see more cities, more interiors of buildings, than perhaps any other environment that falls into the category of neither total fantasy nor total reality. Interestingly enough, a great many of these cities are dystopic—often corrupted by technology, partially decayed, and rife with pollution, as in the popular Deus Ex titles. This says a great deal about our perception of cities, certainly, but it is especially ironic in that games are only made possible by that same technological

progress. Thus, games that feature these urban dystopias encapsulate our addiction to technology in their popularity but also our unconscious awareness of technology's negative aspects in their content.

Outside the city, however, in natural settings, we find our protagonists equally threatened. In games set in natural environments, animals, volcanoes, rapids—anything that could be construed as a natural hazard—have been represented in games as early as "Pitfall" and as recent as "Jak 3." If natural settings differ from constructed ones, it is principally in the relationship between the protagonist and the environment. In nature, the protagonist's mythic importance is often secondary to the power of nature. He or she can change the course of events that take place in such environments, but not the environments themselves, as in series like Tak or later Donkey Kong titles. In games that take place in man-made environments, these environments often change and shift in response to the player—in some, like "Halo," the player is even capable of destroying entire man-made planets. By contrast, the

Above:
From Crimson Skies: High Road to Revenge.
Publisher: Microsoft Game Studios.
The 1990s according to the 1930s—a beautiful example of how designs of the past can be reworked and updated in games. The environments here are populated with the blimps, Art Deco buildings, and prop planes that recall the visions of the future found on old pulp magazine and book covers.

From Cold Fear. Developer: Darkworks.
*Scientific research grown beyond our
ability to control is a common theme in
many survival horror titles. Here, the hi-
tech, but decaying, environments echo
the game's Frankenstein-like
consequences of pushing the scientific
envelope too far. The game also
explores some latent Cold War fears,
since the lab responsible happens to
be of Soviet origin.*

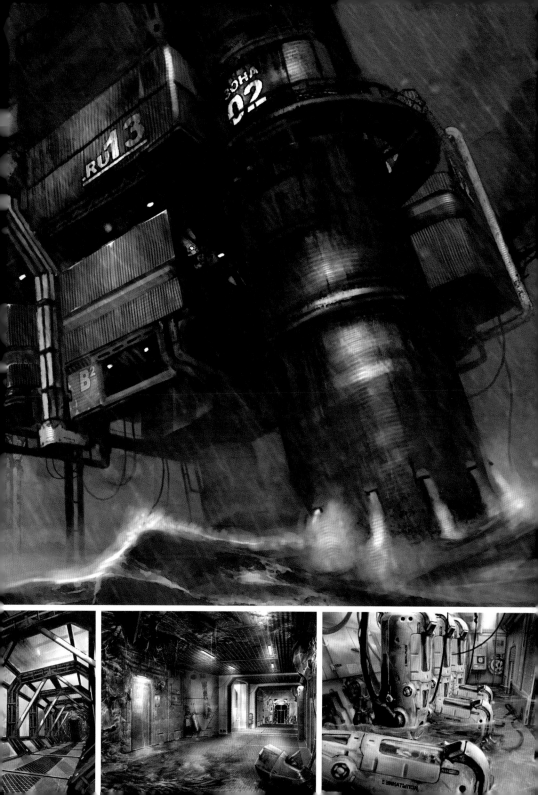

Beyond Good and Evil

natural environment in games is often everlasting or, at most, only changed to be restored to an ideal state of unadulterated, paradise-like perfection by the player's actions, as in some of the Final Fantasy titles. In this sense, the natural environment in games offers similar philosophical contradictions to the dystopic cityscape—the advances in technology and industry that have enabled games to exist and tell these stories of eternal, immutable nature are the same advances that slowly destroy the climates and habitats of the real world.

When we begin to look across enough environmental archetypes like those outlined above, we start to see that as a natural result of the purpose of the game environment, there are two important ways in which these spaces become representative of broader, more profound human experience.

The first of these ways is by symbolizing our real-world experience of the unknown and its exploration. Game environments may be intended to provide obstacles and difficulties, but they are considered most accomplished when they also deliver a sense of discovery and exploration to the player. This is most evident in the cosmetic changes that environments undergo during the course of a game. Whether in relatively unknown titles like "Rygar" or in hugely popular titles like the Zelda or Metroid series, as the player progresses through the game, he or she is rewarded with areas that are more and more spectacular, more and more beautiful and fantastic, as well as more challenging. This provides the player with a sense of satisfaction; the simple urge to discover and explore these new areas is a strong driver of successful games. Without new places to explore, and new looks to environments, games quickly become monotonous, whereas the reverse is not as true for

Opposite page:
From Beyond Good and Evil. Developer: Ubisoft.
Here the idyllic environments provide a stark contrast to the sinister plot uncovered in the game, and certain background details—such as the whale or the Italianate buildings—create an illusion of completeness and depth even when the environments themselves may be of limited scale.

In creating these environmental concepts (or "locale postcards") for "NOLF," many different techniques were employed to create single images:
"1. Traditional sketching on paper or marker drawings on whiteboards happen all the time to quickly explore ideas or convey direction. Sometimes these sketches are scanned and painted in Photoshop for more color and lighting information, sometimes not. This is still the fastest way to solve a problem on the spot. 2. Digital sketching with Photoshop...same as above but straight into Photoshop.
3. Photo manipulation. Several of the locale postcards were created from a mix of representative images and painted over digitally, adding in details and tweaking the color and lighting.
4. Painting over a roughed-out 3-D model was another method used for creating some environment and object concepts."

DAVID LONGO, ART DIRECTOR ON "NOLF"

**From the No One Lives Forever series.
Developer: Monolith Productions.**
*Monolith's environmental concept
work is particularly interesting
because it combines a variety of
techniques to achieve a specific kind
of Impressionism, which is then itself
interpreted when converted into
actual game environments.*

elements of gameplay. But the importance of the exploratory component of a successful game environment is also highlighted by the concept of the "secret area." Almost all non-reality-based games across all genres include spaces that must be searched carefully in order to be discovered. Such spaces usually include benefits for the player who locates them, which are not available to players who do not explore the game world so thoroughly. Thus, exploration is not just passively experienced, but, like so many elements of the video game, actively encouraged. In the video game, even simply exploring a new space must become an interactive task, as designers set challenges for the players that are entirely based in their ability to explore new spaces and nothing more.

This sense of discovery, of seeing that which has not yet been seen and of reaching levels or secret areas other

players may not find, provides the player with a sense
of satisfaction, of feeling special in some way;
it allows him or her to have an experience of the game that
is somehow more personal, more individualized, in the way
different readers may interpret the same book differently.
In video games, the revelations and discoveries of
the physical space become as important as the revelations
and discoveries of the narrative in traditional media.

In fact, the power discovery holds over us is perhaps
nowhere better demonstrated than in games that
emphasize distortions of familiar environments—places that
should need no exploration but do nonetheless.
Environments like these are the settings for horror titles or
postapocalyptic adventures, games that, by making the
known unknown, become terrifying or exciting. From "Silent
Hill" to "Resident Evil" to "Fatal Frame" to "Eternal

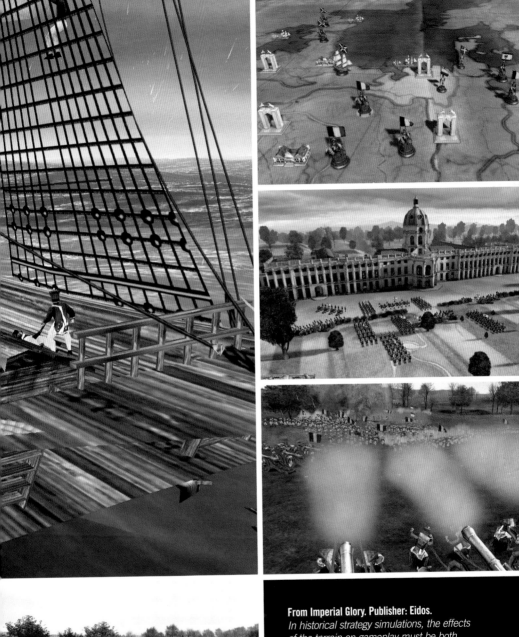

From Imperial Glory. Publisher: Eidos.
In historical strategy simulations, the effects of the terrain on gameplay must be both predictable and realistic to strike the right balance between re-creation and gaming.

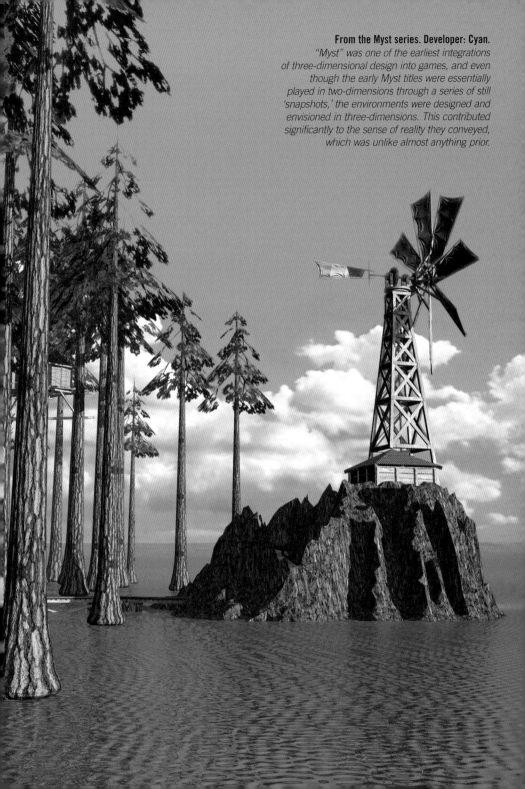

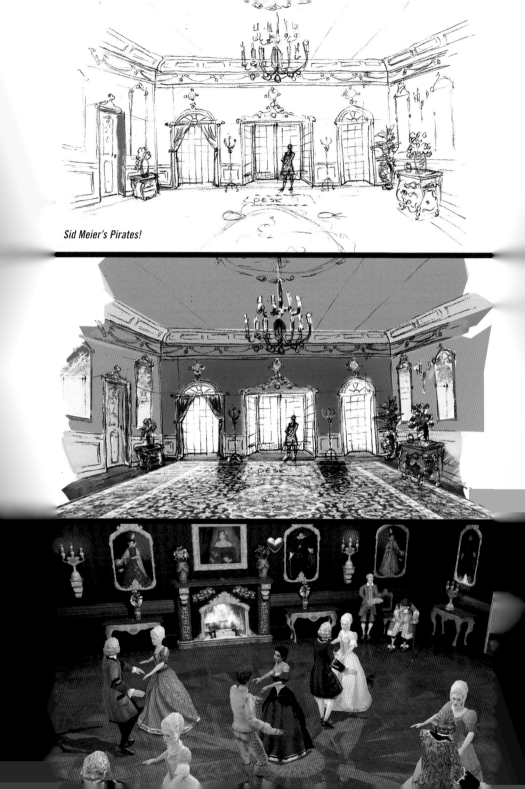

Sid Meier's Pirates!

Darkness," all the most popular horror titles share this concept: an otherwise familiar place, frequently an everyday American town, becomes changed in some way that makes it unfamiliar and difficult to navigate. This visible distortion of places that should be familiar but are not is interesting because it points rather directly to the overall appeal of the horror genre regardless of medium. It is not the unknown that is terrifying, but the almost known—the dead who have come back to life, the possessed, the house that is now haunted, the wolf that was once a man. Why this aspect of horror is so clearly demonstrated in game environments is deserving of much deeper analysis, but it may have something to do with the horror genre in games having its origins in Japan rather than in the West. Traditionally, much Eastern horror, like the Chinese ghost story, for example, emphasizes just such subtle distortions of reality, as opposed to Western horror, which favors individual creatures like the werewolf or the vampire as its most popular focus. Since the survival horror game genre was really brought into its own by Japanese developers, such influences may, at least in part, account for the prevalence of the distorted familiar environment as the setting for horror-gaming titles. But regardless of their origins, the effect such game environments have on us clearly demonstrates the importance and power of discovery as a human experience, and in a manner found in few other places.

The second way in which game environments become more far-reaching in their symbolic and unconscious appeal is by being such explicit, overt representations of man's struggle for survival in the world. This is why finding that secret cave or moving on to a particularly beautiful mountain forest become as important in games as

Opposite page:
From Sid Meier's Pirates!
Developer: Firaxis.

Following pages:
From Syberia 2.
Developer: Microids.
In the same way that the game's name is suggestive of a real place, the visual representations of that place echo Russian architecture and geography but are not precise reproductions of those buildings and places.
From Syberia 2.
Developer: Microids.
(pp. 178–179)

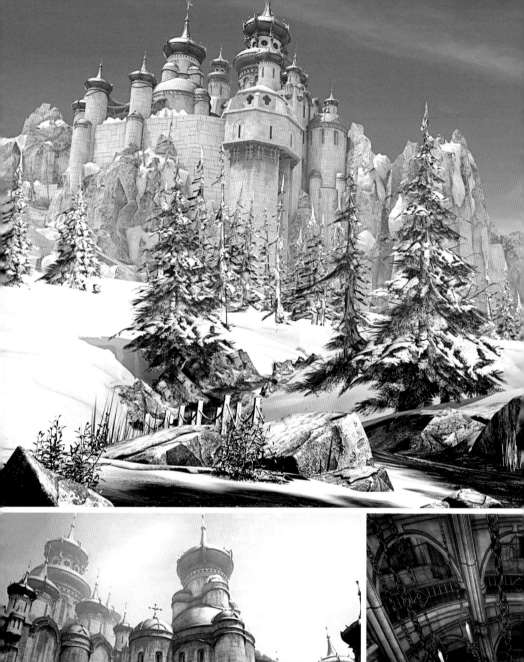

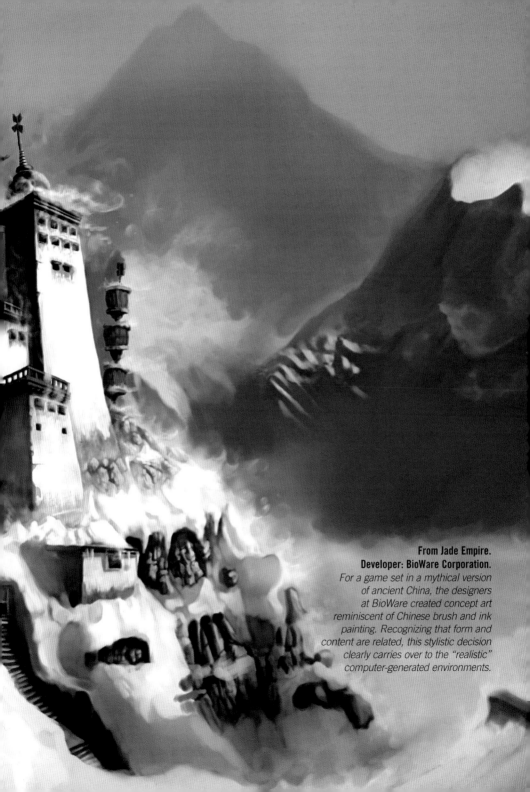

From Jade Empire.
Developer: BioWare Corporation.
*For a game set in a mythical version
of ancient China, the designers
at BioWare created concept art
reminiscent of Chinese brush and ink
painting. Recognizing that form and
content are related, this stylistic decision
clearly carries over to the "realistic"
computer-generated environments.*

discovering who the protagonist's real father is or other narrative moments of great impact. It might also explain why "frontier" environments—for example, the Wild West, outer space, or the rugged outskirts of some fantastic medieval society—are the most common influences on the design and art of gamespaces because they allow the physical unknown and the narrative unknown to work together to create a complete experience in which a satisfactory sense of discovery becomes as important as other elements. Because the game environment is specifically structured to present a challenge to the progress of the protagonist, it becomes the direct corollary of the place occupied by the real world in the player's daily life. Every day we all face unexpected challenges in our lives and are forced to find ways around them, ways to succeed in spite of those challenges, ways to overcome them. The video game makes those challenges explicit, and in doing so, gains tremendous power as a medium. Seeing those struggles and challenges played out in an understandable way on a stage where the rules can be understood and remain consistent is remarkably appealing. Games allow us all to live

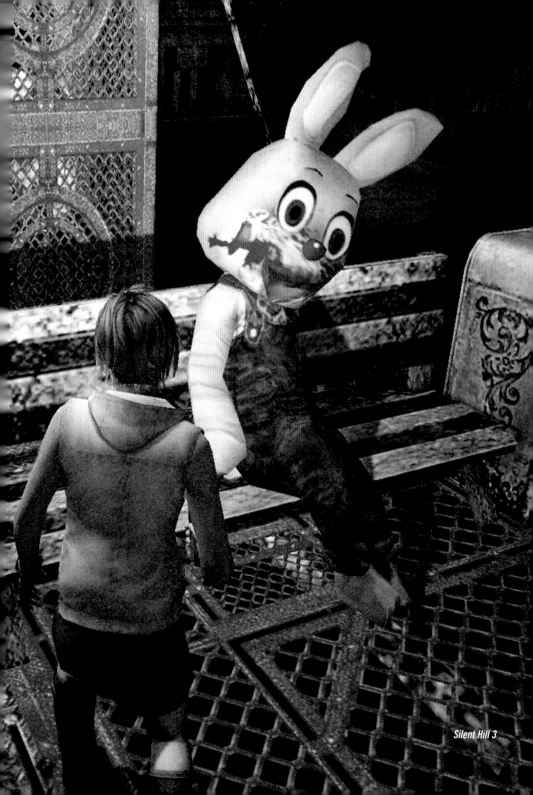

Silent Hill 3

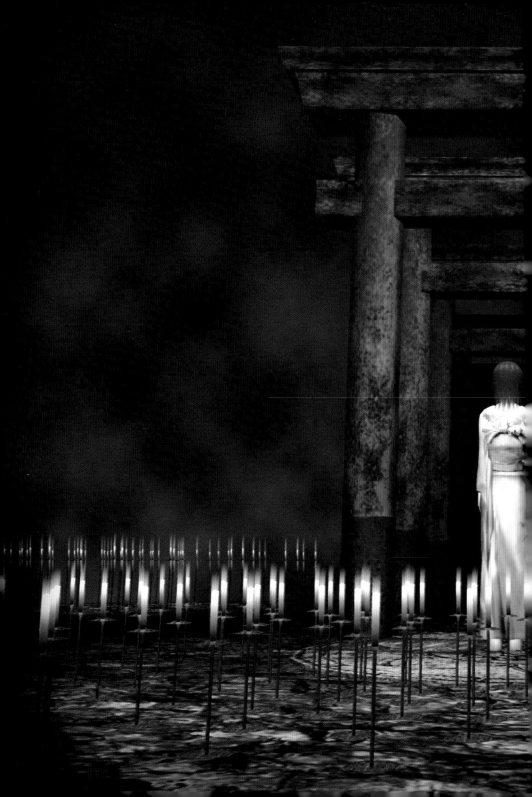

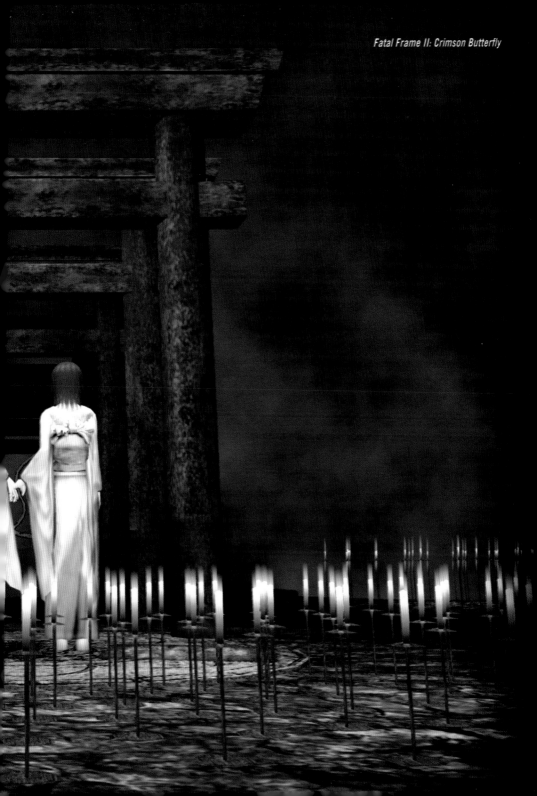

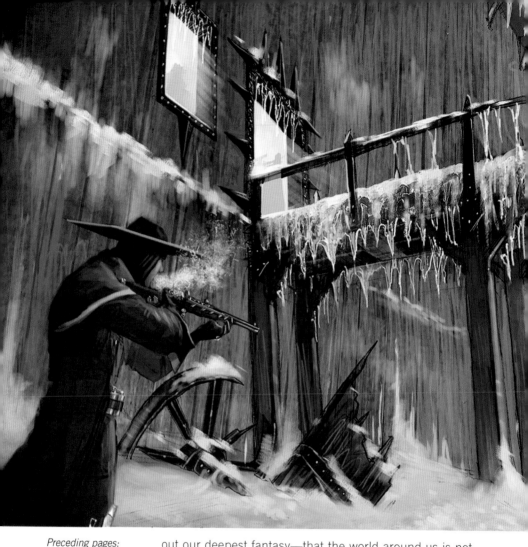

Preceding pages:
From Silent Hill 3. Publisher:
Konami. (pp. 182–183)
From Fatal Frame II:
Crimson Butterfly.
Publisher: Tecmo.
(pp. 184–185)
The distortion of familiar space creates a terrifying effect; here, the conversion of innocence to evil as a theme in Japanese horror is emphasized thanks to the child-like twins or the horrifically corrupted stuffed animal.

out our deepest fantasy—that the world around us is not only manageable but often conquerable, that we can overcome any obstacle and get where we need to go.

In video games, the world is always threatening—cities are dystopias, and even nature tries to kill the player—there are hazards everywhere we look, but we still overcome them. Man visibly triumphs over an environment that is, quite literally, conspiring against him. Could there be a more primal representation of the basic human desire to see this triumph illustrated than the video game? In some ways, the

game environment, as a symbol of the world around us, allows the equivalent of the "feel-good" Hollywood ending to be experienced over and over again, as the player simply continues to navigate through it successfully.

With such powerful symbols inherent to the structure of the medium, it is little wonder that the form has such appeal and power, a lure bordering on and frequently compared to addiction. Where else can the human condition be played out so directly and so successfully? One need only see a single game player leap up and

Above and following pages:
From Darkwatch.
Developer: High Moon Studios.
These images show the centrality of scale in video game environments; it is important that the environment seem overwhelming, unconquerable, so that when the protagonist succeeds, his success carries that much more weight.

Darkwatch

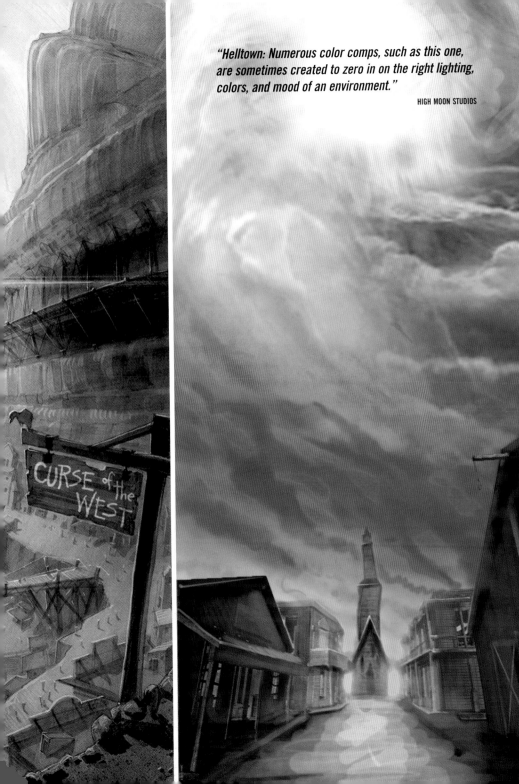

"*Helltown: Numerous color comps, such as this one, are sometimes created to zero in on the right lighting, colors, and mood of an environment.*"

CURSE of the WEST

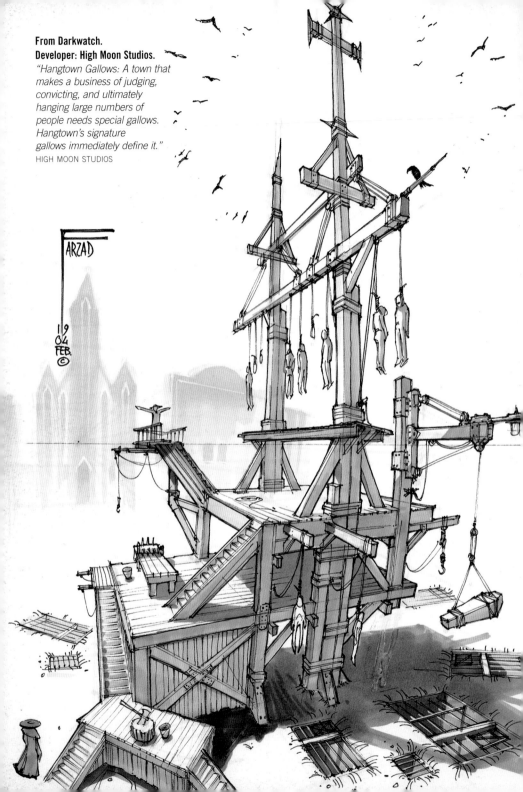

From Darkwatch.
Developer: High Moon Studios.
"Hangtown Gallows: A town that makes a business of judging, convicting, and ultimately hanging large numbers of people needs special gallows. Hangtown's signature gallows immediately define it."
HIGH MOON STUDIOS

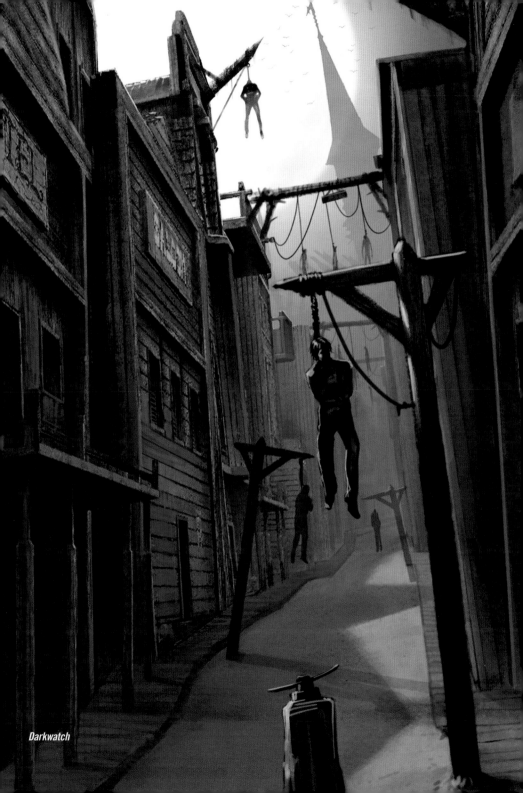

Darkwatch

From World of Warcraft. Developer: Blizzard Entertainment.

Echoing the films of John Ford, environments like this one draw upon preestablished mythologies to enhance their own. In "World of Warcraft," the culture of the Taurens echoes that of the Native Americans—complete with the threat of invading civilizations destroying their way of life. The reference to classic cowboy films is more than simply a look; it also highlights a cultural tradition from the real world that then transfers meaning to the fantasy world.

perform a victory dance after navigating a particularly difficult segment of an environment (a dance one never sees performed at the end of a Hollywood action movie) to recognize the kind of power the game environment has over us. It represents the challenge of the unknown, the world as antagonist, the game of survival clearly depicted for all to see. It is no surprise, then, that in the same way the protagonist becomes mythic and larger than life, the environment does, too. It must be epic to support such characters, but also, as the embodiment of man against his universe, it naturally takes on such characteristics. Even when environments are supposed to be real, designers cannot but help "improve" upon reality. Perhaps the popularity of games—which is growing exponentially and acquiring more "addicts" than any other media form in history—has something to do with their

environments rendering visible an almost perfect metaphor of the human condition and how we wish it could be resolved. In video games, the only knowledge we have of our next step is that it will prove to be a challenge. But we also know that, with enough practice, we have the skills to beat that challenge.

John Wayne in The Searchers, John Ford (1956).

THE INFLUENCE OF ANIMATION AND ILLUSTRATION

The influence of animation and illustration—in particular comic book illustration—is so pervasive in games it is worth reviewing briefly. From the impact of manga (Japanese comics) and anime (Japanese animation) on games developed in Japan, to the impact of Disney, graffiti, and even French graphic novels on games developed all over the world, it is from popular forms like these that games draw their most consistent inspirations.

In Japanese games from role-playing titles like "Xenosaga," to action titles like "Devil May Cry," to fighting titles like "Tekken," we see a variety of stylistic hallmarks of manga and anime translated into the video game format. Characters with large, rounded eyes, long legs, and spiky hair, or weapons and vehicles that appear to have been built from military blueprints are just some of the more obvious ways in which the conventions of these more traditional media have been carried over into the game format. Meanwhile, from "Sonic the Hedgehog," to "Sly Cooper," to "Jak," we have seen the friendly and familiar forms of Western animation styles expressed in character, environment, and enemy designs since the earliest days of game development. Finally, and more recently, we have seen titles like "XIII" or "Jet Grind Radio" that imitate very specific styles, like that of Belgian

Opposite page:
From Samurai Western. Publisher: Atlus Games.
This piece of key art clearly demonstrates design links to the illustration style of the samurai, Western, and blaxploitation movie posters of the mid-seventies. All of these genres are mixed together in the game itself, and thus placing the game design graphically within a time frame is essential at the outset.

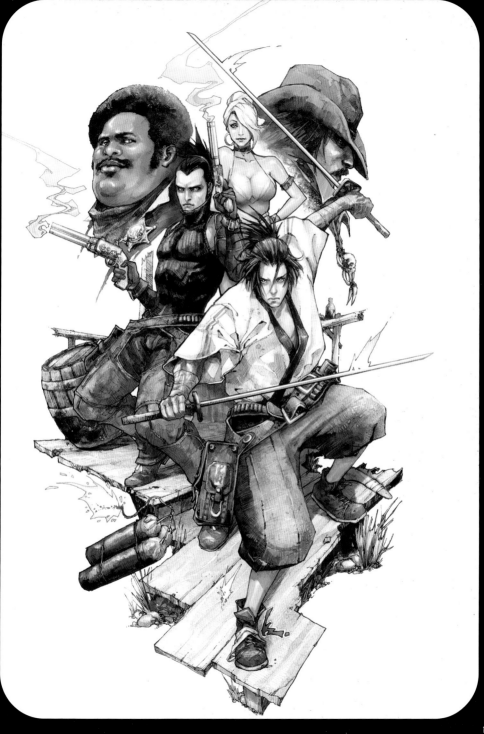

Sly Cooper from the Sly Cooper series. Publisher: Sony Computer Entertainment America. Developer: Suckerpunch Studios.

The Sly Cooper series is perhaps the most impressive example of a "cel-shaded" game. In cel-shaded video games, the game itself actually looks like a cartoon, with black lines separating each area of shaded color. The intention is to create a video game that looks as much like animation as possible.

artist William Vance in the case of "XIII" or street graffiti styles in the case of "Jet Grind Radio."

This prevalent stylistic influence in games is interesting for two important reasons. First, a decade ago, the link between games and animation or illustration was more direct: both were two-dimensional representations of fantasy or science-fiction archetypes and thus, it made sense that the older form would affect and influence the newer one. However, what is interesting is that as games made the leap into three-dimensions, game developers and designers carried this influence over and found brilliant and interesting ways to map these traditional styles into an extra dimension. "Jet Grind Radio," "Sly Cooper," and "XIII" all represent

excellent examples of how styles that we would normally consider to be highly two-dimensional have been given the dimension of depth by innovative game designers. Second, it is interesting that the animated, graphic novel and comic book forms are, to date, really the only influences that game designers have chosen to emulate in terms of stylizing reality. That is to say, the vast majority, if not perhaps all, game designs tend to choose from one of three stylistic palates: creating images that look as real as possible (whether the game is an imitation of reality or not), creating images that look like a comic book style, or creating images that look like animation ("Jet Grind Radio" being the notable exception to this rule in imitating graffiti).

The influence of Western animation in "Sid Meier's Pirates!" is clearly quite strong—what made this a conscious design decision?

"We all admire Western animation style, and some of us were actually trained as traditional animators, so a certain amount of that design quality naturally shows up in the work. However, the end product isn't nearly as "toony" as it might appear at first glance. A simple, clear line style that delineates form and simplifies the details was utilized for the character sketches—mainly for the sake of expediency and to give the modelers some room to add detail on their own. On the other hand, we wanted to get away from anything too realistic in "Pirates!," so we went with more heroic proportions and strong poses—which you are more likely to see in traditional animation than, say, a live-action film."

Were there specific design influences on "Sid Meier's Pirates!"?

"We looked to N. C. Wyeth (as any good pirate-game visual designer should) mainly for his solid figures and palette but also (unexpectedly) for the extreme simplicity of form he employs. Moebius was a major influence in the proportions and rendering of the figures. And although we will completely deny any visual similarity, Disney's Peter Pan was a touchstone. Not so much for specific stylistic touches, but more in the sense of designing a world that was somehow ours yet more vibrant and magical."

We can see quite clearly that, with the technological advancements of the last few years, game designers can now make any stylistic choices they desire. Games have proven they are capable of successfully converting two-dimensional styles to three-dimensions and we have to wonder what other styles we will see in the future—imagine, for example, games based on the art of Klimt or of Van Gogh.

But what is important is that, given the choices available to artists and designers, they have yet to create their own forms, forms with no stylistic reference in traditional media. We have to ask, when will game designers cut loose from the influences of animation or comic books (or film for that matter) and create "voices" that are clearly their own?

With the innovations of even just the last year or two in terms of game art and design, we should expect such voices to be heard soon and this question is one to bear in mind as we move into the next five to ten years of art and design in games.

Opposite page:
The evil pirate crew from Sid Meier's Pirates! Developer: Firaxis.

Illustration by N. C. Wyeth for Treasure Island.

Below:
Shion from the Xenosaga series. Publisher: Namco.

Lady Eboshi from Princess Mononoke, by Hayao Miyazaki.

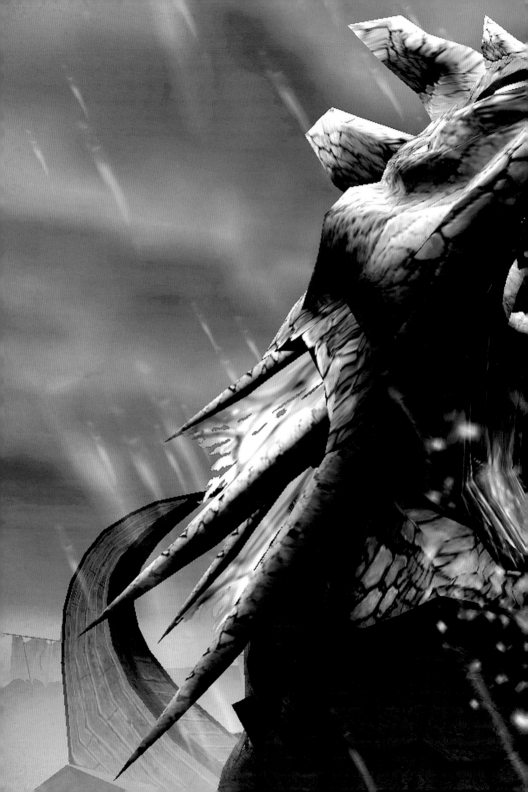

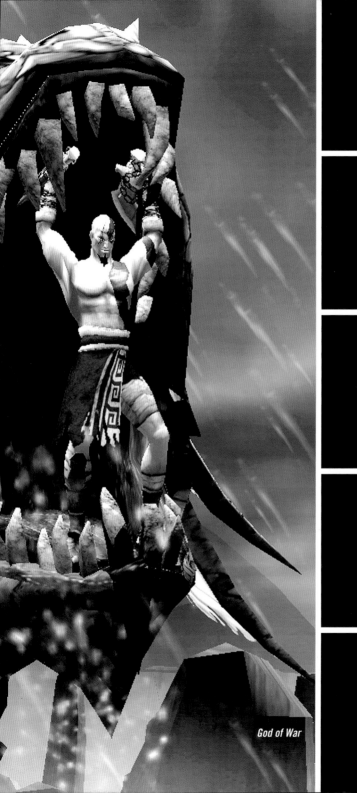

God of War

level 3
ANIMATE:
ANTAGONISTS & ALLIES

While the design of protagonists in games must always feature at least some humanizing elements a player can identify with, and environments are often restricted by the requirements of providing interactivity and exploration, the living inhabitants of game universes who are not heroes are often free of limitations. Consequently, they are among some of the most imaginative components of game design. After all, what does a "demon" look like? The Silent Hill titles and the Shin Megami Tensei titles have completely different interpretations. Or a "tree spirit"? Reference to "The Secret of Mana" and "Neverwinter Nights" again show completely different visual conceptualizations. Or the resurrected god of some ancient and forgotten alien planet? "Metroid Prime" and "Halo 2" differ widely on their visions of just such an entity. With such broad latitude for interpretation, creatures featured in games take on a remarkable array of forms and are worth examining under each of their major groupings— "enemies" (the minor creatures that attack the protagonist throughout a level), "bosses" (the unique and singular enemy that typically attacks the protagonist at the end of a chapter or story line), and "allies" (the creatures that aid the protagonist but are usually not controlled by the player). All of these types have their origins in similar roles played by beings in classical myths and narratives, which, as we will

Preceding pages:
**From God of War.
Publisher: Sony Computer
Entertainment America.**

Opposite page:
**From Oddworld: Stranger's
Wrath. Developer:
Oddworld Inhabitants.**
*The native resistance
leader and ally of The
Stranger.*

Following pages:
**From Darkwatch.
Developer: High Moon
Studios.**

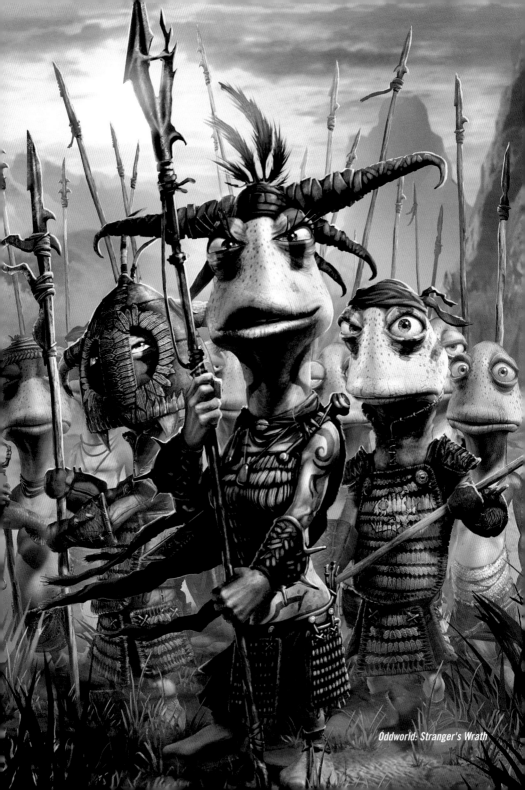

Oddworld: Stranger's Wrath

Cartwright

"A veteran of U.S. wars, General Cartwright took over the Darkwatch in the late 1860s. His no-nonsense approach, brutal tactics against the undead, and support of advancing technology earned him the steadfast loyalty of his troops. It was, however, his ambition that ultimately became his undoing..."

"Cartwright visually embodies strong Western icons such as Buffalo Bill and Custer, as well as their egos. When creating a new and strange vision of the Old West, building on traditional Western icons was critical. The player first needs to be grounded in something familiar before he or she can take a leap into more fantastical possibilities."

Bandito

"Banditos are another example of building on classical Western icons, then giving them a unique Darkwatch twist. As a silhouette, one of note we wanted to strike with the viewer was pointed hats reminiscent of the hoods worn by the Ku Klux Klan."

"Nightmares are wraithlike, undead duelists. The intent of their design was to create a creature underneath the cloak and top hat that is nightmarish. Inspiration was derived from common human fears such as spiders, human mutations such as sightlessness or the effects of severe diseases, and the notion of cannibalism. Nightmares prefer human flesh, but they will start consuming their own limbs if they grow hungry enough."

HIGH MOON STUDIOS

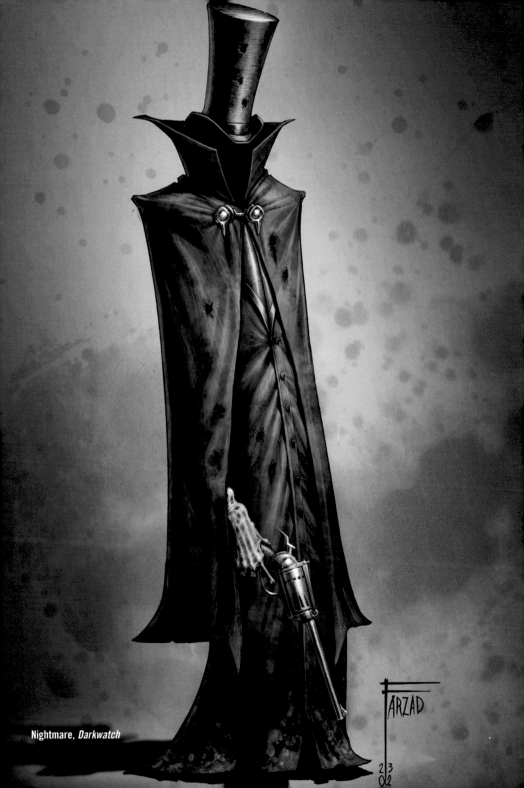

Nightmare, *Darkwatch*

FARZAD

Deep One, *Call of Cthulhu*

"I think their predominant color was a greyish-green, though they had white bellies. They were mostly shiny and slippery, but the ridges of their backs were scaly. Their forms vaguely suggested the anthropoid, while their heads were the heads of fish, with prodigious bulging eyes that never closed. At the sides of their necks were palpitating gills, and their long paws were webbed. They hopped irregularly, sometimes on two legs and sometimes on four. I was somehow glad that they had no more than four limbs. Their croaking, baying voices, clearly wed to our articulate speech, held all the dark shades of expression which their staring faces lacked.... They were the blasphemous fish-frogs of the nameless design—living and horrible..."

H. P. LOVECRAFT, "THE SHADOW OVER INNSMOUTH"
From The Call of Cthulhu. Developer: Bethesda Softworks

see, offer some excellent models for understanding the role of animate in games. However, the demands of the game format change the requirements of the art and design of enemies and bosses in some fascinating ways that are not true for allies, who tend to be much more similar in their design to their models in traditional narratives. Therefore, we will be focusing here primarily on the first two categories and touching only briefly on the third.

"Enemies" can, in many ways, be defined as the minor, nonenvironmental obstacles faced by players as they move through a game. Since the days of "Space Invaders," enemies often come in waves or groups and can usually be collected into species-like affiliations, with their physical characteristics often hinting at the difficulties they will present to the player. In this sense, there are influences on the visual design of enemies that necessitate that designers's imaginations be guided in certain directions. If a particular species is tougher than another species, it may wear armor, for example, or if it is faster, it may slither or have wings or additional legs. Furthermore, enemies often develop throughout the game, diverging into subspecies that look slightly different and have new abilities but can

An Ogre, a Horse Demon, and a Toad Demon from Jade Empire. Developer: BioWare Corporation.
These creatures are modern interpretations and reinventions of traditional Chinese mythological forms.

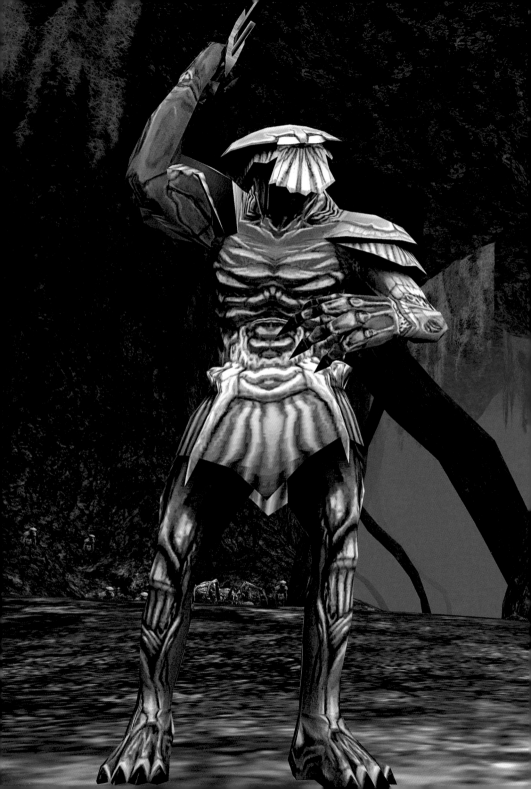

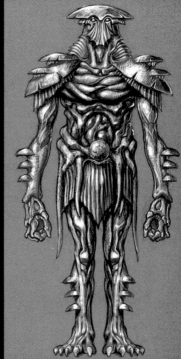

**A Terracite from Dark Age of Camelot.
Developer: Mythic Entertainment.**
*An excellent example of how enemies
are designed to feel like members of a
species, rather than individuals.*

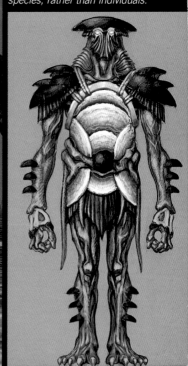

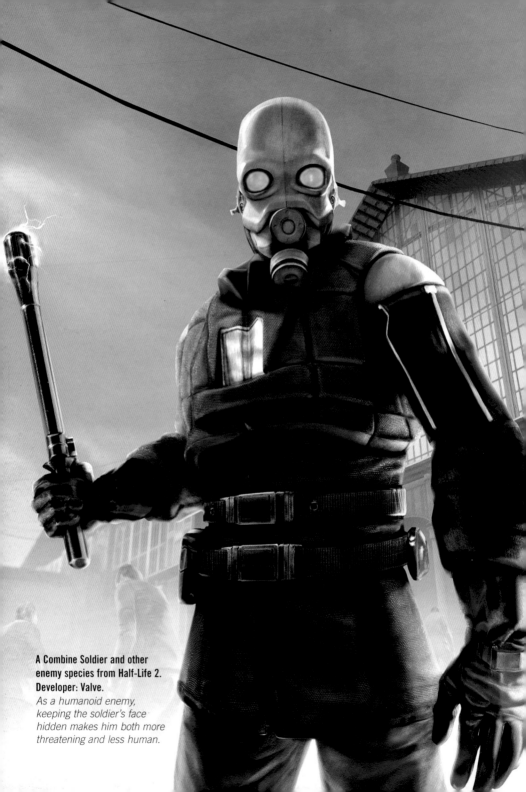

A Combine Soldier and other
enemy species from Half-Life 2.
Developer: Valve.

*As a humanoid enemy,
keeping the soldier's face
hidden makes him both more
threatening and less human.*

Half-Life 2

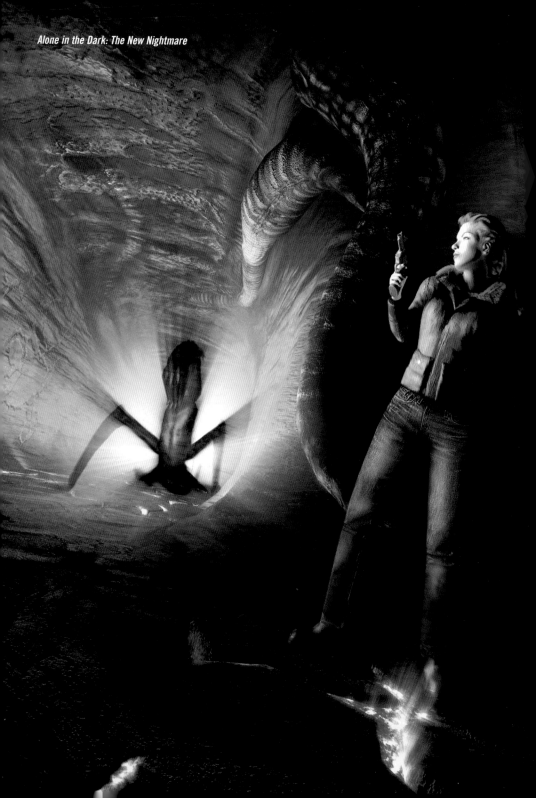

still be conquered using the strategies that defeated their forerunners. Enemies are very rarely human—and when they are, their faces are often hidden behind visors, helmets, or other headgear disguising their humanity. Whether in "Ninja Gaiden" or in "Project Snowblind," it is less ethically troubling to kill wave after wave of faceless human foes than "real" people (even if those people might be categorically evil, as they frequently are in the black-and-white mythic universe of games). As a corollary of their lack of humanity, they are also very often not intended to be perceived as intelligent; enemies are the henchmen of the game universe, intended as a test of skill, but not connected in any meaningful way with the narrative. Consequently, from a design perspective, if they are human, they generally signal their lack of intelligence with heavy brows, lumbering gaits, and dialogue that is less than scintillating, or are simply brainless zombies, single-minded killer robots, or dumb beasts.

In all these respects, these characters fit neatly into the picture of games as the modern outlet for our need for mythology—enemies in games are today's interpretation of the faceless hordes defeated by mythic heroes since

From Alone in the Dark: The New Nightmare. Developer: Darkworks.
A complete study of how an enemy evolves and is finally used in a game. We see here the initial concept sketch and painting, the real-world model that is scanned to create the digital model for game animations, and finally, the creature in its fully realized and rendered digital form.

the days of Homer. They do not have a name, but instead a category: Spartan, Roman, Gaul, in traditional mythology, and Cat-Demon, Metroid Type 1, Lesser Vampire in games today. It is not their individuality that matters, but their collective whole, and it is their sheer numbers that make their defeat impressive. Their division into these groups may be a by-product of limitations on game development resources, but even if the time and money to design and develop an infinite number of enemies for a single game were available, it still seems unlikely this would be the case. There is something about their predictability, about their division into species, which makes them more real. They mimic our understanding of the real world and the way human beings tend to categorize everything we see, particularly living things. Most enemies even have specific habitats within the gamespace, matching their areas and environments as if they had evolved within them in some Darwinian way. In role-playing games, we see Fire Dragons in pits of lava and Hydras in underwater caverns, for example, while in modern action titles we see Robot Guards in hi-tech laboratories and Mafia Thug Types 1, 2, and 3 in waterfront warehouses.

Taking all of this into account, we can look for certain patterns in the design of enemies that are essential to effectively fulfilling their function. To begin with, they must be threatening, but not too threatening. They have to appear to be a challenge, but they cannot steal the boss's thunder when he/she/it makes an appearance at the end of the level. Enemies' fangs can be big, but not too big; their weapons large, but not enormous. Even the scale of their overall body is usually on par with that of the protagonist (although, as

Below and opposite:
From Cold Fear.
Developer: Darkworks.
Here we see a particular subcategory of game antagonist—normal animals or humans that have been corrupted by either the supernatural or by science. The most familiar example of such a creature from mainstream mythos is the zombie, but the concept of the zombie is taken in many new directions in today's games—even becoming the protagonist in "Stubbs the Zombie."

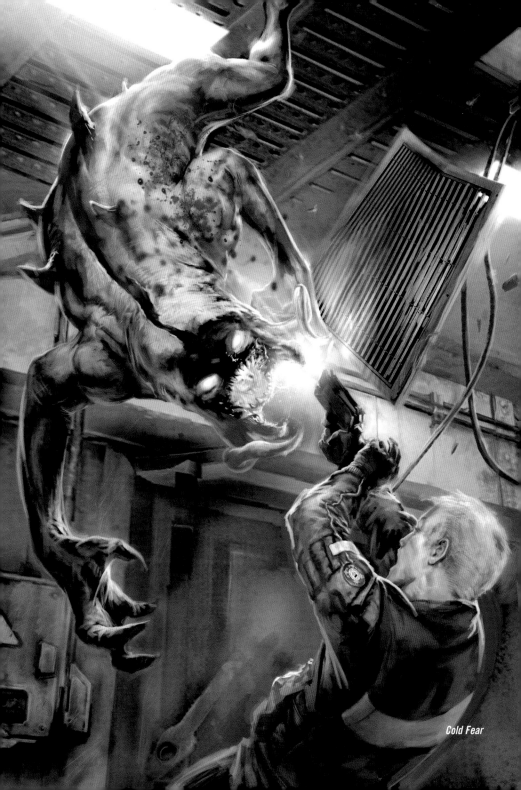

Cold Fear

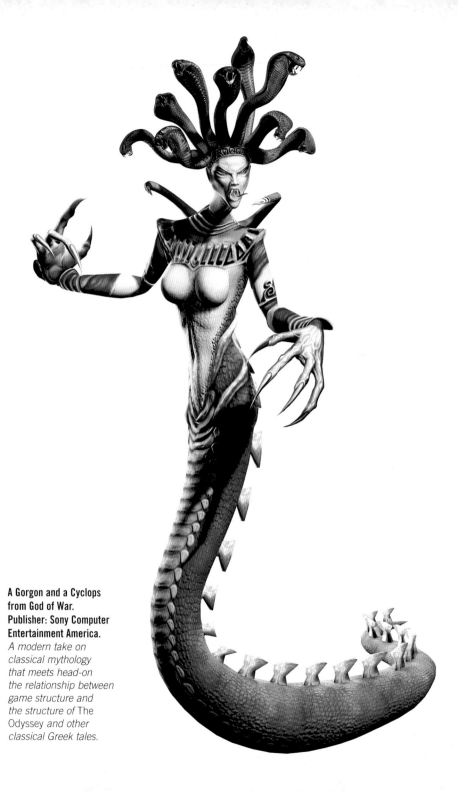

A Gorgon and a Cyclops from God of War. Publisher: Sony Computer Entertainment America.

A modern take on classical mythology that meets head-on the relationship between game structure and the structure of The Odyssey *and other classical Greek tales.*

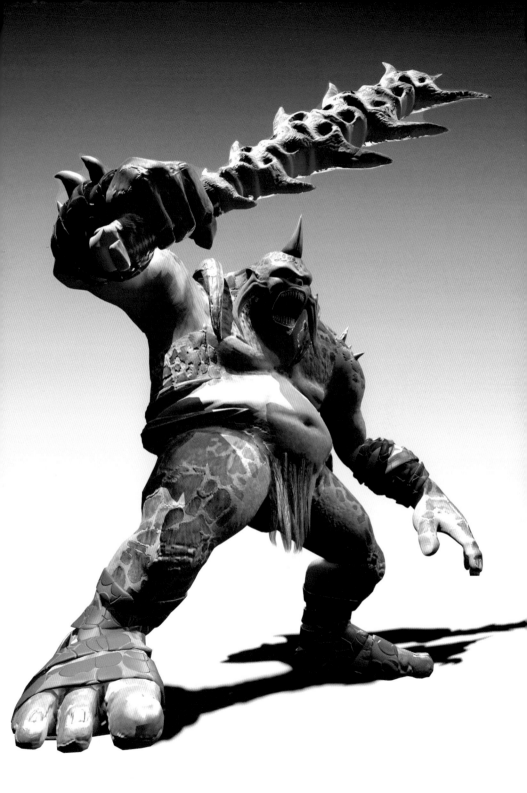

- Oyrim -

From Elder Scrolls III: Morrowind (left) and Elder Scrolls IV: Oblivion (right). Developer: Bethesda Softworks.
Studies of creatures in various attitudes and poses enable the final creature design to feel that much more complete. Even if such poses are never used in the game itself, they create the kind of depth necessary for making these creatures believably part of their own species and culture.

mentioned above, as subspecies of enemies grow in difficulty, they often also grow in size, explicitly demonstrating the common link in mythology between physical size and power). Getting this balance of danger correct is a design challenge met more often than not in today's games; but one of the best examples is provided by the Metroid Prime titles. In these games, we are introduced to enemies at the beginning that then gain powers throughout the course of the game in much the same way as the protagonist. When Samus Aran (the hero of the titles) acquires a new visor that allows her to see infrared signatures, she meets new, higher-ranking versions of an alien species that have invisibility cloaking devices. When she gains the capacity to use heat-seeking missiles, these same enemies also move up in rank, showing the ability to leap more quickly. Furthermore, the enemies throughout

each level provide a steadilyincreasing degree of difficulty,
which is then always surpassed by the level's boss.

In creating enemies, game designers are also meeting the
demand to create groups of creatures. What is it about an
organism that makes it seem to be convincingly and plausibly
part of one group and not another—or part of a group at all,
rather than a one-of-a-kind creature? How does one design
an imaginary being so that it can be easily modified to
indicate it is a more powerful version of an enemy
encountered earlier in the game? What is more, how can all
of this be achieved while making these elements seem
plausible biological adaptations to the game level that is their
habitat? Thus, when looking at enemies in games and
considering them from a design perspective, we should be
thinking about how designers have succeeded in answering
these questions and what new methods have been invented

Following pages:
From Fable. Developer:
Lionhead Studios.
The most familiar "boss"
of medieval literature
and art continues to be
a popular boss today.

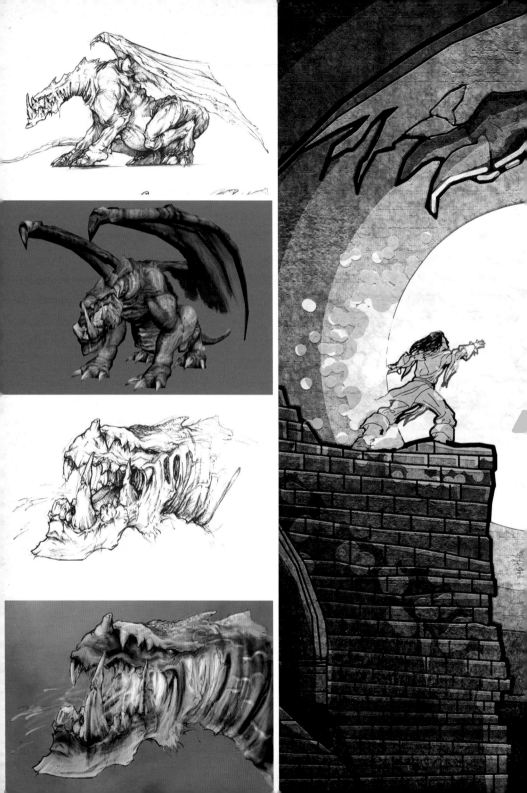

Fable

Blake from Mechassault 2: Lone Wolf.
Developer: Day 1 Studios.
The ultimate boss as religious/political leader—just one of the incarnations of the manipulative genius we are too familiar with in the real world. Concept art like that of Blake addressing his followers is used to not only plan out cinematic sequences, but to also convey Blake's character as he is developed, and to contextualize his place in the game universe.

to tackle them. Designing satisfying enemies that meet these challenges has led to the emergence of an interesting and broad array of design tools. Skin color, hair placement, costume, or types of limbs signal what group an individual belongs to, and thus, its difficulty level (and what strategy will work best to defeat it). Excellent examples of just such categorization are provided by "God of War," in which Minotaurs, skeleton warriors, Harpies, Cyclopses, and Gorgons all come in a variety of sizes, colors, and armors that indicate quite clearly the progression of difficulty. There is as much a codified design language for enemies in video games as there is in the graphic design of roadsigns or the industrial design of kitchenware. This language has not been universally agreed upon by some standards committee, but

has, instead, grown organically out of the cognitive cues we perceive instinctively. If a new enemy has wings, we know it might take flight; if it looks the same as an enemy we have already met but is larger or better armored, we know it will take more hits to kill it. With enemies divided into species and every species having its place, the gamespace in this respect again reflects, in a mythological way, our traditional understanding of the real world. Every species has its place and purpose, with man (represented by the player) at the center and using his understanding and ability to categorize those species and to then dominate them in some fashion.

In many ways, the "boss" position in games is the opposite of the enemies that usually precede it. In classical narrative, the nemesis is the single living creature that

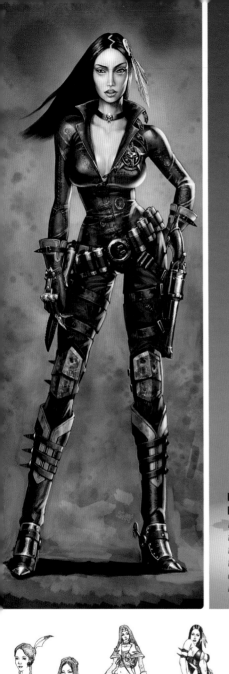

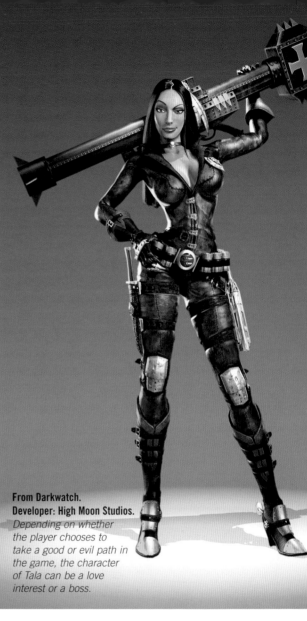

From Darkwatch.
Developer: High Moon Studios.
Depending on whether the player chooses to take a good or evil path in the game, the character of Tala can be a love interest or a boss.

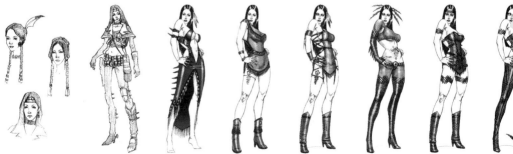

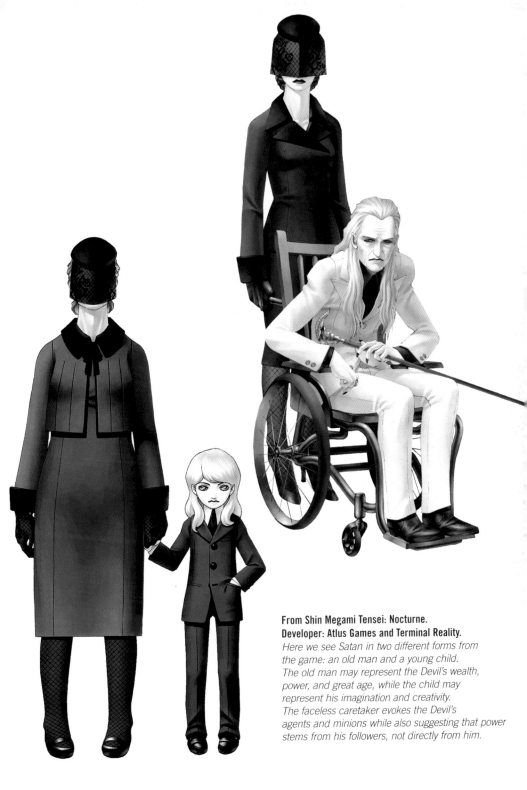

From Shin Megami Tensei: Nocturne.
Developer: Atlus Games and Terminal Reality.
*Here we see Satan in two different forms from
the game: an old man and a young child.
The old man may represent the Devil's wealth,
power, and great age, while the child may
represent his imagination and creativity.
The faceless caretaker evokes the Devil's
agents and minions while also suggesting that power
stems from his followers, not directly from him.*

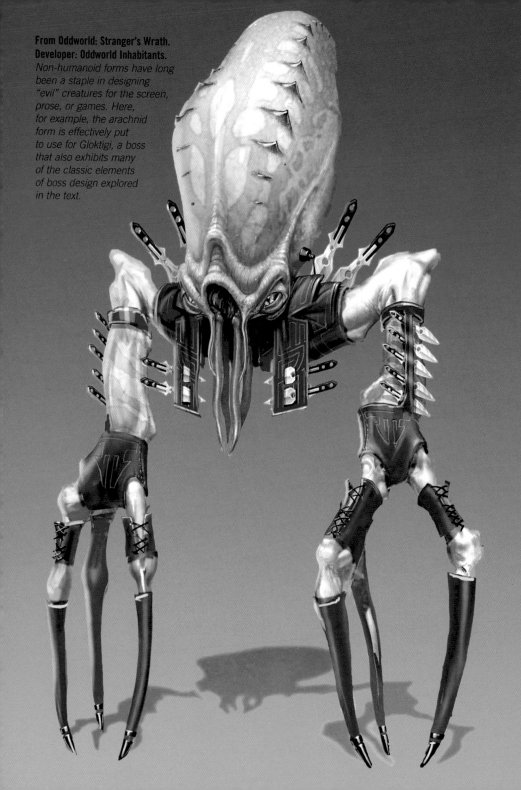

From Oddworld: Stranger's Wrath.
Developer: Oddworld Inhabitants.
Non-humanoid forms have long been a staple in designing "evil" creatures for the screen, prose, or games. Here, for example, the arachnid form is effectively put to use for Gloktigi, a boss that also exhibits many of the classic elements of boss design explored in the text.

embodies and presents the greatest obstacle to the protagonist. In games, the nemesis has a very concrete manifestation in the "boss." Bosses are unique and specialized creatures (or occasionally intelligent machines) that can mark the end of a level or narrative segment, but always mark the end of a game. As any book on formula screenwriting will tell its reader, for a satisfactory resolution of an action-based narrative, the protagonist must eventually come face-to-face with a single person whom he or she can defeat. It is not enough to solve problems or overcome obstacles—the narrative is not complete until the nemesis has been conquered. In mythological traditions, this formula, of course, predates film, by many

Above and below:
From Mechassault 2:
Lone Wolf.
Developer: Day 1 Studios.

millennia. What is *The Iliad* without Hector? What is *Beowulf* without Grendel or *Moby-Dick* without Moby-Dick? It is with reference to the specific myth of *The Odyssey* that we can perhaps best understand the role of the boss in games and thus the demands placed on its art and design.

If we look at the overall characteristics of the many nemeses of *The Odyssey* and the story's episodic structure, we see a near perfect mirror of game bosses, their designs, and their function—characteristics that are perhaps somewhat more easily perceived in a familiar narrative than they might be in games. In the same way that Ulysses moves from environment to environment in each chapter of *The Odyssey,* games present a progression of different levels with their own environmental characteristics. And just as in *The Odyssey,* the protagonist must defeat the nemesis at the end of each level, or chapter, before the narrative can continue. Furthermore, there is an ultimate nemesis responsible for the entire tale in the form of Poseidon, without whom Ulysses would have made it home somewhat sooner. Like most of the creatures that must be overcome in *The Odyssey,* the level boss in games is usually a unique being. Through its unique nature, the boss conveys a greater sense of importance to its existence and therefore a greater sense of satisfaction to its defeat. After all, if the protagonist is capable of defeating this unique creature, then the protagonist himself must be even more unique. Thus, while the point of enemy design is to show the enemy's place in a group, the point of boss design must be to illustrate the boss's unique nature. From a design perspective, bosses often show many of the opposite characteristics of enemies—asymmetry in their biology, such as oddnumbers of eyes or limbs (like the Elder God in the Soul Reaver series), armor or costumes unlike any other in the game (like all the bosses in role-playing games from

Opposite page:
From Mechassault 2: Lone Wolf.
Developer: Day 1 Studios.
In games where machines are the bosses or enemies, they frequently take on biological characteristics to make them more expressive and more capable of articulating a moral standpoint.

Following pages:
Death's Hand from Jade Empire.
Developer: BioWare Corporation.
A boss distinguished by his unique and elaborate armor. In this case, the character's overtly sinister design is used quite effectively to mislead the player into making certain narrative assumptions that prove to be untrue.

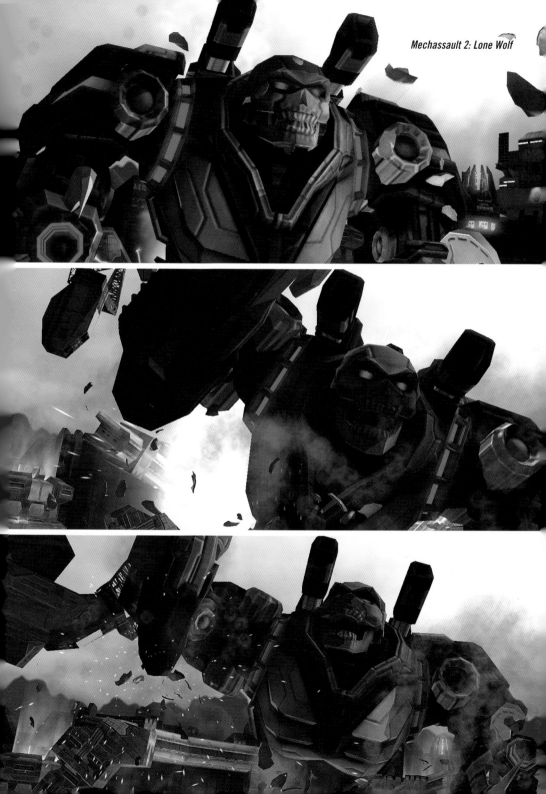

Death's Hand, *Jade Empire*

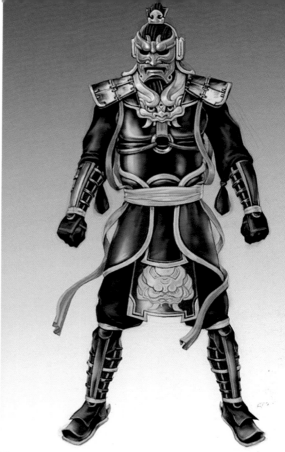

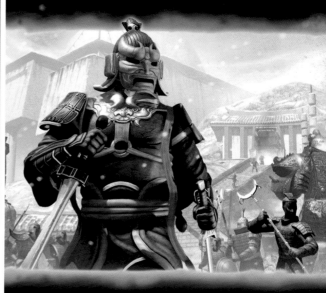

"Knights of the Old Republic" to "Xenosaga"; armor the player often gets to take after the enemy's defeat, just as in Homer); a unique environmental space that serves as their habitat, and which is often the key to their defeat (as in the Demon-Taur in "God of War"); etc. Even in the case of the "parent" boss (i.e., a creature that is the progenitor of the enemies on its level), there are many visual design cues that demonstrate its unique nature and position and therefore allow its status as gatekeeper to the next segment of the narrative to seem reasonable. Interestingly enough, the most common cue to the boss's nature is size, like so many visual cues to the mythic and epic nature of the characters and environments in games. If nothing else distinguishes them from the enemies that have come before, the bosses are always, at least, much larger than any creature on the preceding level.

Another characteristic of the boss, which again is intentionally in contrast to the characteristics of enemies and also recalls the nemeses of *The Odyssey,* is intelligence. While the preceding hordes of enemies the protagonist has faced and overcome are typically non-intelligent, the boss of a given level displays at least some degree of thought and intelligence. Again, this makes him or her a more worthy opponent of the protagonist (frequently, bosses are enormously intelligent if they are not enormous in physical size), but also allows them to be linked to the narrative structure of the game in a more meaningful way. The level's hostile environment and wave after wave of non-intelligent enemies may provide tests of prowess and skill, but without a guiding force behind them, without an embodied intelligence, the myth is reduced to the level of sport. From a design perspective, cues to the intelligence

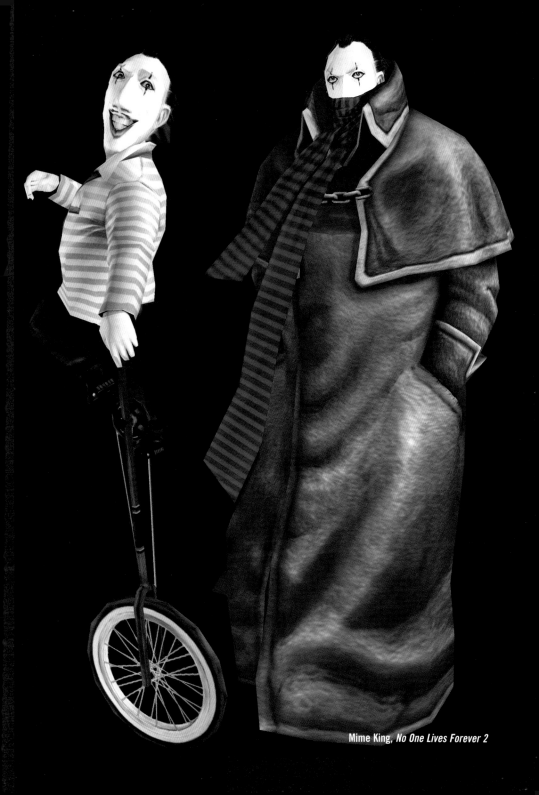

Mime King, *No One Lives Forever 2*

**The Scourge boss from Darkwatch.
Developer: High Moon Studios.**
*This boss demonstrates a variety
of the common features of bosses
that set them apart from "regular"
enemies and even includes some
minor enemies as part of his body,
graphically demonstrating their
hierarchical relationship.*

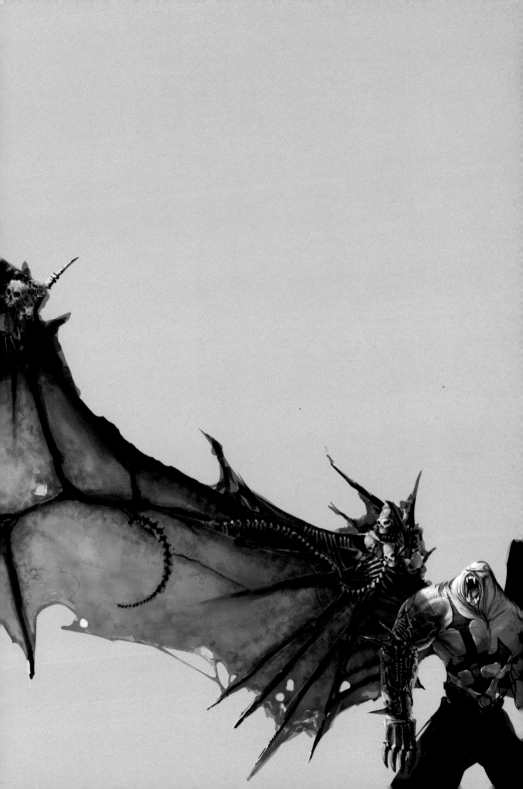

Janos and Vorador from Legacy of Kain: Defiance. Publisher: Eidos.

Interestingly enough, both the protagonists and the bosses in the Soul Reaver series are vampires, but of course, the bosses are less humanoid and more monstrous than the protagonists, symbolizing their status as force of evil.

of bosses—especially those that seem to be little more than dumb brutes on the surface—is frequently part of gameplay rather than visual design. For example, the creature's behavior often shows it to be intelligent, with a pattern of attack that is much more complex and reactive than the simple assaults of the enemies before it. However, visual cues to intelligence can also appear in boss design, from the obvious enormous and exposed brains (like Dr. Neo Cortex from the Crash Bandicoot series) to the monastic robes of a wizard signaling years of learning (like the elder vampire spirits in "Legacy of Kain").

The final important common characteristic of the nemeses in *The Odyssey* is that they each have a unique dangerous power and a unique weakness that allows them to be

overcome. Again, we see this characteristic mirrored in game bosses, and in terms of design, this may be the most important challenge to be met in their creation. Both the nature of their special attack and the "crack in their armor" must be visually perceptible, but not too obvious for satisfactory gameplay. When challenged, for example, by an apparently invulnerable boss that, every few seconds, opens its one enormous eye wider than usual, we realize we must aim for that eye at that precise moment. In addition, in the best designs, these strengths and weaknesses are related to and appear to derive organically from the boss's habitat, form, or both. For example we would expect a Hydra-like bosses to use floods, not fires, as their special attack, and they might be defeated by discovering how to drain their sacred pool.

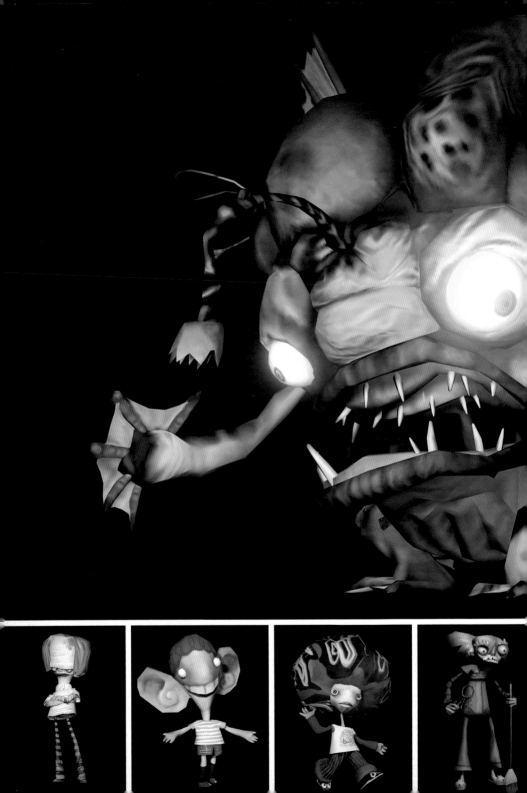

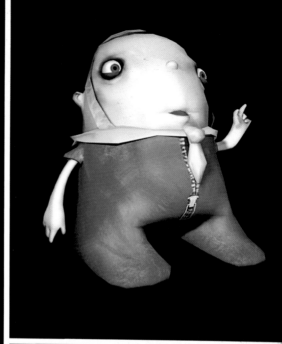

**The Lungfish and various allies and enemies
from Psychonauts.
Publisher: Majesco Entertainment.**
*The Lungfish here offers a perfect example
of how asymmetry is often used in video
game bosses to indicate uniqueness.*

Stede Bonnet

Roc Brasilliano

L.Olonnais

William Kidd

From Sid Meier's Pirates!
Developer: Firaxis.

Overall, then, we are reminded again of the close relationship between mythological traditions and video games: in both forms, there is a unique and worthy nemesis that provides satisfactory resolution to a narrative through its defeat. The visual design, therefore, of these creatures should be judged on its ability to reflect that important position in the game's narrative in beautiful and original ways. Furthermore, because this function is so explicit but also so compelling—the boss structure in games is perhaps the most universal—it may be able to teach us some interesting lessons about the function of narrative and the place of mythology in our lives. Why is it so satisfying that the

Bart Roberts **Jean LaFitte** **Henry Morgan** **Jack Rackam**

final obstacle in a narrative is a living creature—and preferably a thinking creature? Why are stories in which the hero overcomes a nemesis that is actively attempting to destroy him or her so much more interesting to us than stories in which the threat is faceless or environmental? Why is overcoming evil so much more compelling than overcoming simple adversity—particularly when the latter is a much more universal experience? The game boss might provide compelling answers to such questions upon further consideration and reflection.

As we saw earlier, the final major group of living characters in games are the protagonist's allies.

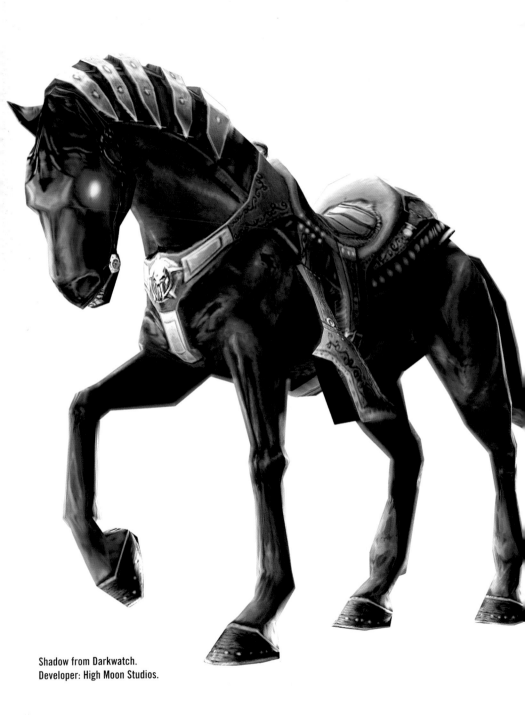

Shadow from Darkwatch.
Developer: High Moon Studios.

This is perhaps the most diverse group of beings in games since, unlike enemies or bosses, allies are not so limited or directed by the requirements of the game form. Allies in games can be the more classical love interests, trusty steeds, fellow heroes, or the comic-relief sidekicks of traditional narratives, but they can also take on highly original and creative roles in many innovative games. In the more traditional categories, we see a fascinating array of design requirements—from beauty and mystery in love interests like Ayane in "Ninja Gaiden," to visual indicators of strength or speed in steeds like Shadow in "Darkwatch," to humorous appearances in the characters providing comic relief, like Daxter in the Jak titles. However, because these allied characters are usually free from the kinds of restrictions gameplay places on enemies and bosses (they frequently play only a narrative role, not a gameplay role),

Elum from Oddworld: Abe's Exoddus. Developer: Oddworld Inhabitants.
Different takes on a staple of mythos: the hero's faithful steed.

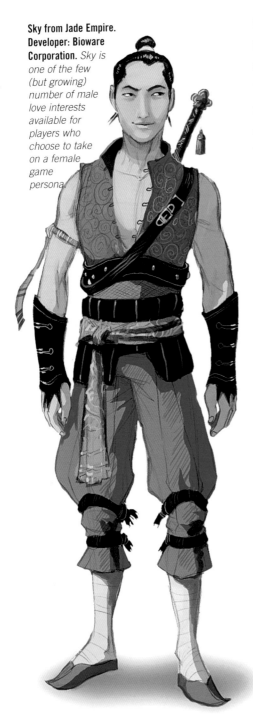

Sky from Jade Empire. Developer: Bioware Corporation. *Sky is one of the few (but growing) number of male love interests available for players who choose to take on a female game persona.*

these visual cues are not that different from similar characters in other media as mentioned above. We might expect a love interest or a faithful dog to look the same, for example, in a film or a book as we might in a game. The allied hero, for example, usually expresses his or her particular area of strength in ways that are found in traditional media—the biggest character is usually the strongest, or the one with glasses the most intelligent, as we see in some of the Wild Arms or Xenosaga titles.

There are, of course, some exceptions to this rule: for example, the prevalence of the tragic love interest in games. While the number of tragic or doomed heroes is growing in games as the medium begins to become aware of its artistic potential, it is extremely difficult to create a satisfactory mythic experience in which the protagonist dies. Consequently, the death of the love interest, as a narrative tool, is frequently used to infuse the story line of a game with more emotional impact that it might otherwise realize. In such cases, the visual design of the doomed character must include additional dimensions, such as the vulnerability signaled by the highly feminine costumes in the case of the Final Fantasy love interests.

It is also worth mentioning that there are some entirely new categories of allies that have been created due to the nature of the game medium. The best example may be the pet-as-tool ally. This has proved popular enough to become an entire subgenre of gaming, most familiarly known through the Pokemon titles. In traditional narrative, the place of the assisting animal is wellestablished—the dog that protects its owner, or the horse that carries the wounded cowboy home—but when the demand for interactivity is placed on these creatures and taken to its logical extreme, they take on a new role as the focus of entire games. These titles, and there are many, from "Monster Rancher" to "Jade Cocoon," have as their object the breeding and training of a variety of animals with the intention of achieving specific tasks—from winning duels to finding treasure. The design of these creatures is often related to their function—dueling creatures may appear fearsome, while creatures with more peaceful functions might appear cute and more petlike. Such titles are clearly intended to appeal to younger audiences and their desire for pets; indeed, there are no such titles aimed at adult audiences (which also contributes to the

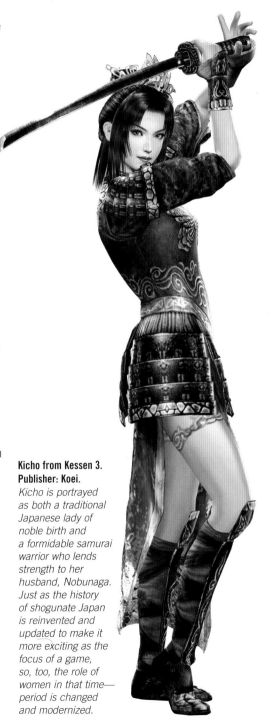

Kicho from Kessen 3. Publisher: Koei.
Kicho is portrayed as both a traditional Japanese lady of noble birth and a formidable samurai warrior who lends strength to her husband, Nobunaga. Just as the history of shogunate Japan is reinvented and updated to make it more exciting as the focus of a game, so, too, the role of women in that time—period is changed and modernized.

Monster Rancher 4

characters' often "cute" look). However, they are still intriguing from a cultural perspective: we again see man at the center of the animal universe (just as we do with enemies), but these games take our role as master of the biological world even further by tailor-making animals to achieve whatever tasks we must complete.

Overall, then, the creatures in games present an interesting paradox. In many ways, they are the aspect of games that is most closely derived from archetypes found in classical narratives and myths, but when compared to game protagonists (who must always exhibit some feature of their design that a player can identify with) or to environments (which must always offer some sense of mystery or interactivity), we find that enemies, bosses, and allies are among the most varied and spectacular elements of games in terms of their design. Game designers have found a remarkable array of solutions to such problems as what makes an enemy appear to be part of a species, what makes a boss's single weakness apparent but not obvious, or how do we make the impact of the love interest's death that much more significant? In fact, if there is one thing these creatures have to teach us about traditional media, it is that there may be room for improvement when it comes to the ways they are being imagined today in film, comic books, and genre fiction.

Opposite page:
Monster Rancher 4.
Publisher: Tecmo.
A good example of the extremely popular genre of "animals as tools" also found in titles like "Digimon" and "Pokemon."

Below:
Courtney Gears from Ratchet and Clank.
Developer: Insomniac.
Publisher: Sony Computer Entertainment America.
Courtney is Clank's love interest.

Destroy All Humans!

level 4
INANIMATE

Inanimate objects play a considerably more central and important role in video games than they do in traditional media. However, when we once again look to myth and legend, we see that this importance is to be expected, given games's similarity to and outgrowth from this form.

Preceding pages:
The Mothership from Destroy All Humans! Publisher: THQ.
A longtime tradition for "invading alien" narratives, the mothership represents the power and strength of the alien culture. This concept image from "Destroy All Humans!" offers a new take on a classic situation as the player assumes the role of the predatory alien and the planet Earth becomes the alien culture prime for exploitation.

Opposite page:
From Jak 3. Developer : Naugthy Dog. Publisher: Sony Computer Entertainment of America.
Even vehicles frequently assume epic proportions suitable for the heroes who drive them. Their size and power also suggest that only a hero would be able to drive them.

Because games are a visual medium and require some kind of progressive achievement throughout their narratives, rewards that are visible and tangible become the natural focal points of that progression. In early games of the 1970s and 1980s, being scored on your progression was sufficient, but this was because games in this early period were more simple tests of skill than narrative experiences. Indeed, the games today that would still be considered to fall into such a category (for example, puzzle or sports titles like "Frequency" or "NBA Live"), still use a points system for players to track their progression. Likewise, direct competition titles, such as the head-to-head fighting games "Tekken" and "Soul Caliber," do not need any indicators of success—all that matters here is if a player is beating his or her opponents with any regularity. But for most games today, the concept of a score has become meaningless, since the principal object is for the player to make his way through a narrative. Consequently, the easiest way for that progress to be tracked and clearly indicated is to reward players with something they can see: an object of some kind.

Jak 3

The Marvelous Dragonfly from Jade Empire.
Developer: BioWare Corporation.

The Marvelous Dragonfly is an excellent
example of how vehicles can serve as
linking tools between levels of a game.
In "Jade Empire," using the Dragonfly
allows the player to access progressive
levels and also allowed BioWare to
include a "mini-game" within the
larger game. As players move
from one level to another in the
Dragonfly, they access
a top-down scrolling "shooter"
reminiscent of Riverraid or Galaga,
making the transition between areas
more interactive and entertaining.

Since even before Perseus went to look for the winged sandals or the helmet of invisibility, the concept of the quest for an object that strengthens the hero in some way has been central to myth. Even recently, objects like the One Ring from *The Lord of the Rings* and the lightsaber from *Star Wars* have become central foci of the twentieth century's most popular new mythologies. A quest for a physical object is a simple way to build a plot structure that does not revolve around complex interactions between characters. It is also easy to see when such a quest has been completed. If there is one major hurdle video games have yet to cross, it is for players to be able to enter into realistic "personal" relationships with other characters (massively multiplayer games excepted, since here players are interacting with other players, not the game). Thus, until the field of artificial intelligence advances considerably further, the progressively more difficult obstacles that a protagonist must overcome in order to proceed through a narrative are most likely to have as their goal the attainment of a particular physical object (as opposed, for example, to convincing a character in the game to "like" the protagonist so that the story can proceed). What is more, since the purpose of the quests for these objects is to provide a series of difficulties that must be overcome before the story can be completed, it is also only natural that the objects themselves, like Perseus' sandals and helmet, should grant the protagonist who attains them the ability to move on to areas he or she could not reach before and perhaps also to conquer previously unvanquishable foes. The simplest example of such an object would be a key that opens a door the

Opposite page:
The sands of time from Prince of Persia. Publisher: Ubisoft.
The goal of the first narrative segment of "Prince of Persia," the sands of time grants the player the new powers necessary to advance in the game.

Below:
A completed lock puzzle from Legacy of Kain: Defiance. Publisher: Eidos.
Only when a series of quests have been completed, each granting ownership of another piece of the lock, can the player pass through the door and continue the narrative.

FORTUNE

ZERO

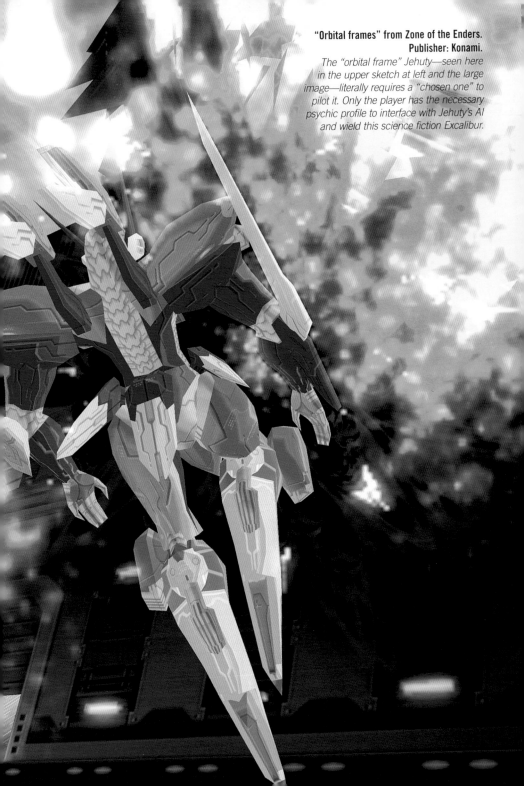

**"Orbital frames" from Zone of the Enders.
Publisher: Konami.**
*The "orbital frame" Jehuty—seen here
in the upper sketch at left and the large
image—literally requires a "chosen one" to
pilot it. Only the player has the necessary
psychic profile to interface with Jehuty's AI
and wield this science fiction Excalibur.*

Above:
Enemy battlemechs from Mechassault 2: Lone Wolf. Developer: Day 1 Studios.

protagonist could not open before. But this simple concept has been brilliantly interpreted and reworked many times over in games, so that today the key can take on various forms, from hammers or grappling hooks in games like the Zelda titles, to new limbs or cybernetic implants in games like "Deus Ex" or "Project Snowblind," to entire spaceships or giant robots in games like "Xenosaga": objects without which the protagonist is unable to pass on to the next area and phase of the narrative. It is true that sometimes the new abilities that allow the protagonist to progress are not externalized in the form of inanimate objects (instead being

internalized by the protagonist simply learning a new technique or gaining some new power, as in the martial arts role-playing game "Jade Empire"), but they are, by far, most frequently embodied in an object.

These objects then, as the point of a quest, as the thing that the protagonist has just worked his or her way through dozens of smaller obstacles to reach, receive an enormous amount of design attention since they must seem worthy of the effort the player has put in to reach them. It is not surprising, therefore, that we find some of the most beautiful artwork in the area of object design. From engraved swords

Following pages:
Player battlemechs from Mechassault 2: Lone Wolf. Developer: Day 1 Studios.
The player's mechs have more personality and are more unique than the enemy mechs. Even machines take on the typical characteristics of protagonists and antagonists in games, with the player in command of machines that are somehow special, and the enemies piloting cloned hordes of inferior machines.

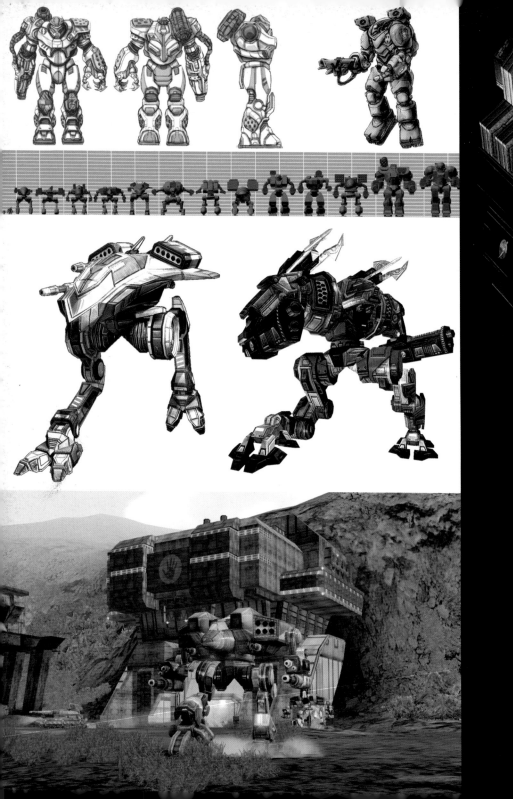

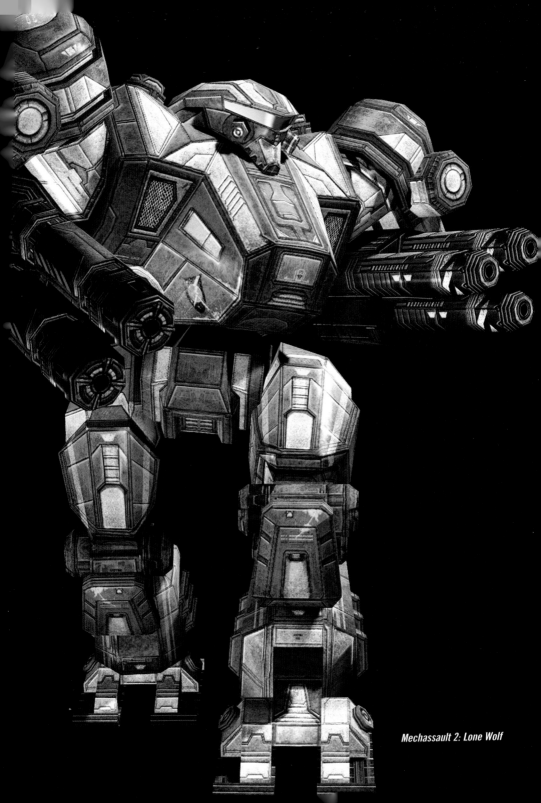

Mechassault 2: Lone Wolf

or armor in role-playing games like the "Elder Scrolls," to couture fashion designs in games like "Final Fantasy X-2" to intricately modeled vehicles in sci-fi games like "Pariah" or "Project Snowblind," we see work in games today that rivals, if not surpasses, the work found in Hollywood films in the related fields of prop and costume design.

The ability to show levels of detail in such objects has increased tremendously in recent years thanks to processor speeds being able to manage that complexity, and such objects only continue to grow more beautiful. With the ability at their fingertips to realistically represent metals, precious stones, fabrics, wood grains, marbles— almost any material or pattern—and the mandate to make the objects in games as spectacular as possible, designers in this field have begun to be limited only by their imaginations. The kind of authenticity offered by materials, and thus objects, that look real is also an important part of the design of games because it is often through such objects that we feel a world is real. Just as how the details in a piece of fiction create the illusion of reality, the authenticity of the objects in games works the same way. Thus, in a game like "No One Lives

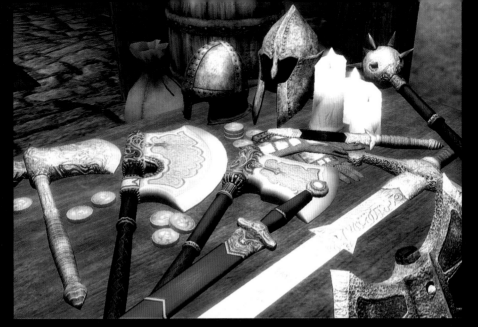

Above: **From Elder Scrolls IV: Oblivion. Developer: Bethesda Softworks.**
Below: **From Dragon Empires. Publisher: Codemasters.**
The details of weapons are extremely important in games, just as they are in classical and medieval myths. Players enjoy believing their weapon is a "storied" one and many games even include backstories for the weapons a player acquires, echoing Anglo-Saxon legends.

Opposite pages: **From the Prince of Persia. Publisher: Ubisoft.**
A protagonist's progression in power is often the result of his or her principal (or only) weapon growing in power or the protagonist learning new ways to use that weapon. The weapon's appearance also changes with time, emphasizing graphically the internal changes it undergoes.

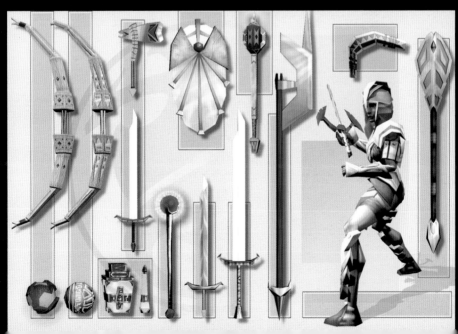

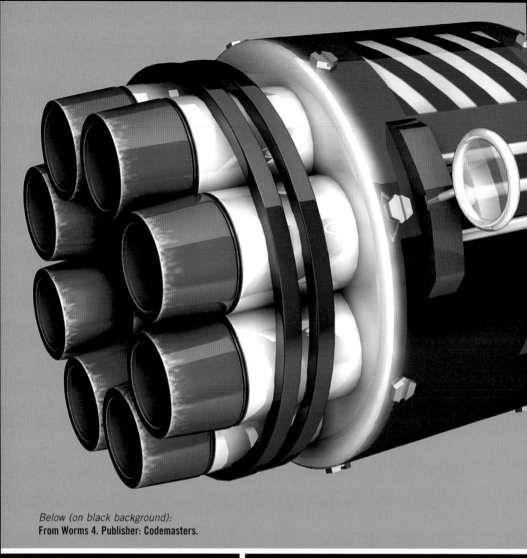

Below (on black background):
From Worms 4. Publisher: Codemasters.

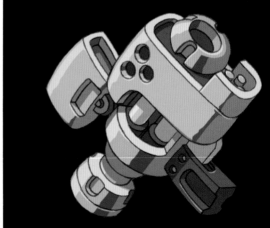

From Ratchet and Clank. Publisher: Sony Computer
Entertainment America. Developer: Insomniac.

M1903 Springfield - Game Model

**From Brothers in Arms: The Road to Hill 30.
Developer: Gearbox Software.**

6A1 Rocket Launcher "Bazooka" - Game Model

M1 Carbine - Game Model

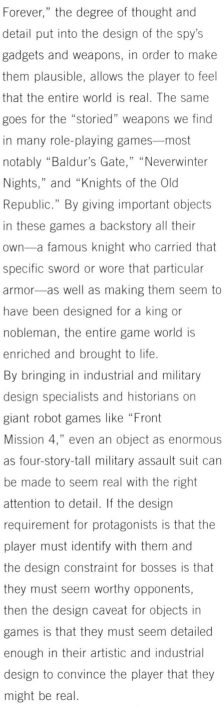

Forever," the degree of thought and detail put into the design of the spy's gadgets and weapons, in order to make them plausible, allows the player to feel that the entire world is real. The same goes for the "storied" weapons we find in many role-playing games—most notably "Baldur's Gate," "Neverwinter Nights," and "Knights of the Old Republic." By giving important objects in these games a backstory all their own—a famous knight who carried that specific sword or wore that particular armor—as well as making them seem to have been designed for a king or nobleman, the entire game world is enriched and brought to life.

By bringing in industrial and military design specialists and historians on giant robot games like "Front Mission 4," even an object as enormous as four-story-tall military assault suit can be made to seem real with the right attention to detail. If the design requirement for protagonists is that the player must identify with them and the design constraint for bosses is that they must seem worthy opponents, then the design caveat for objects in games is that they must seem detailed enough in their artistic and industrial design to convince the player that they might be real.

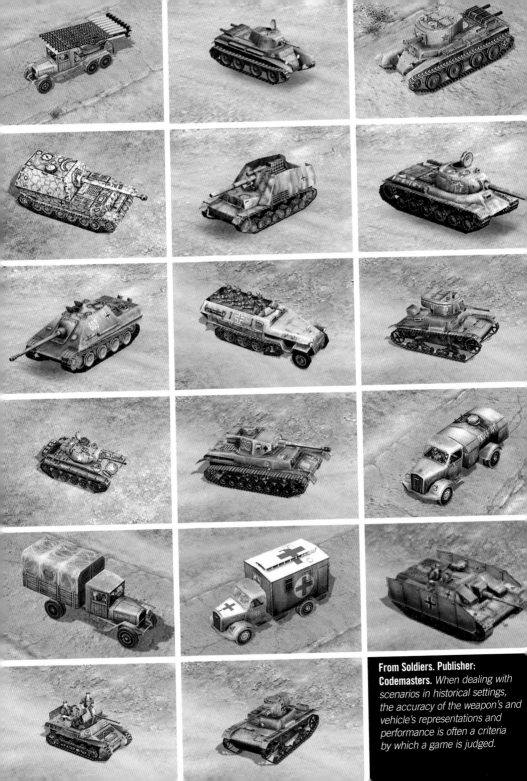

From Soldiers. Publisher: Codemasters. *When dealing with scenarios in historical settings, the accuracy of the weapon's and vehicle's representations and performance is often a criteria by which a game is judged.*

- gilding
- nationality color
- whitewash
- wood

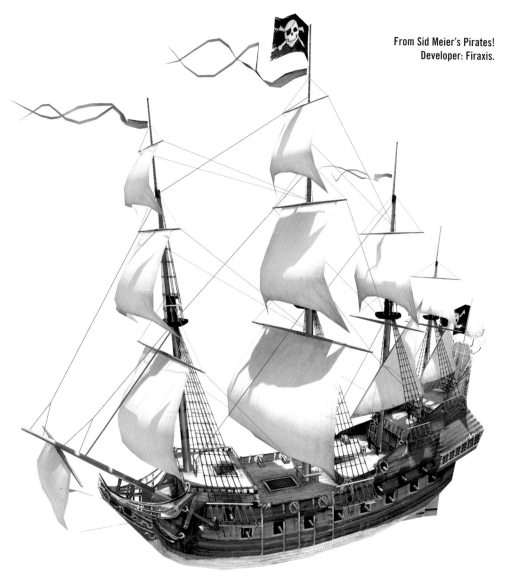

From Sid Meier's Pirates!
Developer: Firaxis.

Furthermore, we frequently see the objects in games take on mythic proportions themselves—giant robots to pilot in "Mechassault" or "Armored Core," enormous motorcycles that fly through space in "Final Fantasy X," flamboyant costumes in "Onimusha," oversized guns and other weapons in "Killzone." To match the spiritual stature of the

increasing popularity indicates, games clearly reach and satisfy some deep-seated needs, and when we examine in turn the importance of objects to a successful game, we must then ask ourselves what that importance means. In the mythic game universe, the world is clearly something to be manipulated, something to be altered in order to achieve the ends of the protagonist, and the way that manipulation is most often achieved is through the use of specialized objects. As mentioned above, the tool as a narrative focus for part of an epic tale is a familiar occurrence, and in games we see the theme of "find the sword, kill the dragon" repeated many times over in different and intriguing forms. But what is truly remarkable is that not only does this format continue to fascinate game players, but it continues to

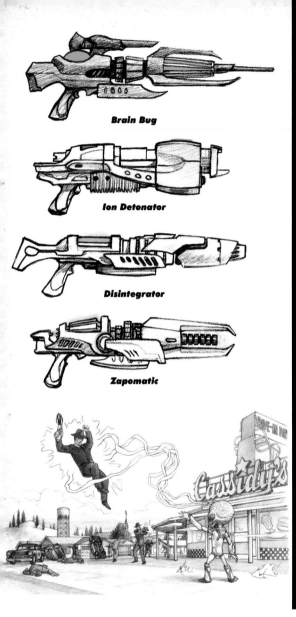

Brain Bug

Ion Detonator

Disintegrator

Zapomatic

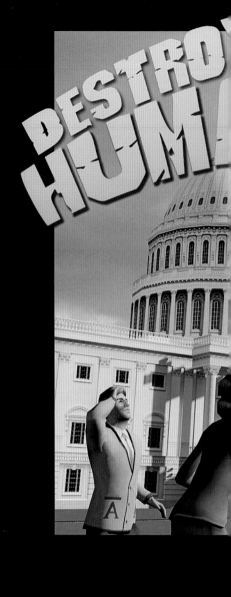

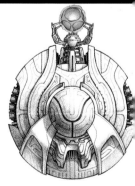

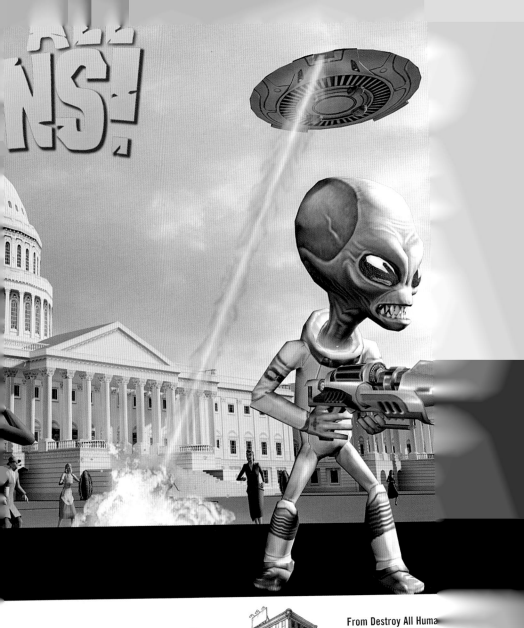

**From Destroy All Huma
Publisher: THQ.**

*The influence of 195(
is clear in these desig
Crypto's flying saucer
but the designs still n
incorporate enough n
technological detail to
current and exciting.*

From No One Lives Forever.
Developer: Monolith Productions.
*What is a spy without her gadgets?
These production design drawings
demonstrate the extraordinary length
designers will go to in making a universe
seem as real as possible. Everything from
a key chain to the way a rocket-launcher
briefcase might "really" work is meticulously
thought out to provide the level of detail
necessary for convincing a player
that this fantasy universe is real.*

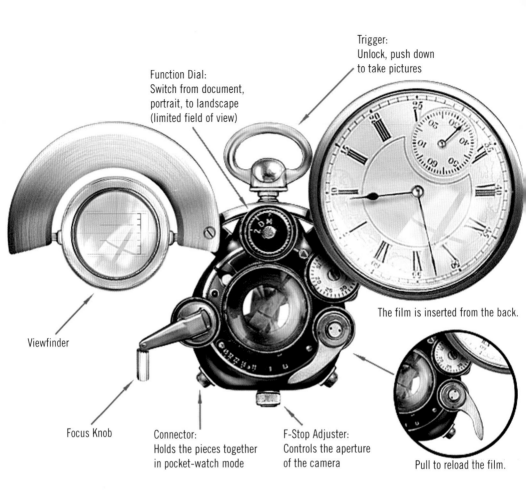

Function Dial:
Switch from document,
portrait, to landscape
(limited field of view)

Trigger:
Unlock, push down
to take pictures

The film is inserted from the back.

Viewfinder

Focus Knob

Connector:
Holds the pieces together
in pocket-watch mode

F-Stop Adjuster:
Controls the aperture
of the camera

Pull to reload the film.

"Steve Lee, one of our talented artists, designed most of our gadgets for "No One Lives Forever 1 and 2." Before joining Monolith, Steve studied industrial design, and he brought a wonderful sense of credibility to his gadget concepts. Having our gadgets look cool was the most important thing and making them functionally believable was something that we hoped to do but didn't restrict our designs by. For example, the belt buckle zip-hook isn't exactly plausible, but sometimes fun is more important than believable when

Inanimate objects play a considerably more central and important role in video games than they do in traditional media. However, when we once again look to myth and legend, we see that this importance is to be expected, given games's similarity to and outgrowth from this form.

From No One Lives Forever.
Developer: Monolith Productions.

Because games are a visual medium and require some kind of progressive achievement throughout their narratives, rewards that are visible and tangible become the natural focal points of that progression. In early games of the 1970s and 1980s, being scored on your progression was sufficient, but this was because games in this early period were more simple tests of skill than narrative experiences. Indeed, the games today that would still be considered to fall into such a category (for example, puzzle or sports titles like "Frequency" or "NBA Live"), still use a points system for players to track their progression. Likewise, direct competition titles, such as the head-to-head fighting games "Tekken" and "Soul Caliber," do not need any indicators of success—all that matters here is if a player is beating his or her opponents with any regularity. But for most games today,

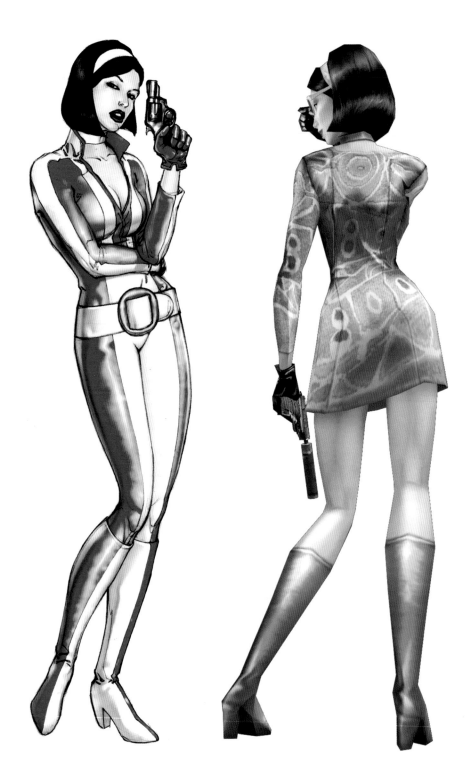

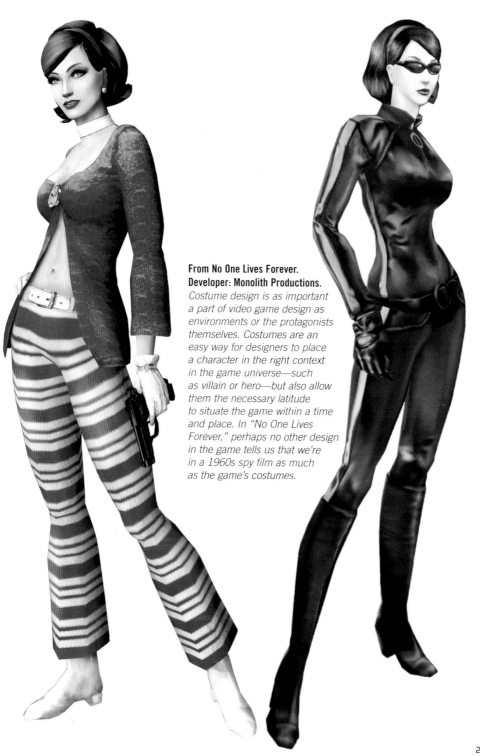

**From No One Lives Forever.
Developer: Monolith Productions.**

*Costume design is as important
a part of video game design as
environments or the protagonists
themselves. Costumes are an
easy way for designers to place
a character in the right context
in the game universe—such
as villain or hero—but also allow
them the necessary latitude
to situate the game within a time
and place. In "No One Lives
Forever," perhaps no other design
in the game tells us that we're
in a 1960s spy film as much
as the game's costumes.*

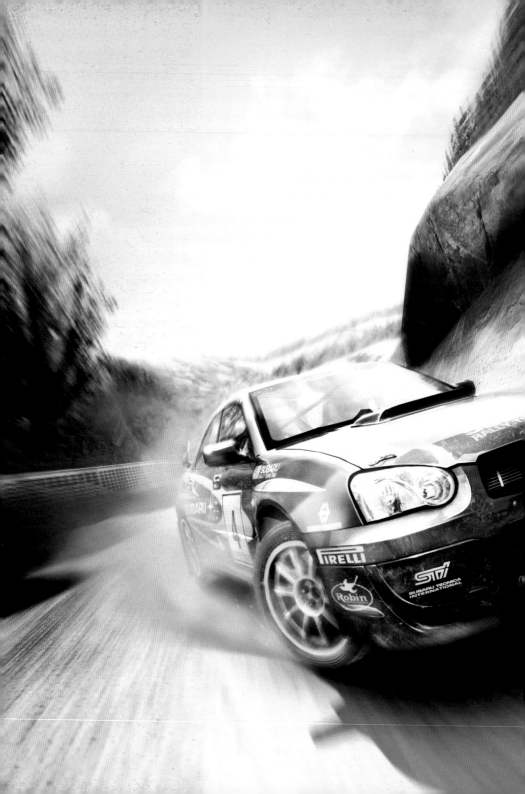

Colin McRae Rally 2005

level 1

level 2

level 3

level 4

level 5

level 5
IMITATION OF REALITY

Every year, games that imitate reality continue to grow in proportion to the rest of the industry as one of the largest subgenres. Once again, as progress in processing and storage technology continues to allow more objects with more rounded surfaces to be displayed on-screen at once, the ability of games to imitate organic objects like faces, bodies, trees, or grass continues to improve. And with this improvement, we have begun to see an extension of this subgenre, from its origins in sports and everyday life simulation, into other gaming subgenres such as military action or crime drama. With the continuing and increasing popularity of this sub-genre, it is worth looking briefly as some of its subcategories and some of the most important points about their art and design.

It is crucial to remember that the very first home video game, "Pong," was, at its heart, an imitation of reality. Before characters, before environments, before antagonists, the game of Ping-Pong was converted to video, however simply, and the centrality of sports simulation to video games continues to be of great importance today. Games like "Madden" football, "NBA Live," "Gran Turismo," and "Club Football" are among the most popular in the world and are considered "system sellers" in that there are entire subsections of the game-playing audience who own video game systems only so they can play these titles. In titles like these, the goal frequently is, quite simply, to imitate reality

Preceding pages:
From Colin McRae Rally 2005.
Publisher: Codemasters.

Opposite page:
From Tycoon City.
Developer: Deep Red.

if it feels good....

MEDI-COVER*

GLOBALCOM

GLOBALCOM
CONNECTING COMMUNITIES

CHILLED

GLOBALCOM
CONNECTING COMMUNITIES

HECKING

ANK

TIMES SQUARE

Tycoon City

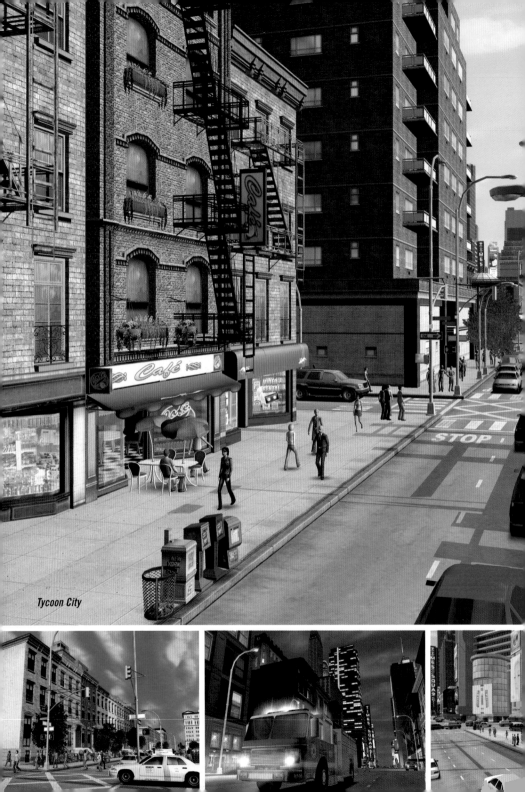

Tycoon City

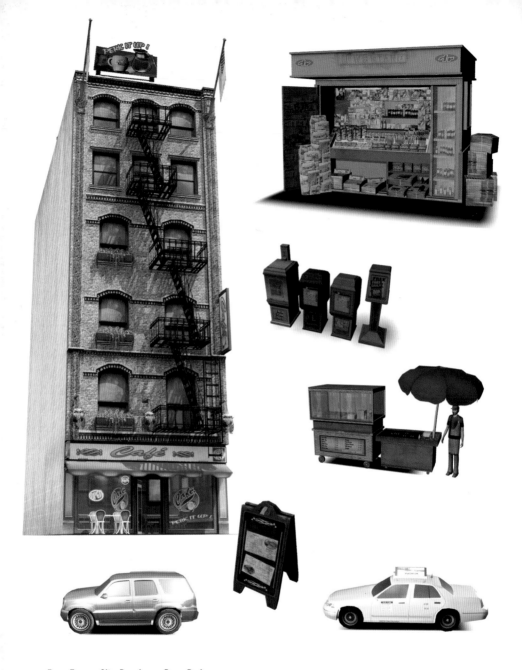

From Tycoon City. Developer: Deep Red.
The level of detail demanded today in simulation titles, combined with increased processing power, allows developers like Deep Red to achieve unheard-of degrees of reality. In these images from Deep Red, we see some examples of how the images on the preceding pages are built up from component parts, which are then combined using a proprietary algorithm that prevents duplication of objects, buildings, and people, thereby simulating reality more effectively.

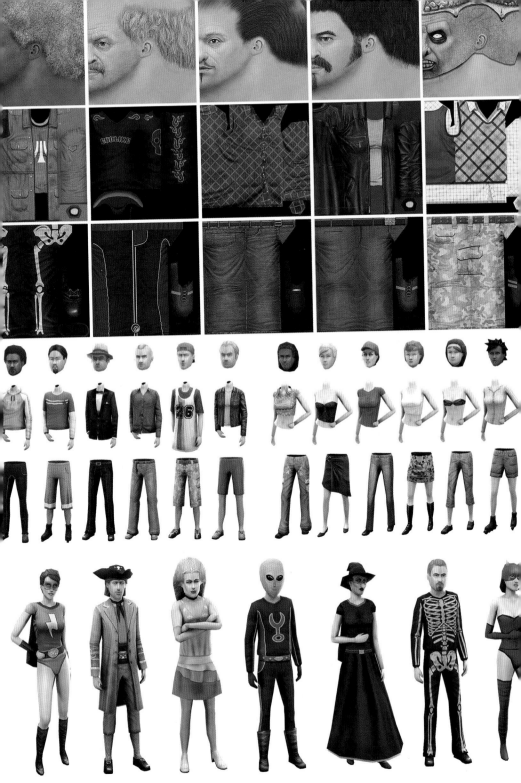

From Club Football and from LMA Manager.
Publisher: Codemasters.
In sports titles, the closer to reality, the better—especially when it comes to modeling not just the looks of the players but their motions. These must seem completely authentic for the game to be credible, and while motion is usually captured from the players themselves, it must still be tweaked by the developer for actual gameplay. Executing these "moving sculptures" is an art form unto itself.

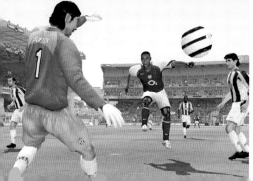

VIEIRA

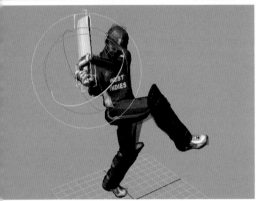

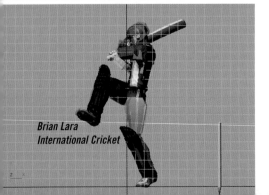

Brian Lara
International Cricket

as closely as possible. At its most basic, this goal is achieved by releasing new versions of such titles every year—or as often as possible—so that the games might include the latest players and team rosters. But beyond this, and in terms of their art and design, these titles are constantly trying to improve how close to reality they can appear visually. Whether representing players' faces and movements or populating stadiums with fans who cheer, move, and shout or in adding voice-over from real announcers who comments in real time on gameplays, the artistry of these games can typically be judged on how close it comes to convincing us that what we're seeing just might be real.

The next largest category of such games is what are typically referred to as "sim" titles. The groundbreaking game in this genre, developed in the late 1980s, was the original "SimCity," in which players attempted to design, build, and manage a modern city. But today, games in this category allow players to "realistically" design, build, and manage everything from roller-coaster theme parks, to zoos, to beach communities, to entire empires, both ancient and modern. This category also, of course, includes the phenomenon known as "The Sims" which, historically,

From Gran Turismo 4.
Publisher: Sony Computer
Entertainment America.
Developer: Polyphony
Digital.

was an outgrowth of the original SimCity titles. "The Sims" is noteworthy not only because it is the best-selling title of all time, but also because the largest proportion of its audience is made up of people who do not play (and have never played) any other video games. In titles like this one, the consideration when examining the art and design can be stated most simply by asking, on all levels, what did designers decide to include and why? In the enormous undertaking of re-creating entire subsections of reality (not "just" a sports arena or racetrack), decisions must be made about how best to represent a certain piece of reality. These choices extend from what dress patterns are available for your newest "sim" to wear to work or what color cat she can choose for her house (in titles like "The Sims") all the way up to how many thousands of men can be displayed at a re-creation of the Battle of Waterloo, or what major architectural achievements best represent 2,000 years of a particular country's history (in titles like "Civilization IV"). In games like these, designers are determining what best represents reality in much the same way that a painter or a novelist makes that same determination, and the work of these designers can be judged by asking the same question we ask of traditional media: Are their choices, and are their depictions, successful in creating the illusion of reality?

When a player tells his technology minister in "Civilization" that he wants to focus on the development of electrical engineering within his empire, does that minister respond intelligently to this directive? Or, if we focus on art and design, do the choices of shoes or furniture in "The Urbz: Sims in the City" seem appropriate for the time and fashion they are emulating? This illusion is not the same as the hyperrealism of sports simulations, or sims, because it is just that: an illusion created by designers consciously

Gran Turismo 4

Sgt. Matt Baker
502 PIR, Fox Company,
Platoon, 3rd Squad Leader

Lt. Col. Robert Cole
502 PIR
3rd Battalion Commander

Lt. Homer Combs
502 PIR, B Company
2nd Platoon Leader

c. Benjamin "Legs" Leggett
502 PIR, Fox Company
3rd Platoon Radio Opr.

Sgt. Greg "Mac" Hassey
502 PIR, Fox Company
3rd Platoon Sergeant

Pvt. Dale McCreary
502/F/3/3
Assault Team

Pvt. Jack Courtland
502/F/3/3
Assault Team

Pvt. Mike Desola
502/F/3/3
Assault Team

Pvt. Jeff Garnett
502/F/3/3
Fire Team

Pvt. Stephen Obrieski
502/F/3/3

Pvt. Johnny Rivas
502/F/3/3

Pvt. Tom Zanovich
502/F/3/3

choosing what they feel is the most important subset of objects, places, people, and scenarios. Unlike sports simulations, such titles do not relentlessly pursue greater and greater detail and accuracy in what they have achieved in past years; rather, they seek to broaden their scope, encompassing more subsets of the worlds they imitate, but still always deciding what to leave out and what to include. In addition, while such titles obviously draw on historical and current sources for their inspiration, ultimately these "imitations of reality" are acts of imagination. This is also critical to remember when looking at their art and design: everything you see has actually been created to appear real, but created nonetheless.

The final major category of this subgenre worth mentioning here is the relatively new military or crime action sim. Again, as improvements in technology have allowed the kind of realism found in the limited arenas of sports simulations to cover ever-increasing amounts of material in a single game, in the past few years titles like "Brothers in Arms" and even "Grand Theft Auto San Andreas" have extended the idea of the imitation of reality. In titles like these, the art and

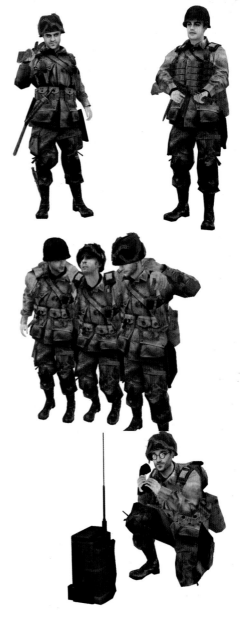

From Brothers in Arms: The Road to Hill 30. Developer: Gearbox Software.
In crafting believable fictional people, developers sometimes draw upon famous faces for inspiration. Many of the faces here are recognizable, and their familiarity lends the characters a degree of realism they may not have otherwise achieved.

From Brothers in Arms: The Road to Hill 30.
Developer: Gearbox Software.
These images show how designers might take real locations and redesign them slightly to suit the purposes of being a video game level, while still retaining a heightened sense of reality.

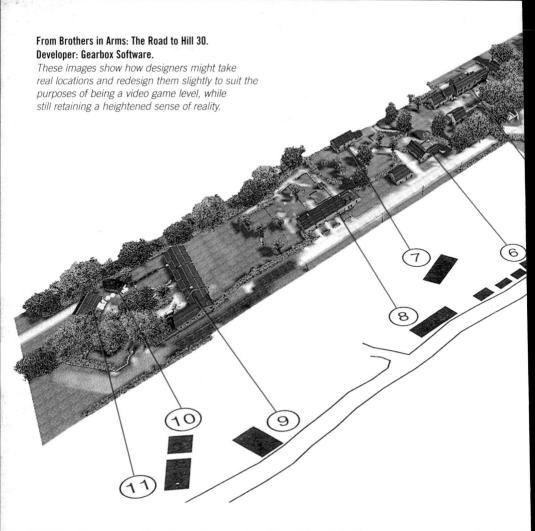

Building 11, Summer's Charge: *Building 11 was a large, two-story farm building that was used as a barracks to house a company of German troops. They started firing out of the windows at two different levels when Sergeant Harrison Summers attacked. Staff Sergeant Roy Nickrent, the battalion operations sergeant for 1st/502nd, arrived and fired a number of bazooka rounds at the roof of building 11. About 50 Germans were killed and the rest surrendered.*

Buildings 2, 3, and 4, Summer's Charge: *Sergeant Harrison Summers, armed with a Tommy gun, attacked Building 1 alone. In Building 2, Sergeant Harrison Summers found a sick child. Approaching Building 3, Summers got covering machine-gun fire from Private William Burt. Summers burst in and shot six more Germans. Building 4 was empty.*

Building 9, "XYZ" Complex: *This is a 1994 shot in building n 9 of the "XYZ" complex, showing the former dining hall used by German troop. Author's photo.*

Building 9, Summers's Charge: *Building 9 is a large, impressive chateau that the German artillerymen used as their mess hall. Summers entered and found 15 Germans seated at a long table, eating. They were either oblivious to the fight outside or, as Summers put it, "The biggest chowhounds in the German Army." At any rate, as they rose to get weapons, Summers swept the lot of them with his Tommy gun.*

9

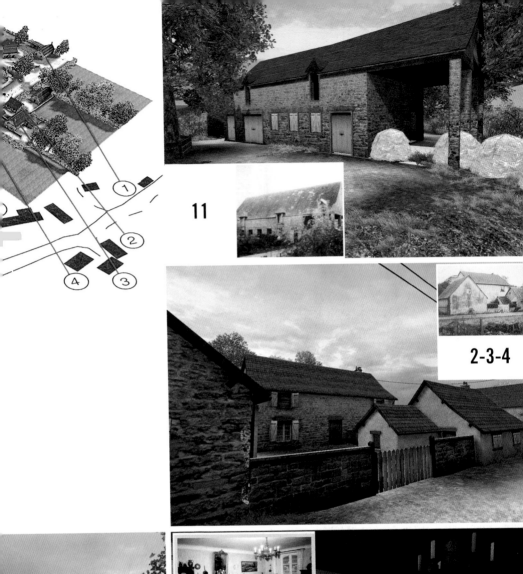

11

2-3-4

9-XYZ

From The Movies. Developer: Lionhead Studios.

An interesting entry into imitations of reality, "The Movies" re-creates the world of a Hollywood movie studio, placing the player in the position of simulating reality within a simulation.

design moves one step further than that found in sim titles, as game designers and artists interpret and manipulate real sources to create a "realistic" experience that is still a gameplay experience. In "Brothers in Arms" and "Call of Duty," real places are photographed and then rearranged to provide an environment that offers more challenges or clearer direction; in "Gran Turismo" and "Mafia," real fashion lines or makes and models of cars are used as sources, but are then enhanced or exaggerated to fulfill the epic needs of the narrative. Because these worlds are not as extensive as those found in pure sim titles, the designers certainly had the option of making reality in these games seem as accurate as it does in sports simulations. But in creating "as realistic" an experience as possible, they chose, instead, to "improve" upon reality. Just such subjective interpretation of reality is often said to be the heart of the artist's endeavor, and it is not surprising, therefore, that military simulations like "Brothers in Arms," at their best moments, become genuinely moving experiences.

The imitation of reality has always been at least one of the goals of the artist, but in video games, with the

ever-increasing power of the computer as their very medium, such imitations are rapidly approaching the point where they are capable of being indistinguishable from reality. However, as this point approaches and designers begin to be able to make decisions about what to represent based on choice rather than limitation, it begins to be worth asking of such games, as we would of any art form, what do they tell us about ourselves, about our perceptions of the world, and even about the nature of reality itself? With a medium like games, which is so unself-conscious, the answers seen in their mirror will very interesting indeed.

Advantage

39 Bad Guy (Rapier) 47 Pirates (Longsword)

39 Bad Guy (Rapier)

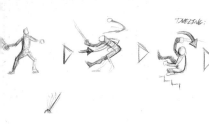

DUELING: FALLING DOWN STAIRS

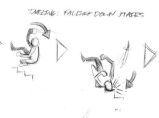

From Sid Meier's Pirates! Developer: Firaxis

Advantage

39 Bad Guy (Rapier) 47

35

"All of the animation in "Sid Meier's Pirates!" was hand-animated (no mo-cap) to make it more visually exciting, to communicate the state of the player-controlled-character (and his foes), and to illustrate a character's personal style. When the player character knocks an enemy dueler down some stairs, for example, the enemy bounces and rolls, taking care to hit every hard wooden step along the way (he's not doing so well in this duel). Then, instead of simply running down the stairs after the enemy, the player character leaps ten feet in the air and slides down the railing, landing confidently on his feet (illustrating his heroic nature)."

SID MEIER, DIRECTOR OF CREATIVE DEVELOPMENT, FIRAXIS GAMES

"We try to put the player in a situation where they can be something really great—king, pirate captain, tycoon, entrepreneur—and present an interesting, dynamic, and visually exciting world in which they can have an adventure, build an empire, conquer the world, etc. Through decisions he or she makes as he or she plays the games, each player will create his or her own story...a story that is all his or her own."

FIRAXIS

SMALLE
TEMPLES

MAIN
TEMPLE

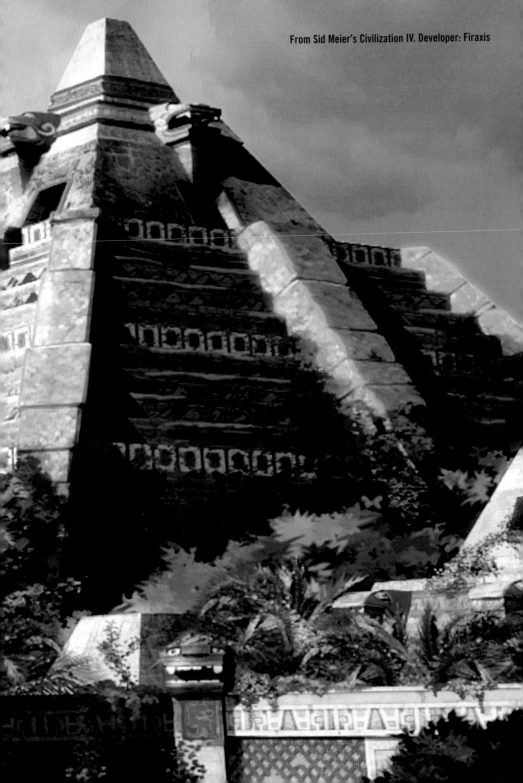
From Sid Meier's Civilization IV. Developer: Firaxis

CONCLUSION

What is art? Does the *Mona Lisa* qualify? The works of Shakespeare? What about the Tiger Shark Damien Hirst preserved in formaldehyde in 1991, titled *The Physical Impossibility of Death in the Mind of Someone Living,* which recently changed hands for $12 million? There are so many answers to this question, so many theories, so many ways of looking at the question, especially today, when most people feel the term "art" has lost any true meaning. So, when a book like this one presents as art a medium stereotypically seen as little more than violent entertainment for young boys, it is not unlikely that many people's initial reactions will be skeptical.

But if those same people look carefully at these pages and see the depth of thought and degree of talent behind the creation of games today, it's difficult to believe that even the most hardened skeptic would not perceive the extent to which games now engage us in themes and issues that have always been central to art. For example, there appear to be many unique characteristics of the medium that might make it the most powerful form of expression to date for themes of a mythological or legendary nature. In this respect, games could even be said to represent art in its most pure, most unadulterated form—what, after all, are the first cave paintings if not depictions of individuals, spear in hand, overcoming wave after wave of beasts or other men in the face of an adversarial environment?

Opposite page:
Ghandi from Sid Meier's Civilization IV.
Developer: Firaxis.

Ghandi, Sid Meier's Civilization IV

From Rag Doll Kung Fu.
Developer: Mark Healey.
Just one more interesting direction that game development is taking: independent video games of professional quality. Just as digital technology has revolutionized the filmmaking industry, cheaper and cheaper processing power and storage is revolutionizing video game development and promising more latitude in artistic interpretation. Here we see a tongue-in-cheek homage to the kung fu films of the 1970s, which stars the developer himself.

It is true that the unique presence of interactivity in this medium and its early, toylike origins cloud the issue and make it hard to understand exactly how video games might work inside our more conventional ideas of art. But these should be seen as challenges to our understanding of what art really is, not as excuses for excluding a new medium that clearly, even if only on an intuitive level, we sense has become an art form. Interactivity certainly sets video games apart from more widely accepted forms of art, and the addition of this dimension to a narrative definitely makes that narrative a different experience than it would be on paper or on the movie screen. This does not mean, however, that it somehow changes that narrative from an artistic endeavor to one of pure entertainment. It simply means there are changes in the way that story must be told, changes in the way it is experienced, and ultimately, perhaps, changes in the way we must think about art. Furthermore, just as digital technology has revolutionized the filmmaking industry, cheaper and

cheaper processing power and storage is revolutionizing video game development. As it becomes more possible for individuals to create professional-looking games, it is not unreasonable to expect that we will see increasingly diverse types of artistic content in the games themselves.

No one would argue that the elements of games like those shown in this book have attained the status of art. From the design of characters and costumes to that of environments and enemies, every component of games has clearly achieved a level of artistry in recent years that rivals similar attempts in traditional media. What is still in need of definition, however, what still needs to be understood more deeply, is how games as a whole can become part of our understanding of art. Video games may not fit our most traditional definitions of art, it is true, but they just might make us reconsider these definitions whether we want to or not.

VIDEO GAME PRODUCTION PROCESS

Concept Phase

The lead designer, usually in conjunction with other designers, conceives the game concept: What genre, characters (if any), and story line (if any) will the game feature.
Will it invent its own genre or fall into an established one? (etc.)

Prototype Phase

A prototype of the game is "built." This prototype will contain all of the key elements of core gameplay in a limited fashion but still give a sense of how the complete game will play and what it might look like. In this phase, some of the key core design work on characters, environments, etc., will be executed, although it may be altered in the next phase.

Preproduction Phase

Paper art and design process begins in earnest. Keyart—a single large image encapsulating the look and feel of the game as a whole—may be created at this stage or in the prototype phase. Key character sketches, environment sketches, and so on are begun, and the story line, as well as any cinematic segment storyboards are created. Audio scoring is begun. In addition, during this phase technical design issues are mapped out, such as what tools might be used to program the game, how control schemes might work, etc.
Finally, a single segment of the game is completed during this phase to serve as a model for the rest of the game. This segment may or may not be based on the prototype.

Production Phase

Production begins in earnest. Characters and environments are translated into the digital medium through a variety of methods and tools: for example, sculptures may be created by hand and then scanned into the computer as a basis for the three-dimensional computer model. Textures—flat images that appear to contain shading as well as other details—are created for characters and environments and then "wrapped" around the three-dimensional models. A variety of software tools and programs are used for these processes. As different characters, environments, and so on are completed, they are put into motion, have sound and effects added, and begin their integration into the completed game. Motion may involve motion capture technology for realism, sound may involve recording actual vehicle or weapon sounds as well as dialogue and music recording, and effects may include proprietary technologies used to make smoke, fire, water, changing light, and so on look as real as possible. As this process occurs, the programming of the gameplay that will finally bring all of these elements together is also executed. This includes such obstacles as ensuring that different objects interact the way they are supposed to, the camera moves correctly around the action, and non-player characters behave intelligently.

Tuning/Quality Assurance Phase

In this phase, early "completed" versions of the game, known as "alpha" or "beta" "builds," are tested extensively to find faults that are then corrected. Other elements might also be tweaked such as musical cues, dialogue recording, or even specific textures. It is at the end of this phase that the game theoretically receives its ESRB (Entertainment Software Rating Board) rating.

Marketing Phase

Final packaging and advertising are determined, and the game's final marketing push begins. This step can be as complex—and expensive—as the marketing of a major Hollywood film or CD release.

It is important to remember that these phases are never so concretely defined as they are above. They often overlap—sometimes by two to three months—and many individual elements of game production may begin well before their official "phase" and end well after. Marketing, for example, tends to begin quite early in the life of the game, and if the game relies on a brand-new software engine for its gameplay, the engine's development may begin hand-in-hand with the game concept and may continue right up until the end of the tuning phase.

TIME LINE

1958

William Higinbotham (a former Manhattan Project scientist) and Robert Dvorak assemble **"Tennis for Two"** using an oscilloscope as the video display and two controllers, each with a dial to control the racket angle and a single button to hit a "ball" back and forth over a "net."

1961

In order to fully demonstrate the capabilities of the new mainframe computer at MIT, the Digital Equipment Corporations PDP-1, a group of programmers, develop **"Spacewar!"** The game pits two simple spaceships against each other against a background of stars on the $120,000 computer and uses up a total of 9 kilobytes of memory (versus, for example, 2 million kilobytes or more for games today)

1966–1972

Ralph Baer conceives of a way to make television an interactive experience using a device and two controllers that would allow players to compete against each other in Ping-Pong, hockey, volleyball, and the like on their television sets. Baer and Bill Harrison build a prototype that, after a few years, is eventually built for the mass market by Maganvox and sold as the Odyssey game system, retailing for $99.99. Magnavox sells 100,000 units at release.

1971

Nolan Bushnell markets a version of "Spacewar!" to bars as the first arcade video game—the three-button, single-dial **"Computer Space."** The game does not sell well.

1972

Bushnell and Ted Dabney establish Atari (named for a particular game state in "Go") with $500. They go on to develop and market the second arcade game, **"Pong."**
"Pong's" instructions read simply: "Avoid missing ball for high score."

1973

The arcade market explodes with a variety of companies marketing a range of games including **"Tank," "Drag Race,"** and **"Sprint."**

1974–1976

Atari creates a home version of "Pong," which, at $100, becomes Sears's number one selling item for Christmas 1975, with 150,000 units sold. Warner Communications buys Atari in 1976 for $28 million.

1976

"Death Race 2000," a game based on the 1975 Roger Corman movie, becomes the first video game to be based on a movie and also the first video game to be removed from the market after outcries over its violent content—a square monochromatic "car" chasing down monochromatic stick figures against a black background.

"Breakout" is released by Atari.

1977

Atari produces the second major home "video computer system" after failed attempts the previous year to imitate the earlier success of the Odyssey system by other companies. The Atari unit retails for $200 with very little profit, but the game cartridges, including **"Combat,"** which ships with the system, cost almost nothing to produce and are sold for $40. This establishes a pricing model for home game systems that continues today.

1977–1981

The year of *Star Wars* release, the first arcade game to feature "vector graphics" is released—another version of "Spacewar!" Vector graphics technology allows faster gameplay with clearly defined objects and proves popular. Several titles are released using this technology, including **"Star Castle," "Battlezone,"** and **"Tempest."**

1978

Toshihiro Nishikado, working for Taito, a manufacturer of arcade Pachinko games, creates **"Space Invaders."**

selling 70,000 units, becomes the most popular arcade game of all time.

Namco, a Japanese former manufacturer of merry-go-rounds, releases the first-ever multicolored video game, **"Galaxian."**

The first "Multi-User Dungeon," or **"MUD,"** is invented by Roy Trubshaw at Essex University. A series of interconnected imaginary rooms, entirely text-based, allow multiple users to "move" from room to room by entering text commands and then interact with other users in those rooms, as well as monsters.

1980

Taito introduces the first video game to integrate speech with the arcade game **"Stratovox."**

Moru Iwatani, working for Namco, creates **"Puckman"** (in Japanese, *pakupaku* means to open and close the mouth), later named **"Pac-Man"** in the U.S. to prevent unwanted graffiti. "Pac-Man" becomes the new best-selling arcade game of all time, at 300,000 plus units worldwide, the first game to feature levels, the first game to feature a protagonist, and the first game to have other media based on it, such as a cartoon.

Mattel creates Intellivision for home use —the first serious competition to the Atari system, now called the Atari 2600.

1980–1982

After losing money on their system for nearly three years, Atari licenses "Space Invaders" for home use. This year Atari grosses $415 million and invests the capital to develop more than 200 games. More than 15 million systems are sold, and titles like **"Barnstorming," "River Raid," "Pitfall," "Missile Command,"** and

1981

Universal produces the first "platformer" game, **"Space Panic."**

"Centipede" and **"Frogger"** are released as arcade games.

Shigeru Miyamoto, working for Nintendo, a former Japanese playing-card company, creates **"Donkey Kong"** and its protagonist, Mario.

1982

Coleco (the former Connecticut Leather Company) releases another competitor in the home game market, **"Colecovision,"** which ships with the home-licensed version of "Donkey Kong."

1981–1983

A variety of classics are released from a range of companies, including **"Defender," "Scramble," "Super Cobra," "Berzerk,"** and **"Joust."**

1983

The first game to feature laser disc technology—which would eventually be refined to CDs and then DVDs (the current medium of most console games)—is released: **"Dragon's Lair."**

1985

Nintendo enters the home game market with the first Nintendo console, the NES, or Nintendo Entertainment System, featuring the now famous **"Duck Hunt"** and **"Super Mario Bros."**

"Gauntlet" is released in the arcades and allows up to four players to explore the same dungeons together.

1987

The NES is the number one selling "toy" for the year in the United States, and the NES game **"The Legend of Zelda"** becomes the first game to sell more than 1 million units.

"Streetfighter" is released in arcades; the game defines the head-to-head fighting genre.

1989

Nintendo releases the first handheld video game system to use game cartridges, the Gameboy. Nintendo's Mario character is now as widely recognized by children as Bugs Bunny and Mickey Mouse.

Sega releases the Sega Genesis home entertainment system.

1990

The first **"Final Fantasy"** title is released by SquareSoft in Japan.

1991

Nintendo releases their next-generation home console system, the Super Nintendo, which doubles the processing power of the previous system and establishes the five-year life-cycle model for consoles. It is released with **"Super Mario World"**; titles like **"Super Metroid," "Killer Instinct," "Donkey Kong Country,"** and **"Legend of Zelda: A Link to the Past"** become famous over the next five years.

1992

"Mortal Kombat" is released in arcades; using "digitized graphics" of real people, it establishes a new standard for graphics quality, as well as for speed and variety, in head-to-head fighting games.

1994

Sony releases the Sony Playstation, with double the processing power of the Super Nintendo. On this system over the next five years, **"Metal Gear Solid"** breaks new ground for mature narratives in games, **"Final Fantasy VII"** becomes the most popular role-playing game of all time, **"Gran Turismo 2"** establishes new standards for racing simulation games, **"Resident Evil 2"** brings the horror genre into its own, and **"Oddworld: Abe's Oddysee"** sets new benchmarks for quality of art and design.

1996

Nintendo releases the N64 home system, with double the processing power of the Sony Playstation, at 64 bits. It is the first home system to allow games to be played in true three-dimension, and titles like **"Mario 64," "Goldeneye,"** and **"The Legend of Zelda: The Ocarina of Time"** establish a variety of new conventions for three-dimensional gaming over the following four years.

1998

Sega releases the 128-bit Dreamcast. **"Soul Caliber"** establishes a new standard for head-to-head fighting games in three-dimensions.

Nintendo releases the first **"Pokemon"** game for Game Boy Color. "Pokemon" becomes a multibillion-dollar industry and at one point accounts for more than half of Nintendo's revenues.

"Dance Dance Revolution" is released in arcades and becomes its own phenomenon as players compete against one another with their own choreography. Arcade games are now more focused on specialized, often complex control mechanisms or booths that cannot be duplicated by home console systems and that offer more "immersive" experiences.

1999

"Everquest" is released and becomes the most popular online, multiplayer game to date, firmly establishing the Massively Multiplayer Online Game as a new genre.

2000

Sony releases the 128-bit PS2.

Nintendo sells its 100-millionth Game Boy unit. Game Boy accounts for nearly one half of all game hardware revenues in North America; the new Pokemon titles sell 1.4 million copies in their first week of release.

2001

Microsoft releases the 128-bit Xbox. The first-person shooter, **"Halo,"** is released exclusively for Xbox and becomes one of the best-selling games of all time, as well as the new example of a "system selling" game, more than twenty years after "Space Invaders" built the Atari system.

Nintendo releases the 128-bit GameCube.

2003

All home console systems are now enabled to play games online.

2005

Sony enters the handheld game market with the PSP—a device that plays both movies and games. Microsoft releases the Xbox 360, the first "next Next Generation" console.

PHOTO CREDITS

KOEI Japan is looking for artist talent. For additional information go to www.koei.co.jp

ACKNOWLEDGMENTS

First and foremost I would like to thank my editor Kay Guttmann, my designer Nelly Riedel, and my publishers Prosper and Martine Assouline for all their vision and belief in this project.

In addition, I would like to extend a special thanks to Professor Henry Jenkins for so kindly finding the time to write our preface. It is much appreciated, Henry!

I would also, of course, like to thank tremendously all the wonderful PR, marketing, art department, and legal people who worked with us at their busiest time of year. These people made this book possible and include, but I'm sure are by no means limited to: Activision's Lisa Fields, Ryh-Ming Poon, and Mike Mantarro, Atlus's Gail Salamanca, Bethesda Softwork's Diana Calihanna and Pete Hines, Bioware's Jarrett Davis, Craig Priddle, and James Ohlen, Blizzard's Gloria Soto and Denise Lopez, Capcom's Arne Cual-Pedroso, Codemaster's Liz Darling, Cyan's Chris Brandkamp, Darkwork's Guillaume Gouraud, Digital Extreme's Meridith Braun, Dreamcatcher's Tara Reed, Eidos's Jefferson Dong and Sheila Leunig, Firaxis's Kelley Gilmore and Mike Gibson, Gearbox's Brian Martel, High Moon's Sandi McCleary, Insomniac's Ted Price and Ryan Schneider, Koei's Jarik Davis, Konami's Marc Franklin and Denny Chiu, Lionhead Studio's Cathy Campos, Andrew Lindsay, and Mark Healey, Majesco's Leslie Mills de Marco, Microid's Edouard Lussan, Microsoft's Albert Kanan, Monolith's David Longo, TJ Jones, and Samantha Ryan, Mythic's Eddiemae Jukes, Namco's Kristin Calcagno, Oddworld's Kristin Inman, Shaba's Vince Riley (sorry Vince!), Sony's Tim Cummins, Alyssa Casella, Tina Casalino, Ryan Bowling, and Jennifer Clark, SuckerPunch's Dev Maden and Brian Fleming, Tecmo's Melody Pfeiffer, THQ's Craig Mitchell, Tom Stratton, and Gretchen Armerding, Turbine's Erika Braxton-White, Ubisoft's Martin Carrier and AnneMarie Gabriele, Valve's Doug Lombardi, Volition's Kelly Snapka, and Wide Load's Alex Seropian, Leah Heck, and Jim Hudson. A special thank-you to Day 1's Denny Thorley and Deep Red's Graham Davis, Andy Hodgson, and Simon Hughes.

Finally, I would like to thank all my friends who supported me in this project, particularly Lorraine Anderson, Arturo Aranda, Daniel Degnan, Jonathan Hamel, and last but far from least, Tracie Matthews.

The publisher would like to thank all the developers and publishers who have provided images for this book and who have given their support to this project. A special thank-you to Jamie Vuignier (The Kobal Collection), Corbis, Fabienne Grévy (AKG-Image), and Catherine Terk (Rue des Archives, Paris).